W9-BCE-589

Children in Painting

Marie-Christine Autin Graz

Children in Painting

SKIRA

Graphic design
Marcello Francone

Editing
Doriana Comerlati

Layout
Eliana Gelati

Translations from French
Eléonore Pralle

Iconographical research
Massimo Zanella
Alessandra Montini

This book has been sponsored by the bank
Ferrier Lullin & Cie SA

First published in Italy in 2002 by
Skira Editore S.p.A.
Palazzo Casati Stampa
via Torino 61
20123 Milano
Italy

Printed and bound in Italy. First edition
ISBN 88-8491-215-6

Distributed in North America and Latin
America by Rizzoli International Publications,
Inc. through St. Martin's Press, 175 Fifth
Avenue, New York, NY 10010.
Distributed elsewhere in the world by Thames
and Hudson Ltd., 181a High Holborn,
London WC1V 7QX, United Kingdom.

"The one who does not believe in invisible, depends on opinion."

Plato

Contents

9
Preface
Alvar González-Palacios

15
Introduction, texts and selection of details
Marie-Christine Autin Graz

25
Italian Painting

75
German Painting

89
Dutch Painting

111
Flemish Painting

139
Spanish Painting

167
English Painting

181
American Painting

191
Swiss Painting

201
French Painting

229
Acknowledgements

230
Photographic Credits

231
Bibliography

233
List of Illustrations

Preface

The image of a child is not necessarily a portrait, it may be simply a representation; not the idea of a known individual but rather an allegory or simply an ornamental motif. Let me give a couple of examples. The various angels in Fra Angelico's *Last Judgement*, which the author of this book much loves, are an emblem of tenderness but are only recognizable as such. The same thing could be said of the *Madonna and Child* in an infinite number of representations from the Renaissance. As exquisite as they are, they are mainly to be considered as ideas of childhood and not as individuals, just as the mischievous cherubs in Botticelli's panel with *Mars and Venus* are ironic and playful beings without resembling a distinct individual: one is the same as the next. What counts, perhaps, is the game, the joke.

At the same time you cannot say that this approach is a fixed characteristic of a particular painter. The fresco by Fra Angelico in the Chapel of Nicholas V in the Vatican includes both abstract cherubs and figures of beggars, as well as the figure of Saint Lawrence, that can be considered portraits in their own right. And in yet other cases, such as the children of Cosimo I by Bronzino (for example, Giovanni and Bia de' Medici, discussed in this book), the painter delves into the human soul in a sort of pre-Freudian psychological analysis. The same thing happens with the youthful Ranuccio Farnese by Titian and with the family of Ludovico Gonzaga by Mantegna. Giovanni de' Medici portrays innocence, his sister Bia a judicious and serene inclination, while the young Farnese appears given to melancholy. The family of the Marquis of Mantua is a mix of different, almost opposite attitudes towards life, from the phlegmatic nature of the father to the feline stare of the prelate to the still uncertain rapacity of the little ones. The mysterious allegory by Bronzino in the National Gallery of London has a completely different tone, apparently seeking out obscure feelings ranging from lust to love, insincerity, and Time. All, however, take on an abstract aspect that has little to do with a real human being and much less with the childhood that today has become the object of depraved paedophilia.

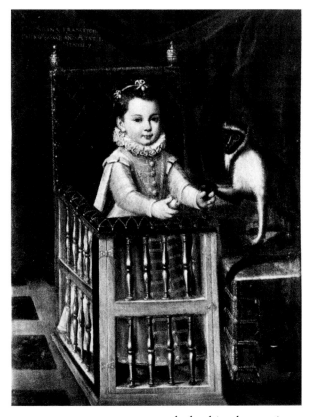

Anonymous, *Francesca Caterina di Savoia*, 1597. Present whereabouts unknown

In one of his last essays, Federico Zeri holds forth with his usual clarity on portraits of children destined for the throne, noting, first of all, how the royal infants are forced to ignore their childhood. In not yet knowing, given his tender years, of the role awaiting him, the prince is trapped right from the beginning within precise structures, sumptuously dressed like an old man in miniature. It is the cowl, as they say, that makes the monk, or better, the man of power immediately becomes the mask of the future king. Zeri concludes his observations not without a touch of perfidy: "Culture takes on a secondary role, its intrusion becomes even to be seen as harmful, what counts is upbringing and the knowledge of myths, customs, family and social relationships, proper manners, the hierarchy and the entire code of obligatory behaviour for those belonging to a class placed above all other common mortals." He has a point: there have been many a sovereign and no lack of noblemen who were not exactly known as being founts of wisdom, even if they often are (or better, were) persons of courteous albeit superficial social intercourse.

The history of art can produce, via complex itineraries, other images that reveal no small amount about the life of human beings in their different ages, often with a touch of the comic or the bizarre. A curious painting of the Princess Francesca Caterina di Savoia when she was not quite two, near the end of the 16th century, shows the child in a cage – or in a sort of stroller, as we would say today – all decked out like an adult, tormented by that *bona fide* instrument of torture, the typical Spanish *golilla*. The irony is not missing from the fact that the martyred infant is imprisoned while the little monkey they have given her to play with appears completely free. Both of them are certainly unhappy, but at least the pet can move about as it pleases.

On the subject of childrearing, pedagogical abuse, hygiene and the cus-

toms that governed the lives of the little princes in the Medici household, the very instructive exhibition organized at the Palazzo Pitti in 1995 by Kirsten Piacenti and Roberta Orsi Orlandini is much to be recommended. It also deals with mysterious habits that take on a more or less liturgical connotation, such as the use of coral ornaments. Actually, little is said of the age-old apotropaic use of this material and not much of it is seen in the volume that you now have in your hands. Yet coral was widely used all over Europe and there are few Holy Childs whose necks are not adorned with those good luck charms (see the portrait of Giovanni de' Medici done by Bronzino), and it continued to be seen well into the 17th century.

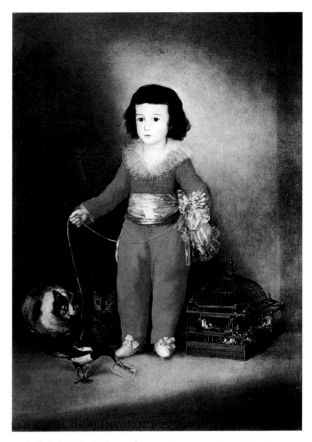

Francisco Goya y Lucientes, *Manuel Osorio*, c. 1788. Metropolitan Museum of Art, New York

This book includes several infantile lineaments by Francisco Goya, but the *Manuel Osorio* (c. 1788) in the Metropolitan Museum is perhaps the happiest composition of this kind by the great Spanish genius: a blaze of purple and a bloodless face, a magpie tethered on a silken thread, three respectful cats and an entire cage full of birds are not enough to annul the vacant gaze of a little one perhaps inured to everything, already slipping into the *desengaño* that will typify the Spanish aristocracy towards the end of the Ancien Régime.

The hallucinatory hyperrealism of certain portraits by Girodet – in which the alternation of light and shadow exalts the fixedness of the usual expressions, and the minute description of common objects becomes obsessive – accommodates tendencies that can already be considered romantic while technically not being at all Neoclassical. In what are presumed to be portraits of the children of Doctor Trioson he starts a completely innovative psychological investigation, which goes well beyond the elegant stylization of David's other pupils. What holds the gaze of these melancholic children preyed upon by a morbid charm? The image of an undecipherable sensitivity seems to be reflected in their eyes, a sensitivi-

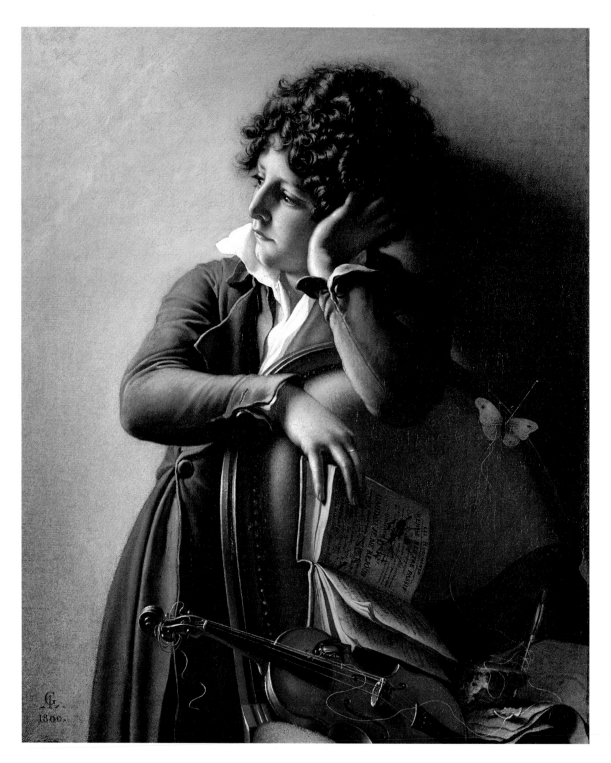

Anne-Louis Girodet de Roucy Trioson, *Presumed Portrait of Romainville Trioson*. Musée du Louvre, Paris

Philipp Otto Runge, *Portrait of the Artist's Son*, 1805. Kunsthalle, Hamburg

ty which has gone beyond the poses of the Louis XVI style to enter the realm of the highest ornamentalists of the modern age while still contradicting them. And this is certainly not, we emphasize, due to the lack of technical skill – few artists dedicated more care to the execution of their works than Girodet – but rather to a different mental position (or deviation). The Alexandrine preciousness with which Girodet attends to every single detail (see the admirable still life arranged on the little Trioson's armchair in which the insidious bumblebee gnaws at the strings of the violin and the multi-coloured butterfly, symbol of the immortal soul, is impaled on a long hat pin, fixed to the upholstery) occasionally trespasses into humour. The boy, magnetized by some unknown force, seems to be the hero of Henry James' *Turn of the Screw*.

Similar premises of taste inform the work of Philipp Otto Runge, who succeeds in generating a magnetic force comparable to the maniacal fixity of Girodet, though neither of them attain Goya's vital burst. In the small canvas with his firstborn son (1805), just a few months old, the painter moves away from the artificial virtuosity at which he often aims arrow-straight and achieves an impetuous power wedged into the chair with the boy, not so systematically dissimilar, *mutatis mutandis*, from that bizarre piece of furniture that some centuries earlier had entrapped a Piedmontese princess.

And now we move on to a series of delicate animals, often not yet bipedal, seen through the restless eyes of painters.

Alvar González-Palacios

Introduction

A child is posterity, so is painting. A child is truth, so is painting. A child is love, so is painting. These are the three main reasons why I chose to write this book. The fourth one was the vision I nearly had while contemplating Fra Angelico's *Last Judgement* in the Museo di San Marco in Florence.

The Gospel according to Saint Matthew (25, 31–46) gives the most detailed description of Doomsday: "When the Son of man shall come in his glory, and all the holy angels with him, then shall he sit upon the throne of his glory; and before him shall be gathered all nations: and he shall separate them one from another, as a shepherd divideth his sheep from the goats: [...] Then he shall say also unto them on the left hand, Depart from me, ye cursed, into everlasting fire, prepared for the devil and his angels: [...] And these shall go away into everlasting punishment: but the righteous into life eternal." In his Gospel, Saint John writes (5, 28–29): "Marvel not at this: for the hour is coming, in the which all that are in the graves shall hear his voice. And shall come forth; they that have done good, unto the resurrection of life; and that they have done evil, unto the resurrection of damnation."

Fra Angelico's picture is the simplest and most perfect illustration of these words.

In heaven, Christ in his glory is surrounded by the concert of angels: with his right hand, he calls the righteous; with his left hand, he sends away the cursed. Close to him are his two intercessors, the Virgin Mary and Saint John the Baptist. While the trumpets wake the dead, twenty-four prophets and saints forming the celestial tribunal take place. On Earth, a path paved with the open graves separates the blessed from the cursed. Still on the left, the side of the damned, bishops, kings, monks, men and women are thrown into the fires of Hell by Lucifer's guards. On the right, in a luminous and luxuriant Paradise, the angels invite the newcomers to join the dance of everlasting happiness. Look closely, in the centre of this Eden two young angels embrace with exquisite tenderness. These are the two "creatures"

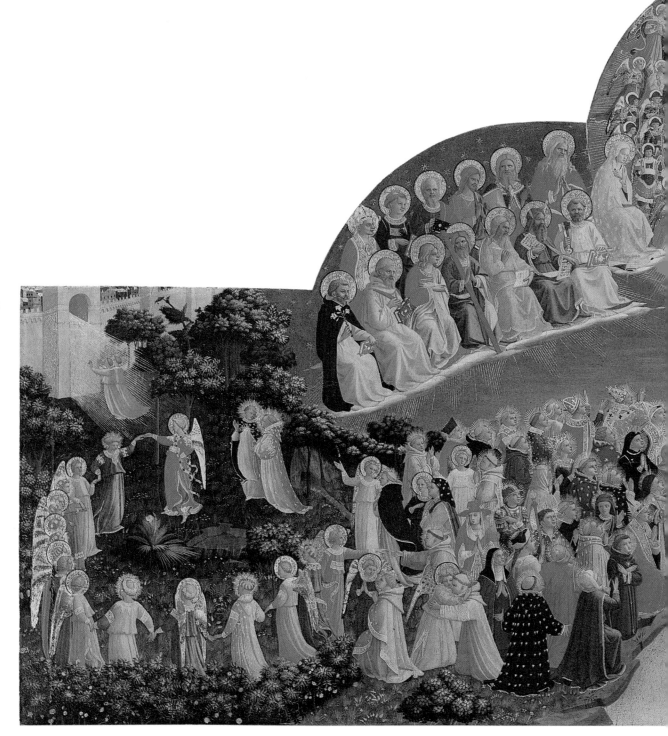

Fra Angelico, *Last Judgement*.
Museo di San Marco, Florence

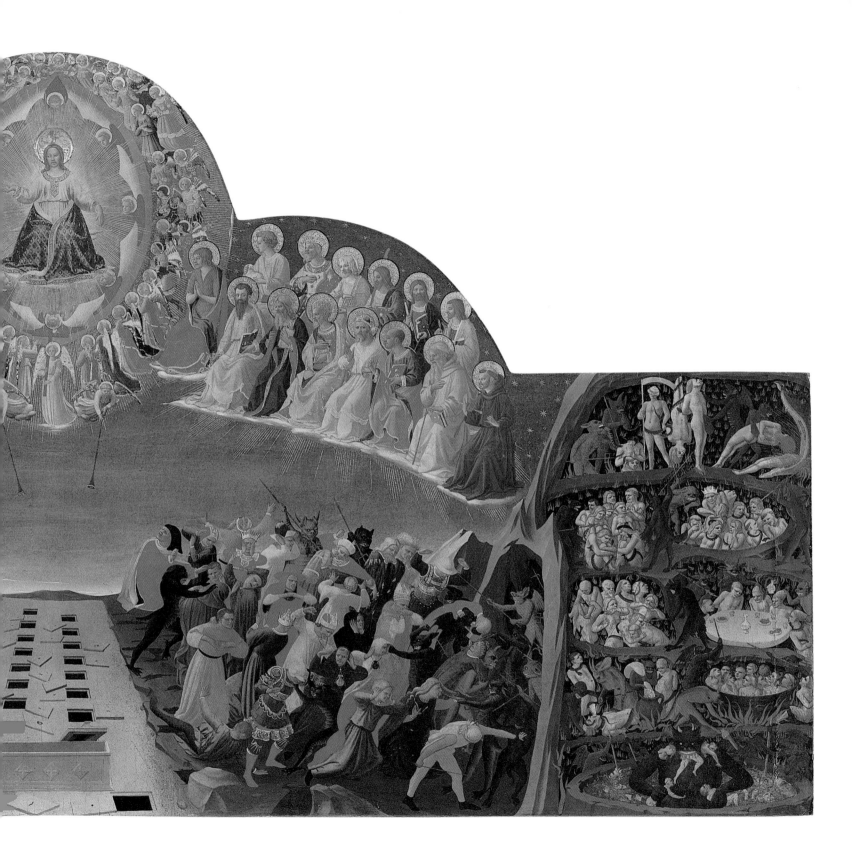

which have inspired this book. Looking at them I felt like loving and embracing the people around me and believing in Heaven. Fra Angelico does not seem interested by Hell and his representation of it is poor. On the other hand, Heaven becomes a celebration of perfect shapes, splendid colours and figures full of glee.

Fra Angelico is divine but is a child so? From the day of his birth until the age of ten, one can believe it so. This is the reason why no child over this age features in this book.

Having a child is a universal desire. Any human being wishes to reproduce himself, to assure his posterity and to perpetuate his qualities and faults in his strife for survival.

A child takes his parents' love for granted. His mother's love becomes an ever-growing and everlasting devotion.

A child is life with its innocence, its capacity to wonder and to trust, its truth, its laughter, its tenderness. The accumulation of these feelings and impressions create the cement of his future happiness.

A child is a constant concern because of his inconsistency, his ignorance, his jealousy, his silliness, his tears and his frights. These make him discover the world and damage his natural disposition to be happy.

Finally, his growing-up will bring the painful separation from the ones who gave him life. Life, love and death are a trilogy, of which he is the hero.

The infinite number of pictures of Virgin and Child, of new-borns, royal family's commissions, merchants' and farmers'commissions, or the multitude of social scenes made choosing a selection of paintings a dilemma. I have tried to show the most varied and extensive display of children in Italian (obviously the richest), German, Dutch, Flemish, Spanish, English, American, French and Swiss painting. This latest one deserves to be mentioned. Its painters although less prestigious and mostly unknown reveal a charm, a poetry and a humility in their manner, which is worth recognition. Unfortunately, the paintings in this book are only a tiny sample of the ones that I had selected at first.

Fra Angelico, *Last Judgement*.
Museo di San Marco, Florence.
Detail

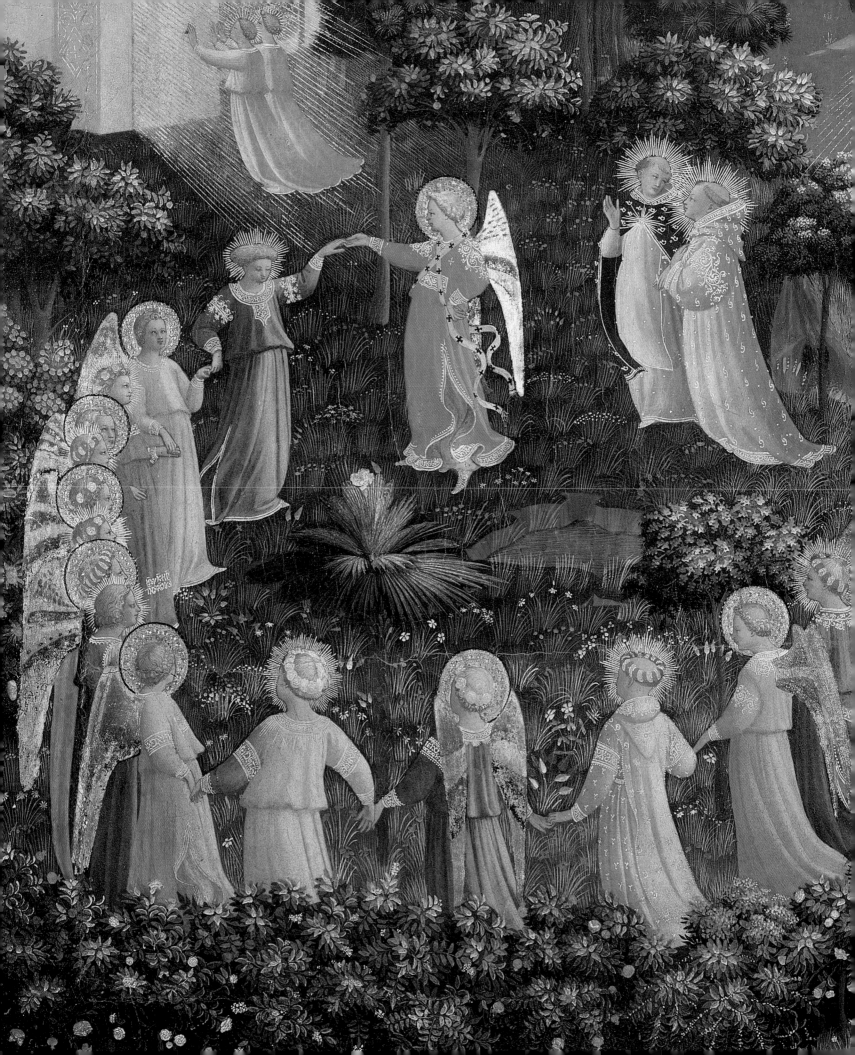

To choose is to take the risk of making the wrong choice and of not satisfying all the readers. My views on aesthetics are of course disputable and debatable, but as Beaumarchais said: "Without the liberty to blame, there is no flattering praise." To refuse this is to collaborate in the surrender of freedom of expression. Art lives through passion, it incenses or destroys, it confirms splendour or horror, it refuses mediocrity and condemns indifference. All artists must meet its requirements, its tyranny and its pains. About his work in the Sistine Chapel, Michelangelo wrote to his friend Giovanni da Pistoia: "The loins come through my belly, by counterbalancing, my backside becomes my head, and it is hopelessly that I shake my feet without seeing them" (Michelangelo's letters, vol. XIII, fol. 112, Buonarroti Archives, Florence).

"Beauty will save the world": I am afraid I do not share Dostoevski's optimism when I look at the artistic failure of the last fifty years. Extremes always meet: Fascism and Communism have played the same political and artistic havoc. The contradictions of creation are such: it cannot be born through unanimity of thought but it cannot accept the tyranny of the biggest number, because, by definition, genius is the miraculous exception offered by the injustices of Nature.

The hard egalitarians might tag me with an "elitist" label, but this would be a dangerous aberration, as they would confuse inequality with difference: "Give the same mind to men / and you shall loose all the salt of society. / Boredom was born the day of uniformity" (Lamotte-Houdar, *Fables*, *"Les amis trop d'accord"*).

Does one need to be reminded that biologically we are programmed for diversity? It is a reserve of independence or dependence, of fortitude or cowardice, of fervour to sin or virtue. We need all these contradictions to find ourselves and to grow; it is by erasing differences that we run towards general poverty.

With regards to "modernism", it has simply refused the past and has remained in a "nothing state", a killing absurdity for art, from which it has not recovered yet. Why should one have the immense pretension to believe that a work of art is born from nothing? How could a musician play without knowing the

Fra Angelico, *Last Judgement*.
Museo di San Marco, Florence.
Detail

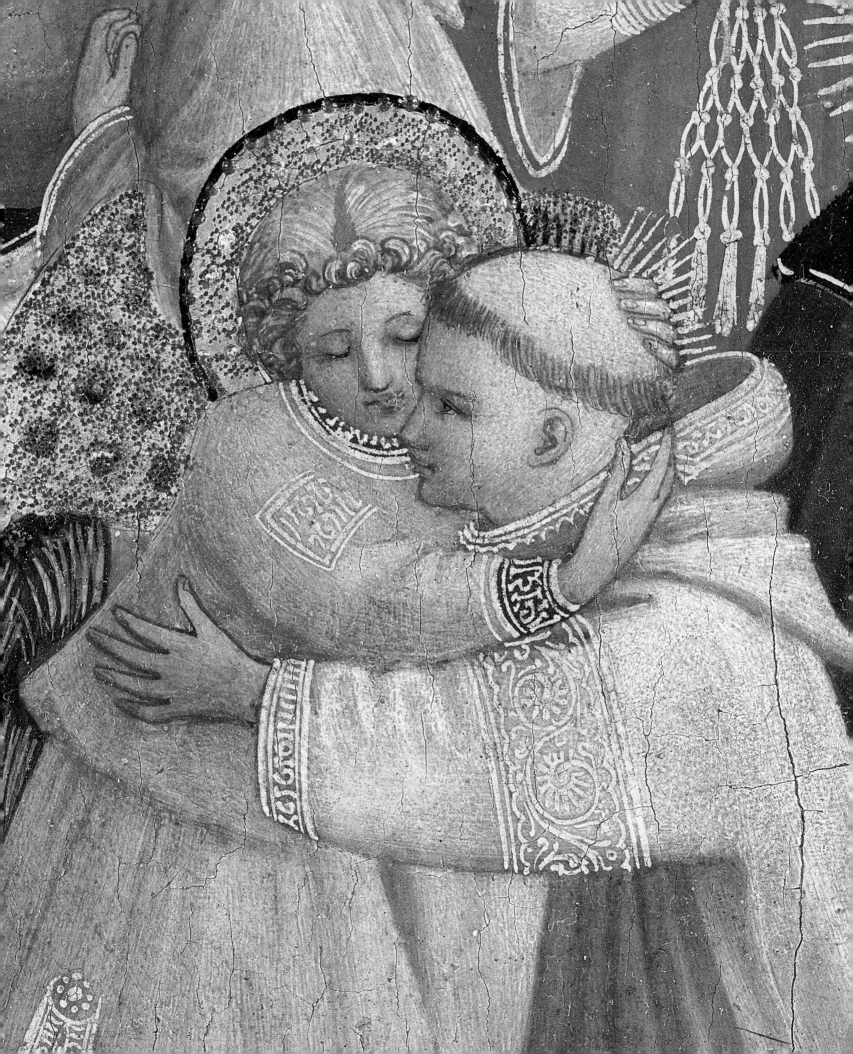

notes, an author write without knowing anything about grammar, a mathematician calculate without knowing how to count, or a painter paint without knowing how to draw? In a few words, how can one express oneself without knowledge?

Today, art has suffered from the incoherence of ignorance, which has become the rule. The gurus of empty aesthetics invite us to the great show of contemporary art where one must swoon in front of Lucio Fontana exhibiting a slashed canvas estimated at US$ 210,000, where it is a must to admire *The Circle of Mussels* by Marcel Broodthaers at a mere price of US$ 570,000 (I would rather have them *marinières* for 20 euros)... We must also reflect deeply on, I quote, "the sensual depths and the vibrating realism" of a square of white Plexiglas about which the author desires to attract our attention on the four nails retaining his piece against the wall, all this for US$ 110,000 (per nail, the price is rather extravagant!). Do not forget to be ecstatic when looking at the wild scrawls signed C. Twombly before being stunned by their price: US$ 430,000. Let us finish with Mark Rothko, three stains without a title (of course!) for US$ 920,000! And those are certainly not the most expensive ones of a very long list, too long to believe it a bad joke one could eventually laugh about, if it were not so expensive. Fra Angelico's universe in his *Last Judgement* or Michelangelo's one on the ceilings of the Sistine Chapel are so far away! Their masterpiece have survived six centuries without ageing, how long will mussels, nails or nothings last? One thing is certain: it would have been impossible for me to write a book on children in painting from the second half of the 20th century to nowadays.

Unfortunately for some, beauty is not always only in the eye of the beholder: the beauty of the Pyramids, of Venice is universal. To refuse beauty is to run the risk of forgetting it and it disappearing in the face of general indifference. The present and the future are built on the past. With the old, one can create the new and even the revolutionary. What is the point of this monstrous ego? Why such arrogance to pretend that one knows without having learnt? What a pity for these scrawlers who will never know the sensual pleasure there is to drape a naked and

shivering body! They will never know how to make an eye sparkle or to render the freshness of a rose. What will they do when the weakness of their brushes will stop them from wetting a lip about to kiss, or from making the light reflect on transparent crystal? Nothing, because they are incompetent and ignorant. The creator, the true one, who interrogates the mind and lifts the soul, knows he is condemned to humility when he realizes his limitations in front of his certitudes.

The child is the revealer of a masterpiece where the ordinary becomes extraordinary. Painters have been obliged to exchange their adult's knowledge for a wonderful innocence where all these geniuses have searched truth to find beauty and vice versa.

Italian Painting

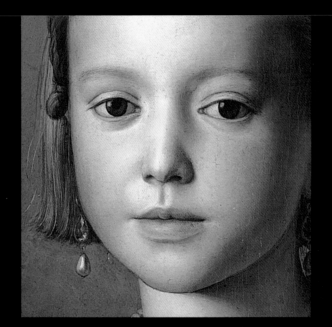

Theseus Liberator

Pompeii, House of Gavius Rufus
1st–2nd century A.D.
Anonymous
Fresco, 94 × 88 cm
Museo Archeologico Nazionale, Naples

*A*fter having been Etruscan, Greek and Samnite, it is in 80 BC that Pompeii becomes a Roman colony. The new inhabitants build sumptuous villas and transform the place into a sought-after city for wealthy families. The healthy climate, the beauty of the setting, the fertility of the land and a very cheap workforce ensure the landowners large incomes.

If Theseus is one of the most amazing heroes of Greek mythology, he is first and foremost the founder of the Athenian democracy. He divided Ionians and Dorians, had public edifices built and structured society into three classes: aristocrats, artisans and farmers.

The king of Crete, Minos, forces Athens to pay a yearly tribute of seven little girls and seven young boys to be fed to the Minotaur, a creature with the head of a bull and the body of a man. Theseus decides to be part of the expedition and to defeat the monster. Once landed on the island, he seduces Ariadne, daughter of Minos. She gives him a ball of thread, with which he will find his way out of Daedalus' labyrinth. The hero keeps his promise: he kills the Minotaur and frees the children.

This fresco is audacious, provoking and even indecent. It is nonetheless of unequalled beauty and realism. Is it shocking and vulgar to place in the centre of the composition a naked man sur-

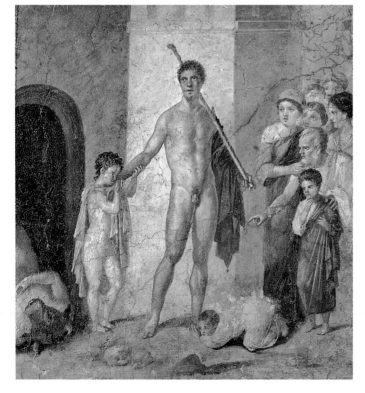

rounded by caressing children? Neither here nor in Pompeii, where people ignore modesty, praise nudity and all its sexual symbols. Theseus' nudity is triumphant, heroic and intact after the fight. His muscles are tense, his skin is still sweating and the determination of the victor can be read on his face slightly scratched by the Minotaur. In a corner, the astounded parents stare at the dead monster.

Twenty-two centuries ago perfection had been reached in painting. What more can be said than that the artist in his greatness and humility remains unknown?

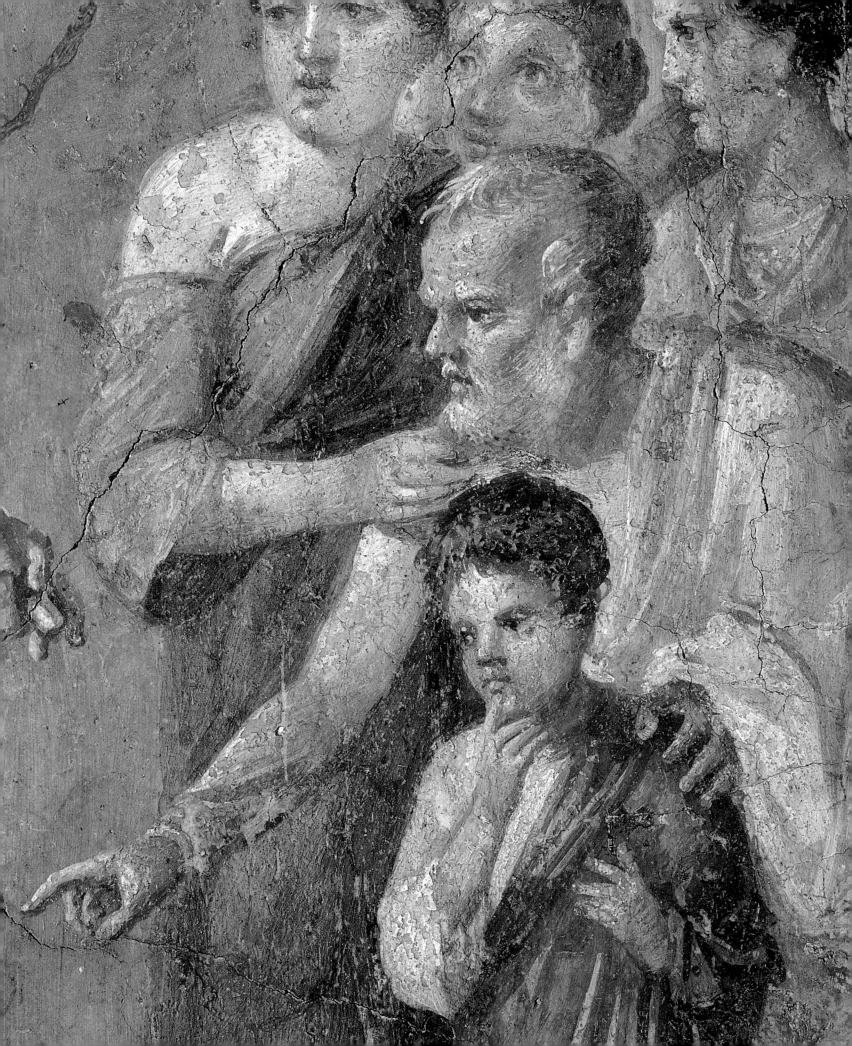

Presentation of Mary at the Temple
Giotto
(Vespignano, Vicchio di Mugello, 1267? – Florence, 1337)
Fresco
Scrovegni or Arena Chapel, Padua

The divine Giotto invites us into his starry sky. With him we are incessantly transported between Heaven and Earth as if he wanted to show us how close they are. Contemplating the frescoes of the Arena Chapel, the atheist discovers faith and the believer is enlightened. Giotto's faith is faultless and it is the inspiration of his art. His world becomes so solid it is nearly aggressive, so geometrical it is nearly abstract, so real it reaches surrealism. The technique *a fresco* does not allow for corrections, he thus draws with a running hand, mixes and shades colours, creates volumes with a precise dash of his brush and lifts the fabrics to let us guess the flesh of the bodies beneath. The art of this genius is inspired, perfect and grandiose.

Reginaldo, father of Enrico Scrovegni, was a well-known usurer, who Dante quotes in his *Inferno*. To redeem his father's soul, Enrico commissions a chapel, dedicated to Santa Maria della Carità, to be built against the eastern part of the old Roman arenas. The first stone is laid on the 25th March 1303. Two years later exactly, on the 25th March 1305, the chapel is finished and consecrated. In his apocryphal gospel, James writes: "The child was three, Joachim said: 'Let us call the daughters of the Hebrews, the ones without fault.' [...] The order was obeyed, they climbed the steps of the temple of the Lord. The priest welcomed the child and having kissed her, he blessed her."

Giotto sets the scene between an everlasting blue sky and a decidedly dark earth. His composition rests on a pyramidal plan from the ground to the top of the roof. The technique of the artist is disconcerting: in the temple, he creates an imaginary geometry; amongst his people, he creates an organized abstraction between shapes and volumes. The artist does not dress the men and women; he wraps them in heavy cloaks gliding on their bodies so as to enhance the expression on their simple faces. Anne, with an elegant gesture, shows her daughter to the last step. Conscious of the purity of the little Mary, Giotto brings out her softness and her innocence, the freshness of her skin and the emotion in her eyes. Gently, he curls her hair dressed by a golden halo and folds her little arms over the pleats of her white dress.

Guided by the Lord, Giotto's hand paints an angel and their meeting becomes a miracle.

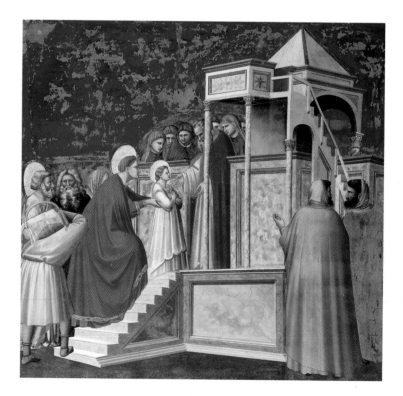

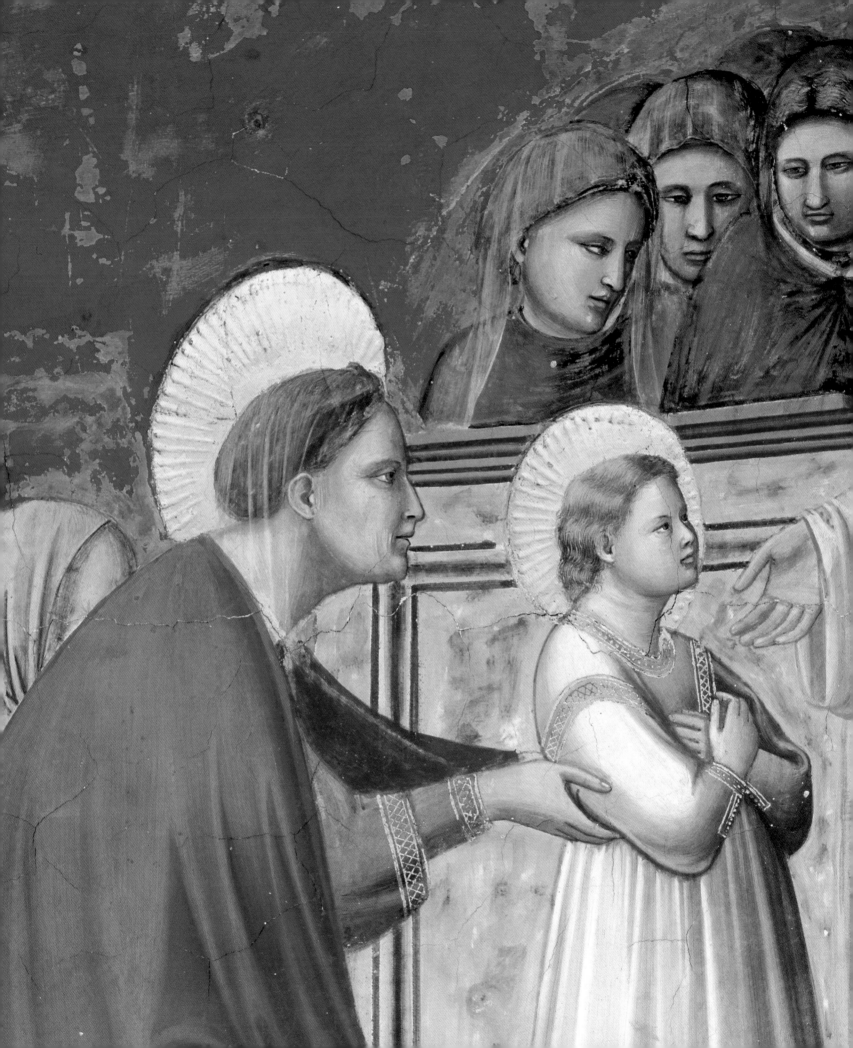

Virgin and Child

Pietro Lorenzetti
(Siena, c. 1280/85–1348)
Tempera on panel, 71 × 41 cm
Museo Diocesano, Pienza

"Primitive" comes from the Latin *primitivus*, "which or who is born first". It is this definition that one must keep in mind when looking at the pictures of the Sienese school. It is one of the most amazing, the most impressive. The pictures are sacred but yet so human, they are sumptuous without ostentation, they delight the eye and soothe the soul. Duccio di Buoninsegna, Simone Martini, Sassetta and the Lorenzetti brothers are the representatives of this exceptional art.

Pietro Lorenzetti, probably elder brother to Ambrogio, works in Siena, Florence, Arezzo and Assisi, where he discovers Giotto, who will influence his style. His technique is delicate and precise. He invents a new way to engrave with a burin the nimbus of the saints. Both brothers die in the Black Plague epidemic of 1348.

This Virgin is *Mona Lisa*, only two hundred years older. This superb *Virgin and Child* was part of a polyptych with *Saint Agatha* (Musée Tessée, Le Mans), *Saint Leonard, Saints Catherine and Margaret* (Museo Horne, Florence). It was commissioned by the pieve or country parish, of Santi Leonardo e Cristoforo in Mon-

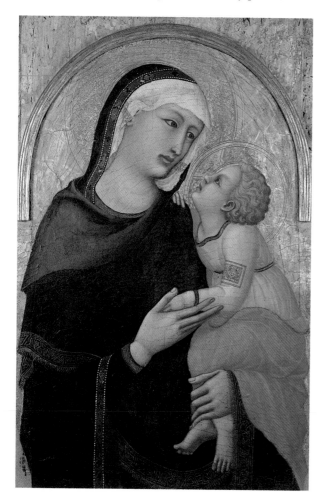

tichiello. Lorenzetti's Virgin becomes a young mother from Siena. She is wrapped up in her coat, which slides back on her head to discover a fine veil framing the regular features of her delicate face. Her brown eyes, almond-shaped, look intensely at her beloved Child. The little child worships his mother. He stretches his neck and his lovely hair falls back. His lips are opened just enough to whisper words of love. His eye admires her and his little hand gently resting on her shoulder protects her. This sweetheart is in love with his mother like most children of his age.

Thanks to this painter, we know that the relationship between Virgin and Child was no different to the one of any mother and child.

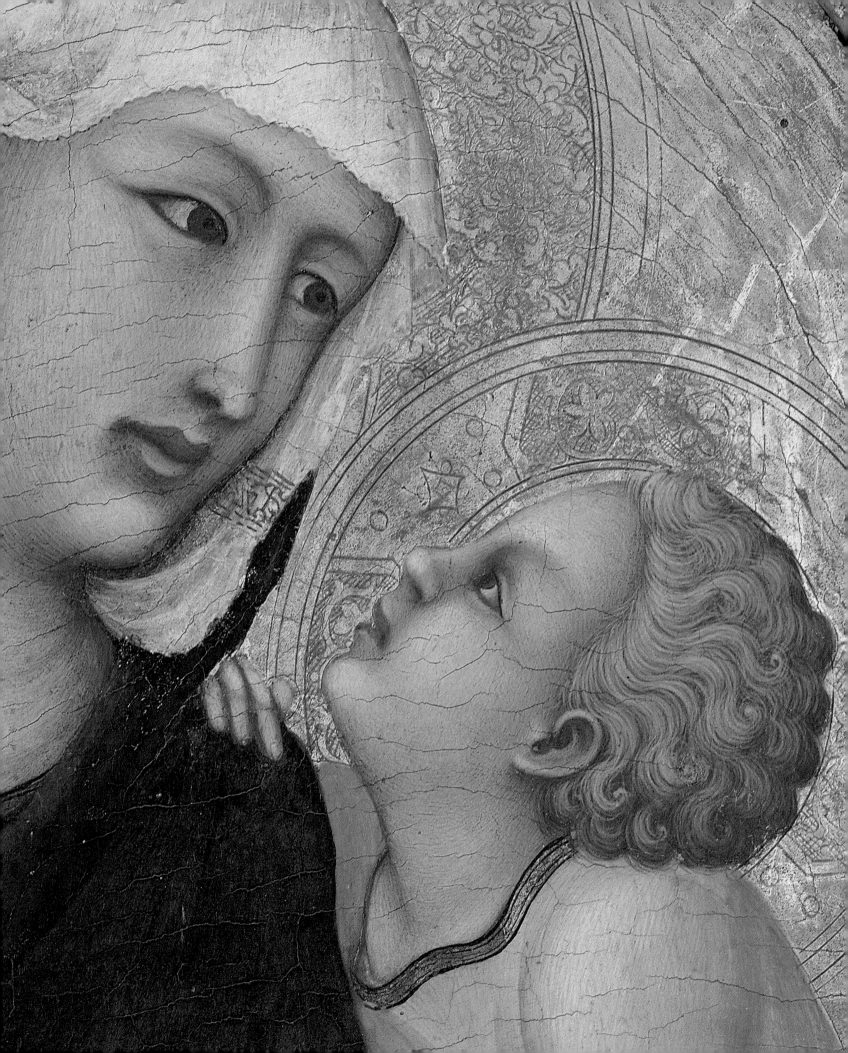

Stories of Blessed Agostino Novello
Miracle of the Child Falling from the Balcony
1328
Simone Martini
(Siena, c. 1284 – Avignon, 1344)
Tempera on poplar, 200 × 256 cm
Pinacoteca Nazionale, Siena

About Simone Martini, Ghiberti said: "The famous, the celestial."

One of the main qualities for a painter is imagination; it brings innovation and audacity. Simone Martini invents, organizes shapes of exquisite elegance and mixes subtle and striking colours. He uses the anecdote to unleash his originality, which is full of fantasy and humour, but is at the same time so delicate and refined. When Martini paints his *Annunciation* (Galleria degli Uffizi, Florence), he is full of cheek. His Virgin, drawn with a cursive dark line, refuses the destiny, which the archangel Gabriel has come to deliver. He looks like a flamboyant migrating bird with his tartan cape, but flies like *putti* fly in Baroque cathedrals. The forefinger of the angel has authority; the young girl is frightened but would not obey the order if it were not divine. This painter has dared to depict a contumacious Virgin.

Blessed Agostino Novello was born in the 13th century at Termini, a village of Sicily. He held many positions of honour in the magistracy. The king of Sicily, Manfred, made him one of his counsellors. After the battle in which Manfred was killed (Benevento, 1266), Agostino determined to serve the King of kings, Jesus Christ. He was received into the order of Saint Augustine, of which he became General. Later, he resigned to live in retirement in the convent of San Leonardo, near Siena. Many of the miracles wrought through the intercession of Blessed Agostino were authenticated.

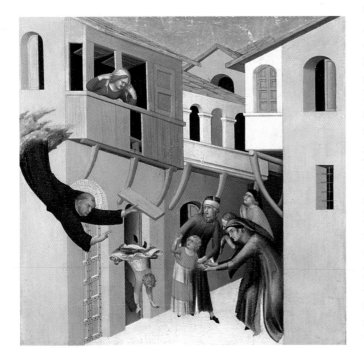

Clement XIV authorized his cult in 1770. A street and four houses bathed in shades of pink, for which only the painters of Siena have the secret, is the set where both saint and painter realize their miracles. A board of the balcony breaks, a mother screams, a child falls, Agostino takes off, saves the child and… the board! The child is safe and quickly comforted by passersby. Martini places within a single frame two subsequent actions, technique which should inspire many cartoonists…

Forty years ago, I was starting to learn the art and the profession of painting. By chance, I opened a book on Sienese painting: it was love at first sight! I was filled with warmth and well-being, it was an enlightenment! Since then, the same miracle happens each time that I contemplate the art of these benefactors.

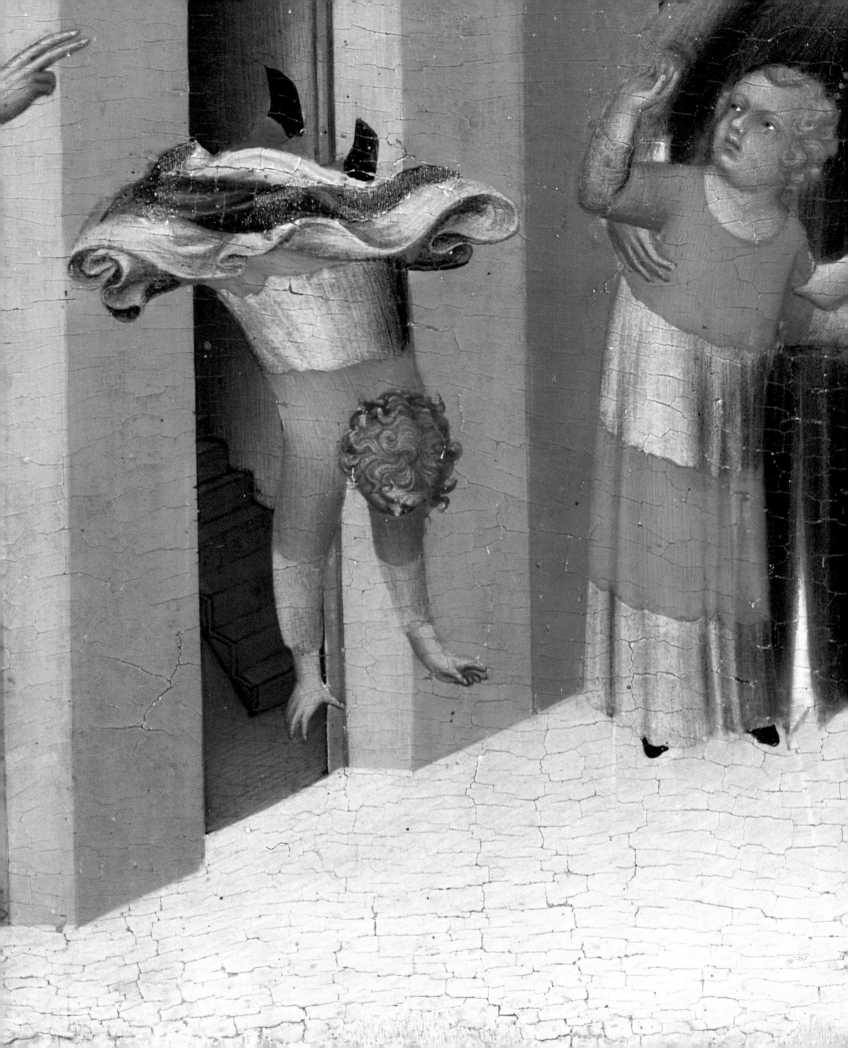

Virgin and Child with Eight Saints
(*Virgin of the Shadows*)

Fra Angelico
(Vicchio, Florence, c. 1395 – Rome, 1455)
Fresco, 273 × 320 cm
Eastern corridor, convent of San Marco, Florence

*I*n 1434, Cosimo de' Medici returns to Florence. Pope Eugene IV, who then resides in town, authorizes him to requisition the convent of the Silvestrins and to give it to the Dominicans of Fiesole. The former assert their rights and do all they can to delay the decision. The authority and the financial power of Cosimo sweep away all conflicts and work in San Marco starts in 1437 under the direction of the sculptor and architect Michelozzo. After five years of work, the forty-four cells are ready and the Cappella Maggiore is consecrated. It is in this very place that years later, as an irony of History, the rebellious monk Savonarole will start the popular revolt against the excess of Cosimo's grandson, Lorenzo de' Medici.

Fra Angelico and Michelozzo share the decoration of the convent. The painter decides to place the *Virgin of the Shadows* in the first floor dormitory, in the middle of the eastern corridor. He uses pigments *in tempera* applied *a secco* on an under-layer *a fresco*. The procedure is unusual but revives the colours.

A Virgin surrounded by eight men: if they were not saints, one could legitimately fear for her virginity! She is young, beautiful, haloed with gold but not one of them sets his eyes on her... Can one blame Fra Angelico? Let us give him the excuse of resisting temptation... All these handsome saints exhibiting their knowledge are either in deep discussion or gaze at us. Saint Dominic, recognizable by his star, stares at us and with his forefinger asks us to follow his doctrine: poverty, humility and charity. The twins Cosme and Damian, both doctors and surgeons, become Siamese twins under the brush of the artist. They listen to Saint Mark, the secretary and double of Saint Peter, who, on the other side, tempers the severity of his lieutenant. Saint Thomas hides discretely behind Saint Lawrence holding his grill. Saint John seems tired of writing his Apocalypse. Amongst these handsome wise men, a magnificent blond and curly head gleams, full of life. It is the dream of every mother. Its beautiful black eyes convert us instantly.

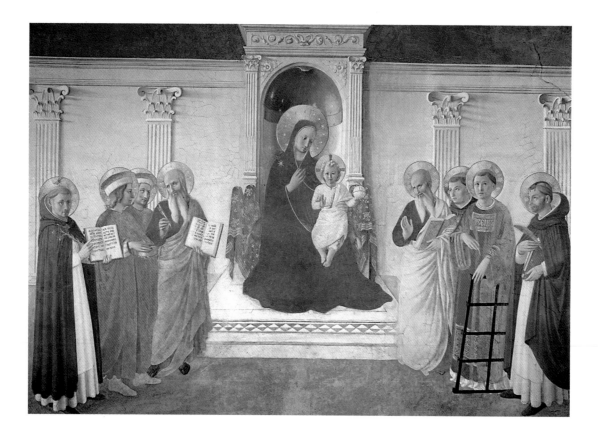

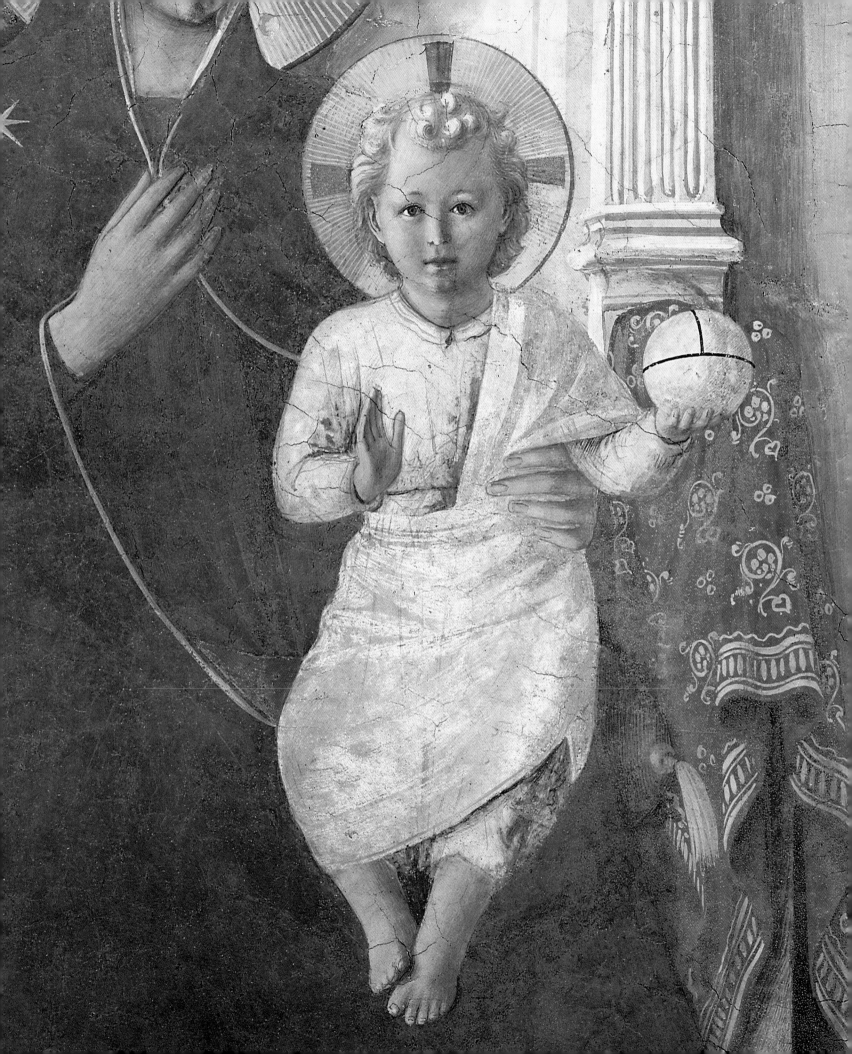

Saint Lawrence Giving Alms to the Poor

Fra Angelico

(Vicchio, Florence, c. 1395 – Rome, 1455)

Fresco, 410 × 271 cm

Chapel of Nicholas V, Vatican

From 1445 to 1449, Fra Angelico is in Rome working for Nicholas V. The pope commissions paintings for his secret chapel where he celebrates his private masses. The three walls of the room are divided into two sections: the top one, illustrating the life of Saint Stephen, and the bottom one, the life of Saint Lawrence. The artist receives an annuity of two hundred ducats plus a salary of twenty-three florins a month.

Saint Lawrence is patron of the poor. Born in Huesca, province of Aragon, he becomes the deacon of Sixtus II. During the persecutions, Valerian delays his execution because he is the pope's treasurer. He hopes unsuccessfully that with his help he may obtain the Church's wealth and archives. Tortured, Lawrence dies on the 10th August 258.

Fra Angelico's paupers are elegant when they limp, dignified when they are blind, have greatness when they are cripple and do

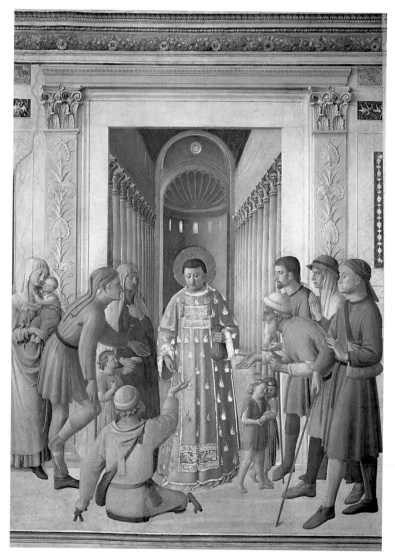

not suffer the humiliation of their conditions. Dressed in his beautiful pink chasuble, the deacon holds onto his purse with one hand whilst, with the other, he distributes his alms. The hands are all outstretched to receive a coin except for the ones of a sweet child who has already obtained his due. He does not really want to share with his little girl friend, temptress as she may be. These two "angels" are happiness to the eye and with Fra Angelico one would not mind so much being poor!

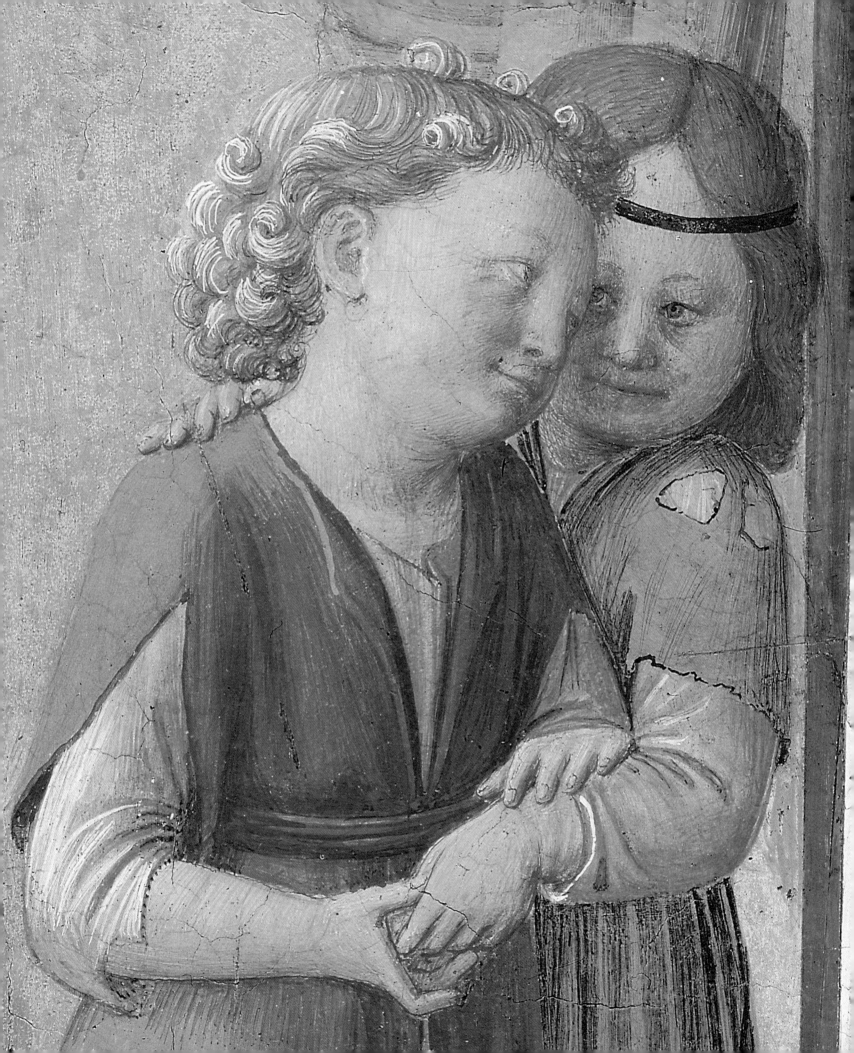

Camera degli Sposi
(*The Chamber of the Spouses*)

1465–75
Andrea Mantegna
(Isola di Carturo, Padua, 1431 – Mantua, 1506)
Fresco
Palazzo Ducale, Mantua

ndrea Mantegna was not a man in a hurry. As well as abusing the patience of his patron, he cost him a lot of money. Five years after the start of the work, Ludovico Gonzaga wrote about him: "Andrea is such a man that he has started our room and has completed only half. One must not cause him the slightest disturbance without his work being delayed by various months or years." It is in 1475 that the marquis and his wife can finally sleep in their room, where they also deal with government affairs.

Traveller, if your steps take you to Mantua stop at the palace, which you cannot miss, it is right in the centre of town. This great man will receive you in his pink gown with his loyal dog Rubino curled under his armchair. His wife, Barbara de Brande-

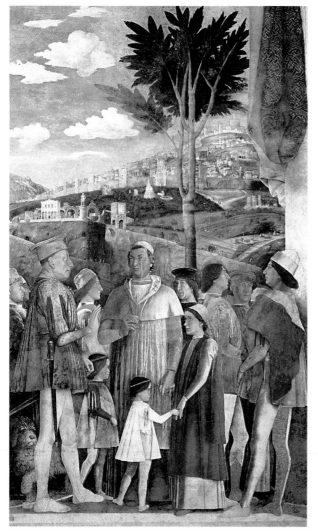

bourg, holds her daughter Paola on her lap and is surrounded by the lovely Barbara, her nurses and governess. All their sons, handsome aristocrats, parade in front of us. Their attire is composed of tunics of brocade, two coloured stockings and a red beret, sign of their belonging to the prestigious family. The secretary brings a message to Ludovico: he must go to Milan to settle some inheritance business.

Turn towards the north wall: Ludovico is on his way back, go and meet him. He is in Bozzolo seeing his son Francesco who has just been appointed cardinal, the first one of the family. The younger brother Ludovico takes the hand of his very respectable brother, and his two little nephews walk forwards to close this loving circle. In Italy, family is an institution, an untouchable fortress where powers and duties are organized. It is the illustration of "strength through union".

Traveller, admire! Mantegna has painted and crystallized for a moment the story of the Gonzaga family. These men, women and children have stopped to open their door. Shut it gently to maintain the privacy of the most beautiful bedroom in the world!

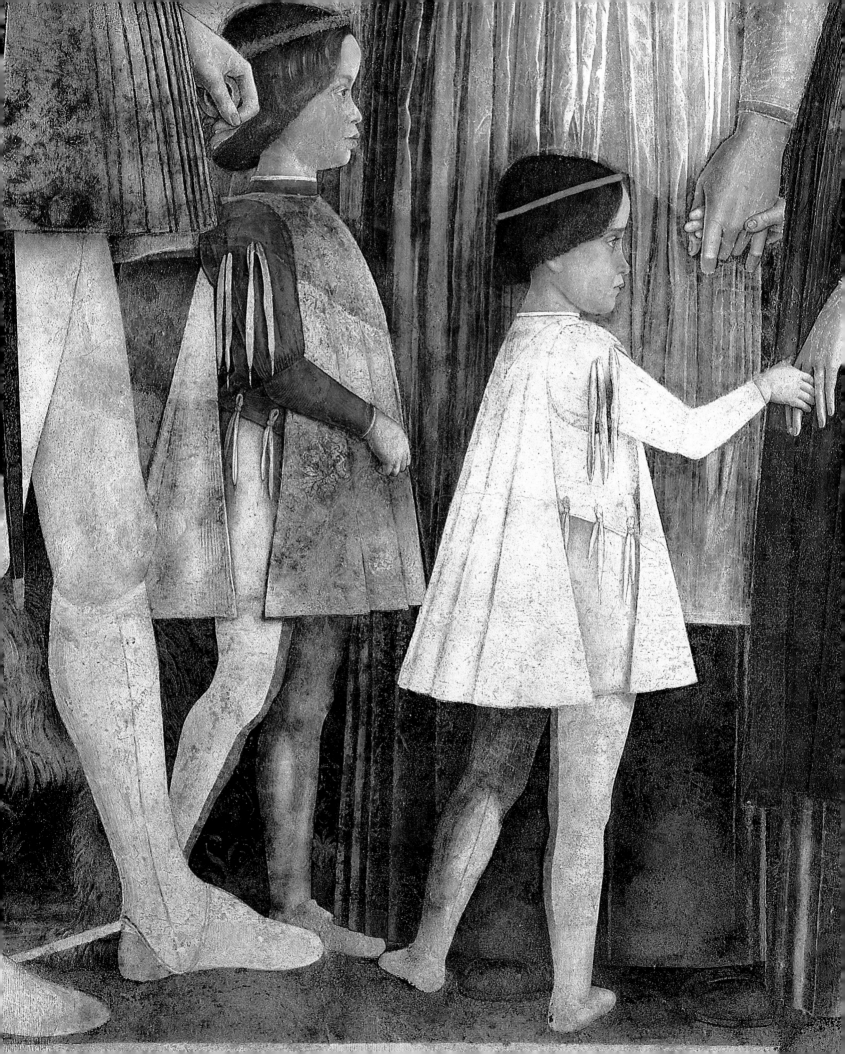

Mars and Venus

Sandro Botticelli

(Florence, 1445–1510)

Tempera and oil on poplar, 69 × 174 cm

National Gallery, London

*M*ars is the first of Venus' many lovers. He is the god of warriors but also the god of spring and of youth, because youth goes to war at the end of winter. Venus is the daughter of Uranus, whose sexual organs have been slashed by Cronos and thrown into the sea. Thus do they deliver this beautiful girl, born of the sea and taken by the Zephyrs to the Cyprus shores. She is then presented to the Immortals by the Hours, daughters of Jupiter.

Divinely sensual, Botticelli's Venus exhibits her languid body under a wave of pleats, which follows the rhythm of her shapes. She looks after her indecent lover fast asleep, who the satyrs cannot wake by blowing in their shells.

The size of the picture make us believe that it was probably intended for a nuptial room. Botticelli offers them an ideal painting with a clear message: making love is exhausting for the man but invigorates the woman!

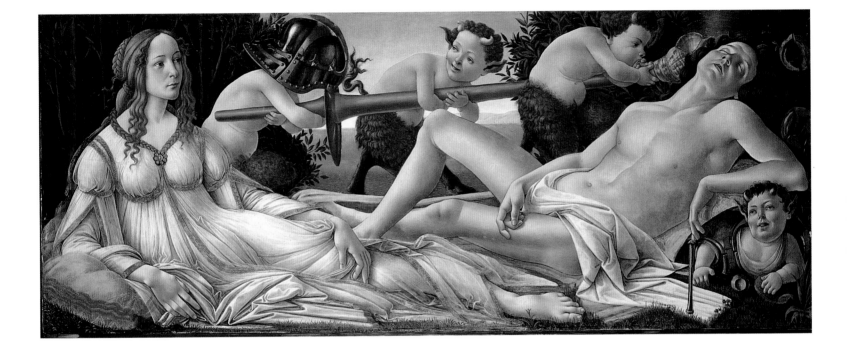

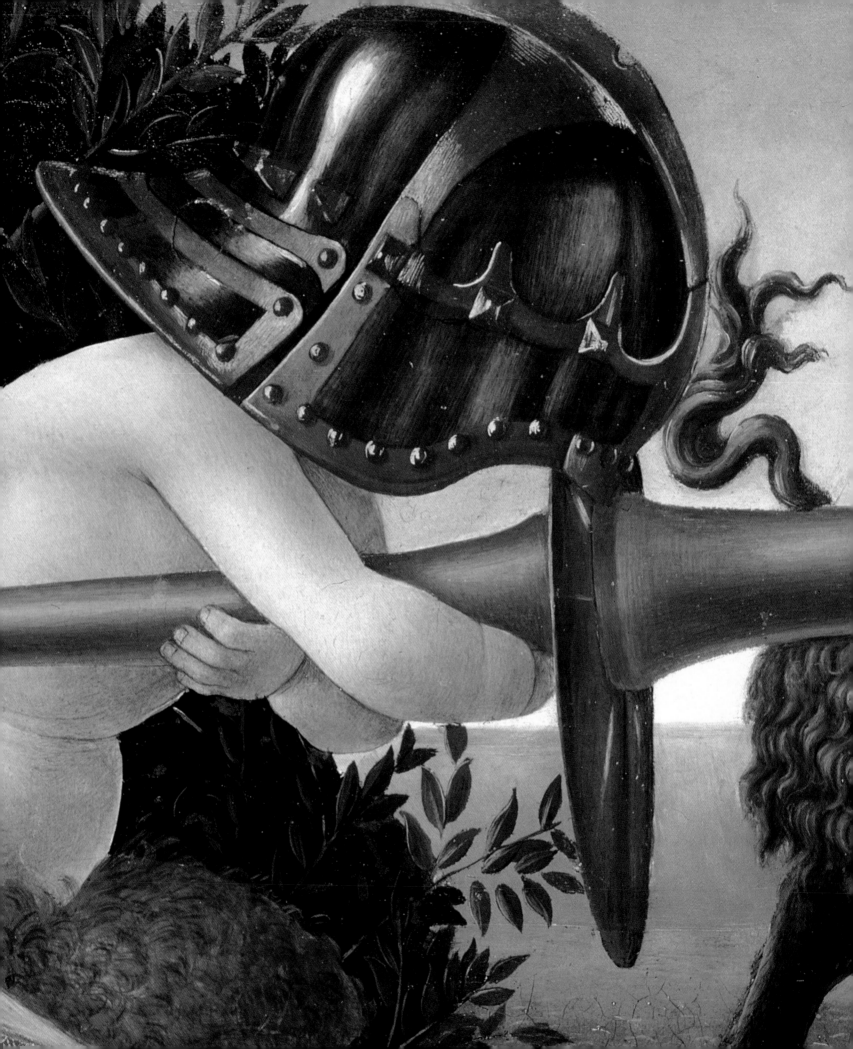

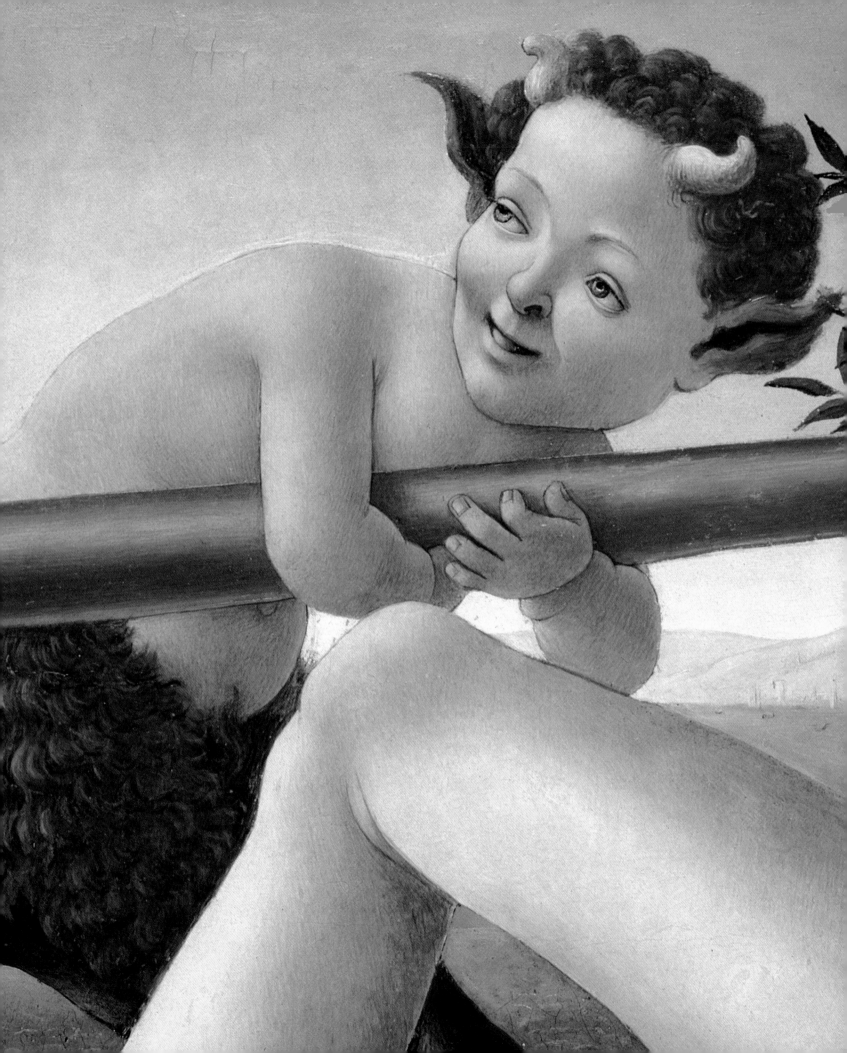

Hasdrubal's Wife and Her Children

Ercole de' Roberti

(Ferrara, c. 1450–1496)
Oil on panel, 47.1 × 30.6 cm
National Gallery of Art, Washington

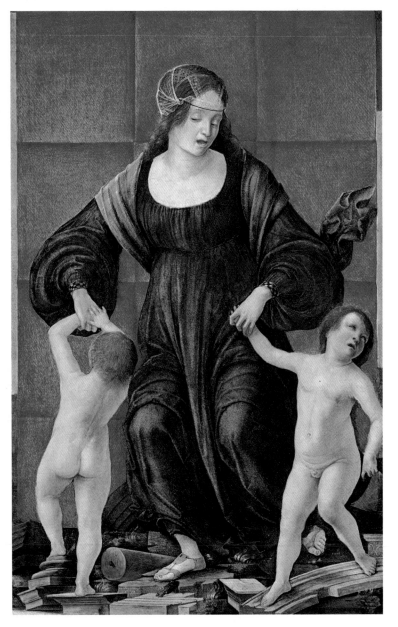

During the 15th century, Tura, Cossa and Roberti are the three great painters of Ferrara. Roberti is twenty and full of energy. After having covered the walls of the palaces with frescoes, he starts work on retables and huge polyptychs. The most surprising one, because of its exuberance, is the one of Santa Maria in Porto (Pinacoteca di Brera, Milan).

This woman is the wife of one of the six Hasdrubals, all of them Carthaginian generals. The first one, called the Handsome, founds Carthage. The second one is Hannibal's brother. Chased by Scipio the African, he crosses the Alps, reaches Italy and is killed on the shores of the river Metaurus. The third one organizes the defence of Carthage around 155; he is taken prisoner by Scipio the Emilian and dies in Italy. The three others have similar destinies.

This energetic and lovely mother is cross with her two naughty children. They are naked, they whine, they stamp their feet, they refuse to obey, but their mother is not ready to give in to their whims. She will not let go and will have them do what she wants, whatever it may cost her.

This may not be a masterpiece but it reflects so well the daily routine of a mother: to impose one's authority is exhausting!

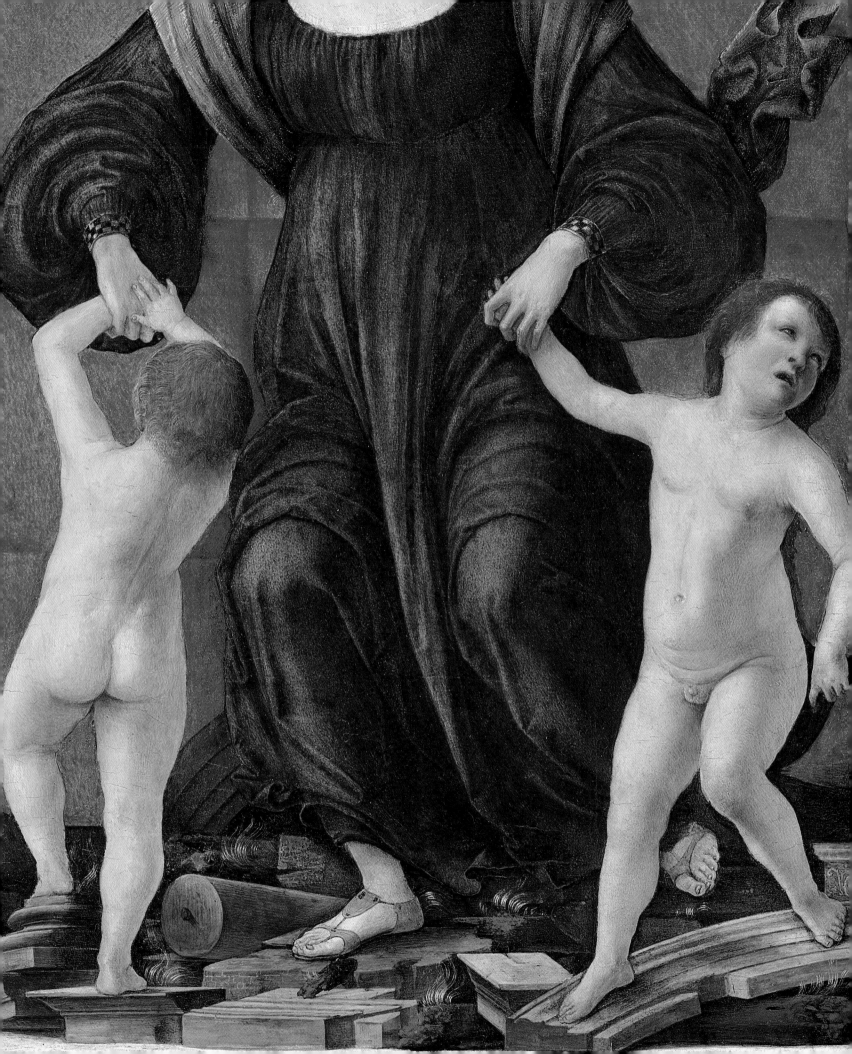

Presentation of the Virgin in the Temple

Vittore Carpaccio
(Venice, c. 1460–1526)
Oil on canvas, 130 × 137 cm
Pinacoteca di Brera, Milan

Carpaccio, the "Oriental Venetian", wants to reach perfection by combining technical rigour, imagination and fantasy.

His violence is contained, bearable and always elegant. His painting is a fiction surpassing reality. To transport us into his magical world, he sprinkles a diaphanous light over fantastic and intricate structures. The events can be read on the faces of the protaganists.

It is in this world that he presents his Virgin in the temple. The gentle Mary is reduced to a little blue cloak set on a cascade of angular steps. Humble, she does not dare to look at the great priest, an imposing old man in his long chasuble of brocade. In the right-hand corner a child dares to summon one of the dignitaries on the balcony. Here, Carpaccio forgets his gravity and lets his fantasy flow. To forgive the child's impertinence, he makes him the bearer of two symbols: the deer, symbol of timidity, and the white rabbit, symbol of the fertility without sin of the Virgin Mary.

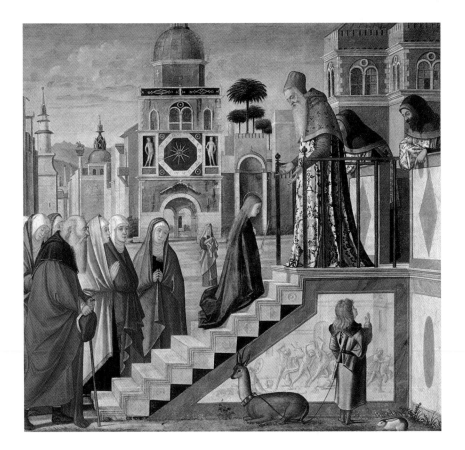

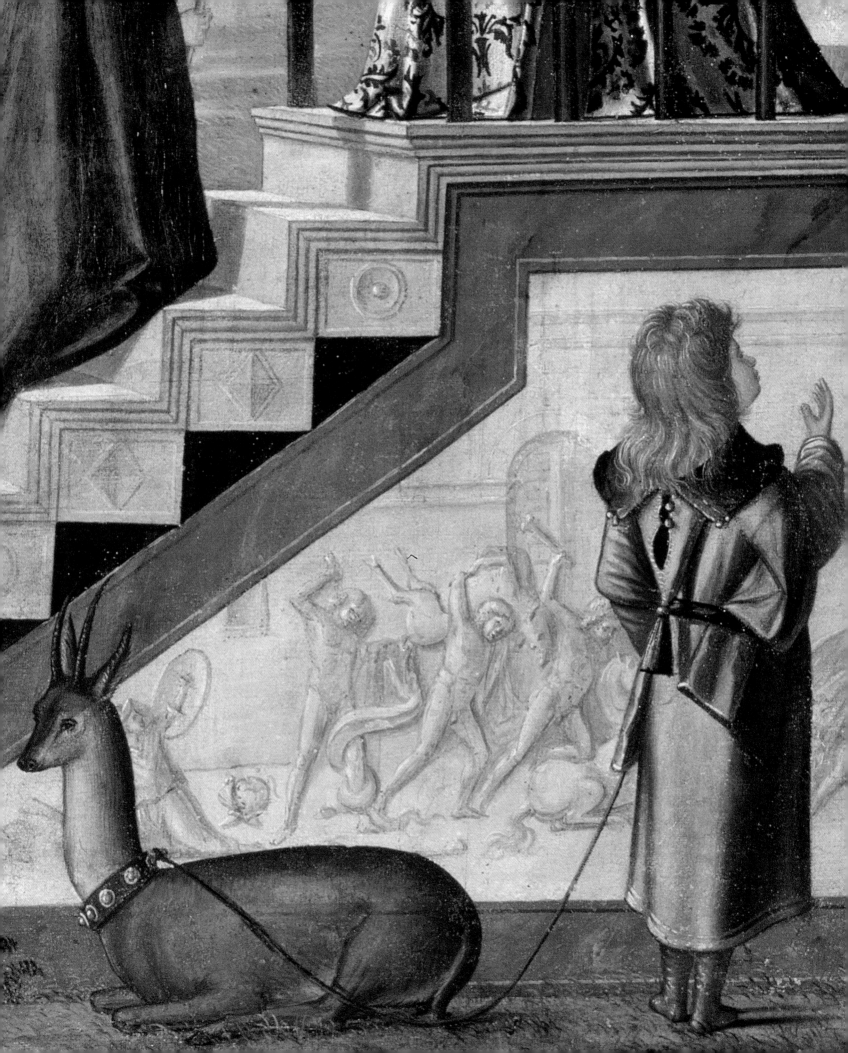

The Prophet Zechariah

Michelangelo Buonarroti

(Caprese, 1475 – Rome, 1564)

Fresco

Ceiling of the Sistine Chapel, Vatican

The world meets in Venice, at the foot of the Egyptian pyramids or under the ceiling of the Sistine Chapel. Hoards of tourists ramble there leaving behind them waste and damage. Multitudinous masses are celebrated but men, women, children and babies gather there not wishing to see, or to listen to the explanations of an exhausted guide. The latter waves a dirty rag, trying to keep together his haggard-looking herd. Unfortunately, we cannot refuse to follow them if we wish to discover a masterpiece, which time has left intact, thus showing us the eternity of beauty.

Both Michelangelo and Julius II have explosive tempers. They fear one another, clash and their confrontation results in an explosion of beauty! The ceiling of the Sistine Chapel is one amongst others.

The sculptor does not want to paint but he has to accept the discipline of an irascible and impatient pope who forces him to take his brushes and to decorate his chapel. It will take four years of colossal and solitary work disturbed only by the unpredictable visits of his patron. The relationship between these two is the one of two mad men possessed by the passion of beauty. The artist delivers his ceiling whilst in terrible pain (see *Introduction*). All

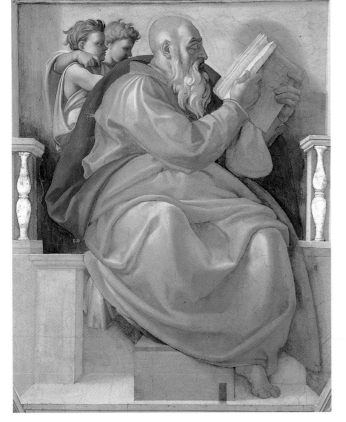

this suffering creates a superhuman work where the size and the fullness of shapes are a challenge to the work of our Creator. Michelangelo struggles to find the truth of a Creation, which surpasses him. Together, they play a game where there is no winner, no loser, but only a supreme referee who agrees to join in. Our fascination in front of such extravagance comes from the artist's hallucinations, which he projects to us.

Zechariah prophesies the entry of Christ in Jerusalem (9,9): "Rejoice greatly, O daughter of Zion; shout, Daughter of Jerusalem: behold, thy King cometh unto thee."

When Vasari saw this figure, he said: "He cannot find what he is looking for in this book." He was right, but the two cherubs behind him will help. Michelangelo remains a sculptor when he paints. Hair, faces, drapes are always filled with vivid and clashing colours, but this is a weakness he had always recognized.

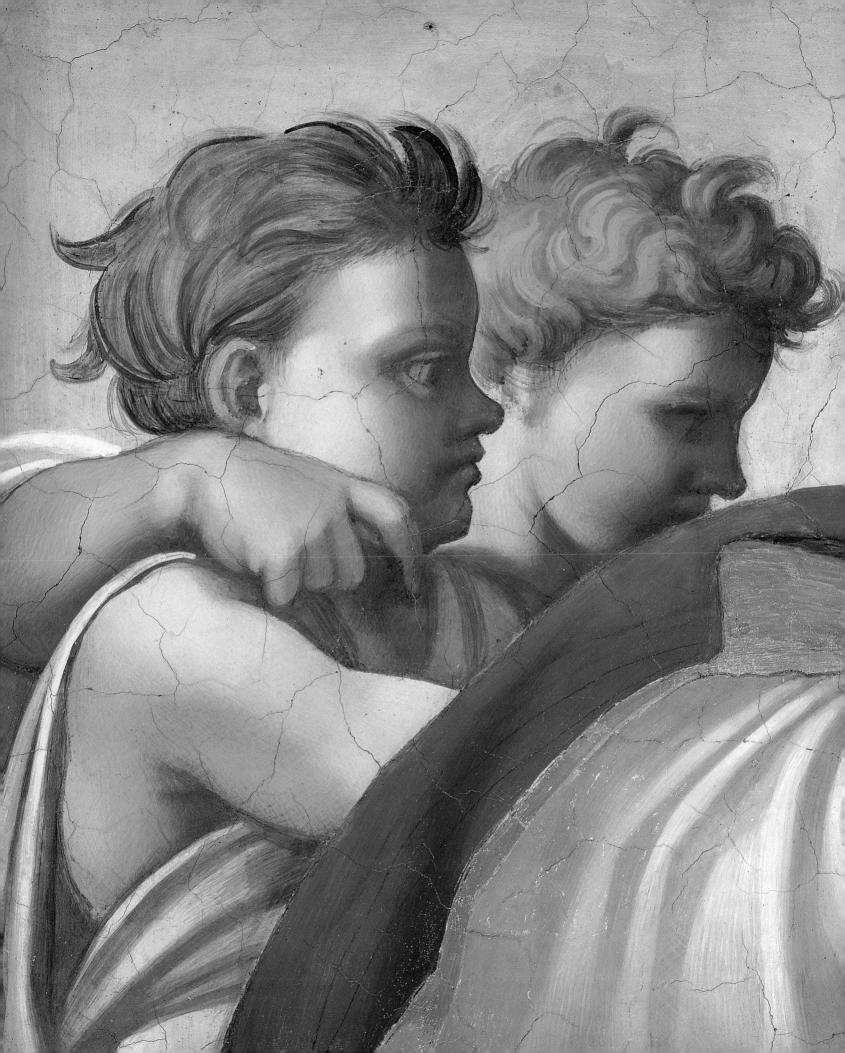

The Sistine Madonna

Raphael

(Urbino, 1483 – Rome, 1520)

Oil on panel, 265 × 196 cm

Gemäldegalerie Alte Meister, Staatliche

Kunstsammlungen, Dresden

As in a theatre, the curtain lifts, the sky is lit and a multitude of angelic faces appear behind the holy "diva". Sensual and captivating, the Virgin walks forwards in a twirl blown by her Creator. With a light foot, she walks on the clouds as if on solid ground. Haughty, she knows she has no equal. At the same time, she wraps and presents her precious baby to the worshippers. He is just a baby, his hair is untidy and his eyes are wide open… Saint Sixtus, displaying his education, has removed his tiara in front of the holy lady. He cannot take his eyes off her but indicates with his finger the sinners we are. Saint Barbe is glorious as impavid goddess. She takes care to check on the two angels leaning on the balcony of the sky. These two lovely chubby angels are behaving. They contemplate peacefully what is happening over their heads.

Raphael loves children but he has genius for women. As an expert, he paints them alive, his brushes flutter without tiring, they free fabulous colours and caress incessantly the voluptuous shapes of a happy body offered to the most wonderful of courtesans!

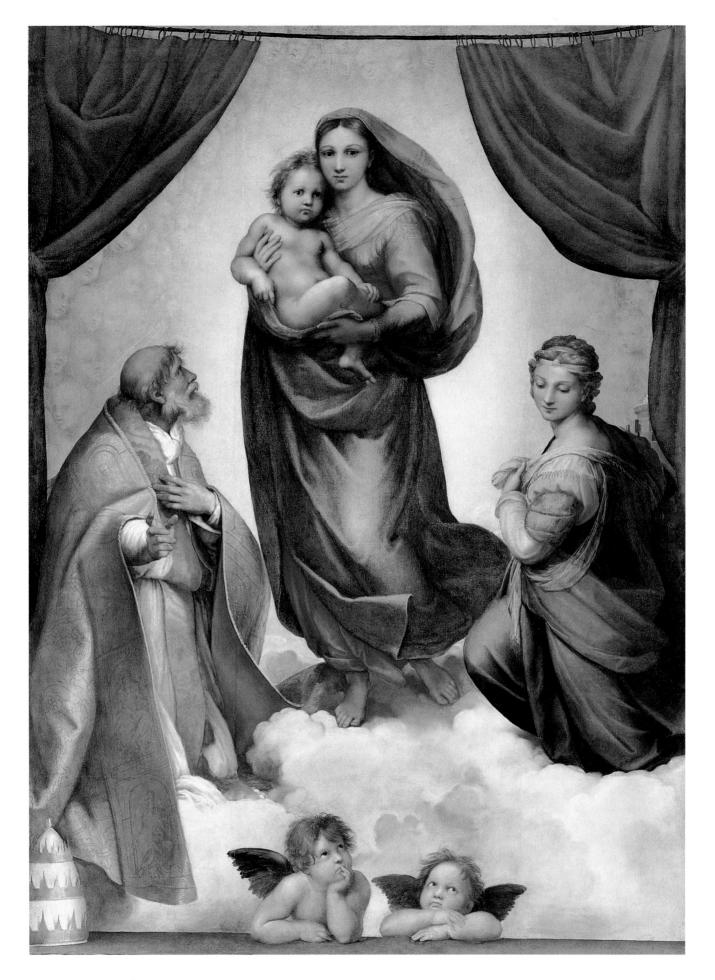

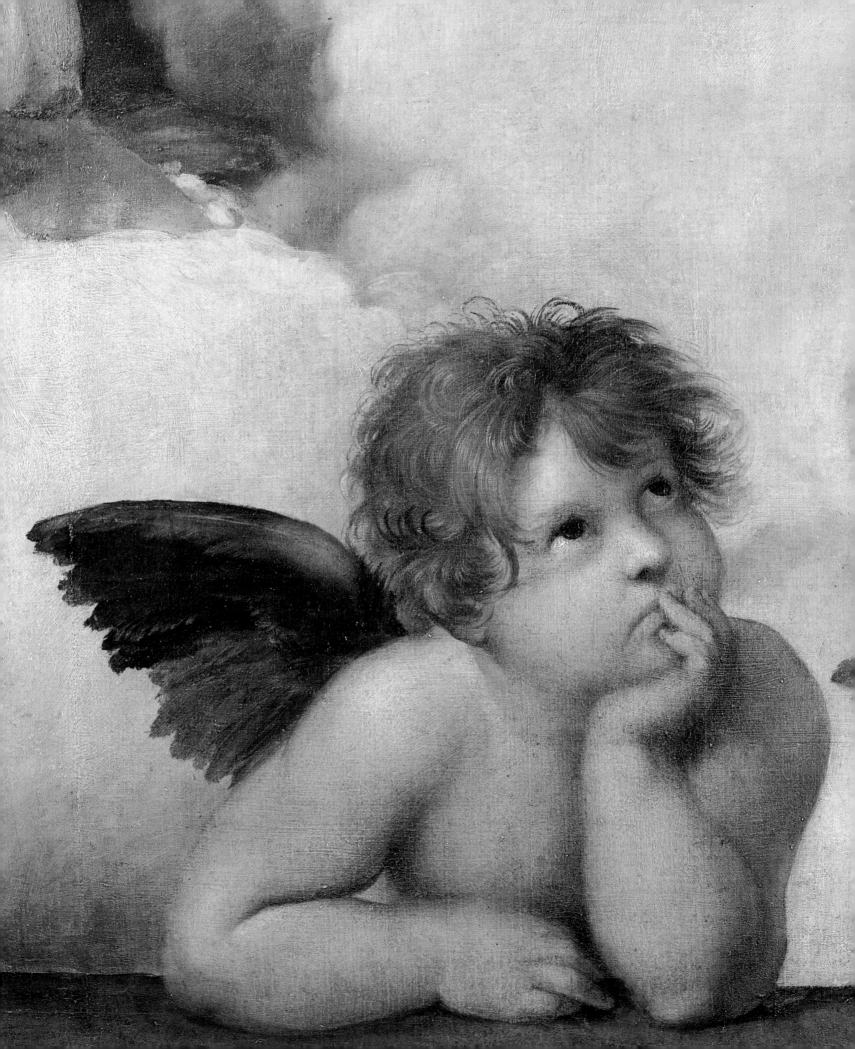

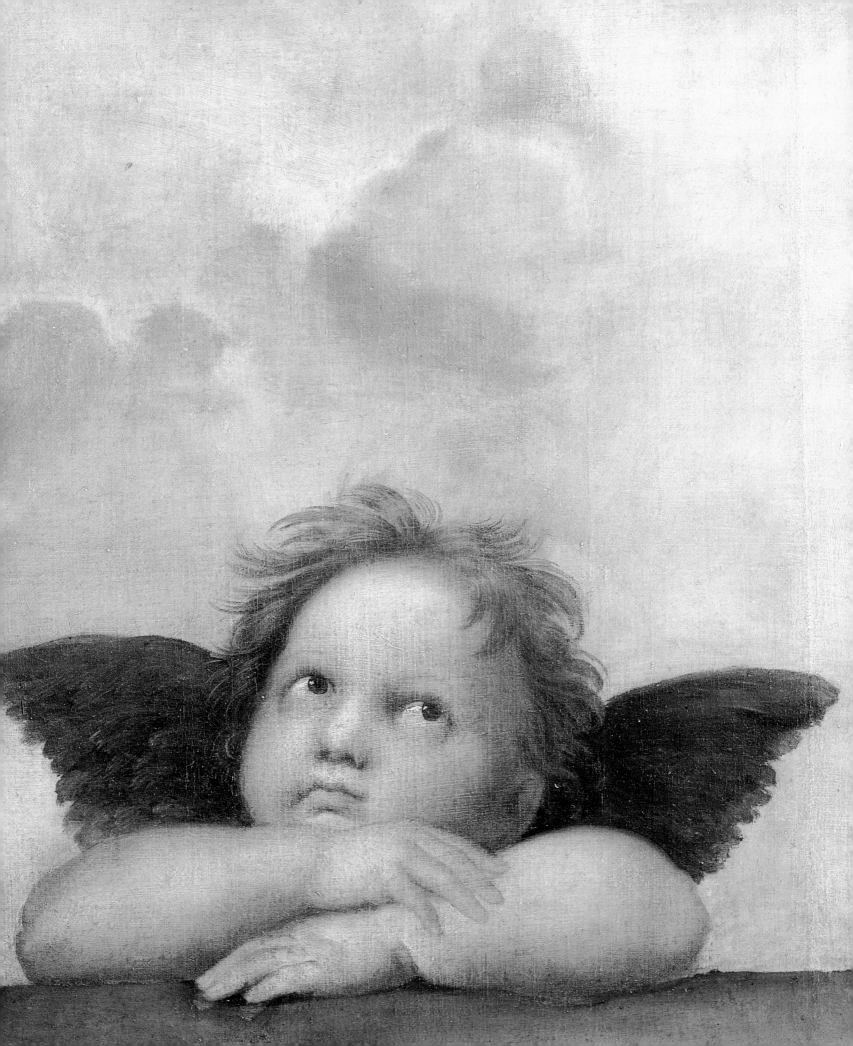

Ganymede

Correggio
(Correggio, c. 1489–1534)
Oil on canvas, 162 × 73 cm
Kunsthistorisches Museum, Vienna

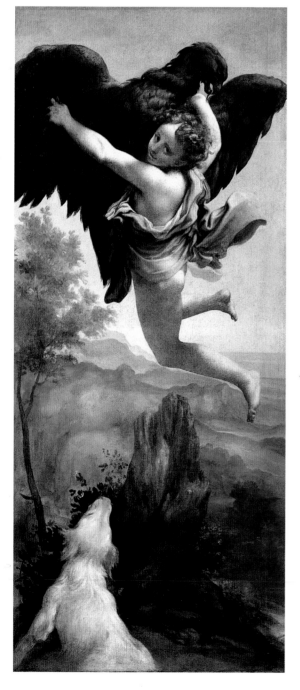

Tros, Troy's eponymous hero, has a younger son, Ganymede. Jupiter falls madly in love with him, transforms himself into an eagle and abducts the youth to Olympus. Later the young prince will become his lover and the cupbearer of the gods. In exchange, Tros will receive two beautiful horses! Jupiter does not give, he takes, but he takes because he loves. Restlessly, he copulates with women and youths of his choice. His affairs are punctuated by brutal and bloody episodes. The god is not a sex maniac; he is more of a Don Juan, his courting announces sensual and voluptuous adventures. He reassures, he wheedles to reduce the anxiety of his victim. But he remains a predator.

Correggio is the only painter who has dared to represent the acme of carnal pleasure without being pornographic. This marvellous artist leaves us the most sensual of legacies. With their respective genius, one could say that Correggio paints and Mozart sings an unsurpassed eroticism.

The artist's Ganymede is an angel with curly hair and skin white as ivory. He is gentle and caressing. He flies away with his innocence, holding on to the thick feathers of a powerful eagle, which is ready to enjoy his prey in a clear-blue sky. The bird and the prince leave the earth under the astonished eye of a spaniel, which would like to be part of the voyage. The brush strokes materialize in soft and light touches; they vibrate only for an instant but it is enough to take us to Olympus where our undeceived love is regenerated.

Jupiter and Correggio become *seductor optimus maximus*.

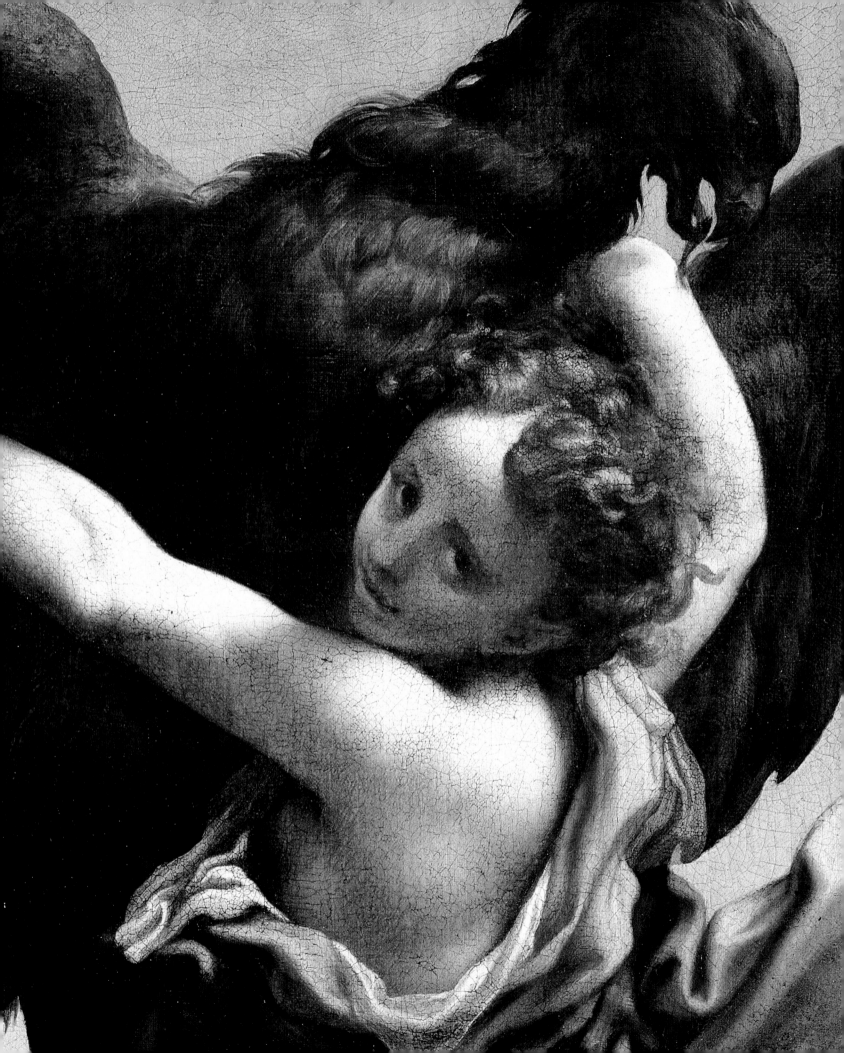

Clarissa Strozzi

Titian
(Pieve di Cadore, c. 1490 – Venice, 1576)
Oil on canvas, 115 × 98 cm
Gemäldegalerie, Berlin

King Philip IV of Spain has sent Velázquez to Venice as his ambassador. This latter one has just bought major works of art and his good opinion is thus sought for. Velázquez did not like Raphael but about Titian he said: "Mi dago il primo luogo a quel penelo. / Tizian xe quel che porta la bandiera" (For me, I give the first place to this brush, / Titian is the one waving the flag" (words recorded by a journalist at the time and written down both in Venitian dialect and in verse).

Clarissa is well born. She is the daughter of Roberto Strozzi and of Maddalena de' Medici, who are in exile in Venice. She is about four years old when Titian paints her portrait.

This is a lovely little girl. She looks like a happy doll with her rosy cheeks and two piercing black eyes. Something has just happened, which stops her from feeding her loyal dwarf spaniel. The jewellery she wears is in no way childish. Few are the little girls who wrap around their waist a garland of flowers made of precious stones and adorn their necks with a heavy pearl necklace weighed down by a cabochon of sapphires and rubies! And all this to feed her dog! Meanwhile, under the table, two naked angels dance, unconcerned. The painter has set things right: there is no need to be rich to have fun!

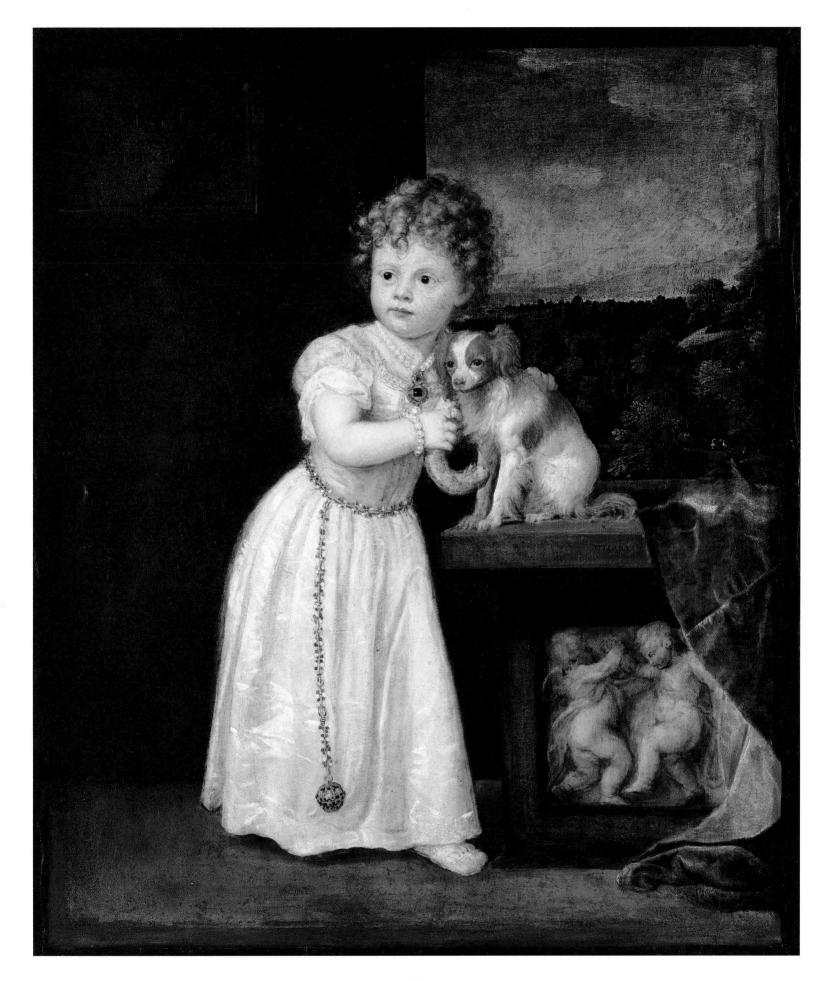

Ranuccio Farnese

1542

Titian

(Pieve di Cadore, c. 1490 – Venice, 1576)

Oil on canvas, 82.7 × 73.6 cm

National Gallery of Art, Washington

Ranuccio is ten years old; he is Prince Farnese, Knight of Malta, son of Pier Luigi and grandson of Pope Paul III. The prince is still a child but one can guess what he will be like later in life. He has just come out of the barber; his haircut is strict and sets off the perfect roundness of his skull. He holds back a smile, opens his ears, his eyes sparkle with intelligence and his nostrils are dilated. All the senses of this boy are awaking and will help him to become a wonderful young man! Only the casket holding his attributes, prettily shut by two bows, will have to be changed!

In this portrait, Titian paints the metamorphosis of the child into a teenager "torn between the call of the flesh and the terror of sin"! (François Mauriac).

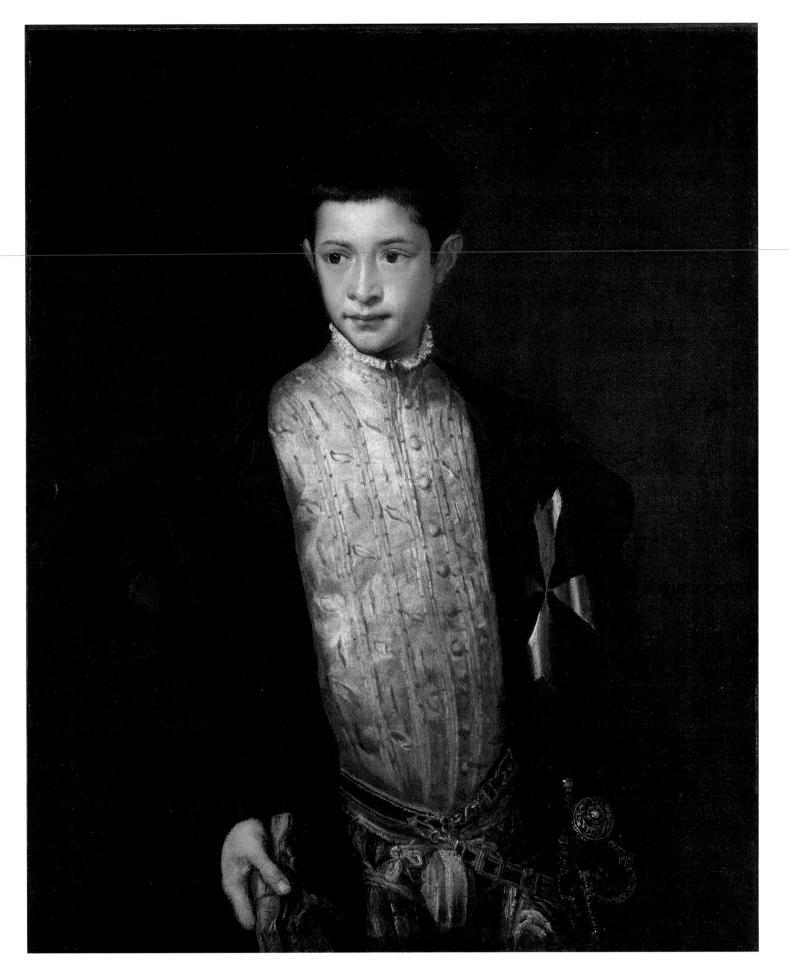

Angel Musician

Rosso Fiorentino
(Florence, 1495 – Fontainebleau, 1540)
Tempera on panel, 47 × 39 cm
Galleria degli Uffizi, Florence

*G*iovanni Battista had a chequered career. Overcome by commissions, he left Florence for Rome. After many misfortunes during the sack of the city, he took refuge in Sansepolcro and then in Arezzo. He made a stop in Venice before arriving in France, where he became the court painter of François I at Fontainebleau. He will die there of natural causes and not by suicide as Vasari suggested in his *Lives*.
This little drowsy angel has difficulty in plucking the cords of his cumbersome lute. Let us leave him to play and fall asleep…

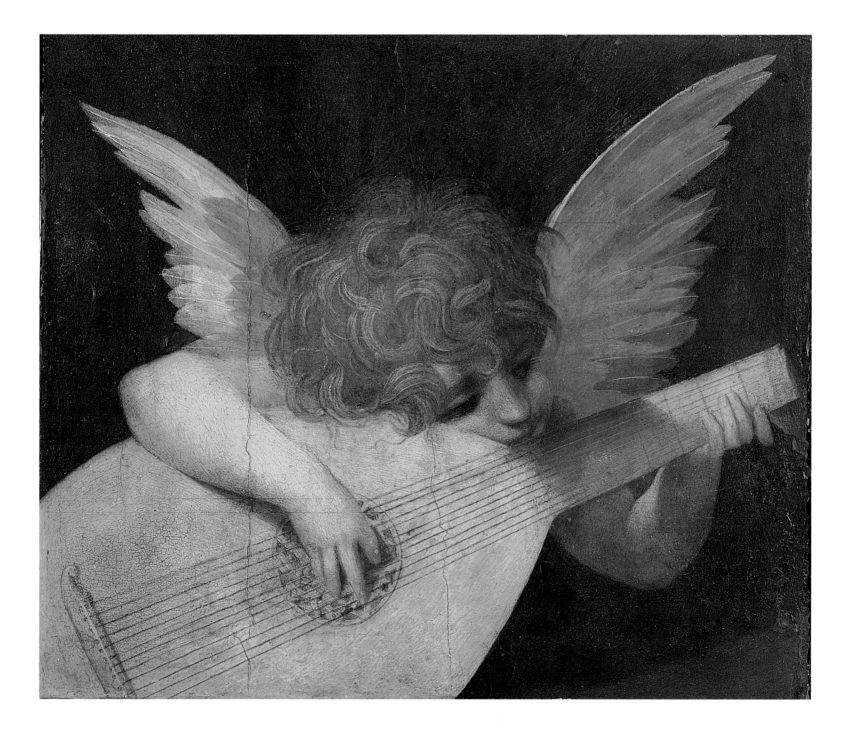

Portrait of Bia, Natural Daughter of Cosimo I de' Medici

c. 1542

Bronzino

(Florence, 1503–1572)

Tempera on panel, 63 × 48 cm

Galleria degli Uffizi, Florence

Obscure puritans call children born outside marriage "bastard" or "illegitimate". Their anathemized parents live their passion hidden from society. But Heaven forgives the lovers and the fruit of their embraces has sometimes the beauty of the little Bia.

She is a masterpiece of innocence and elegance. Her charms cast a spell on us and we are left speechless. She is five years old when the portrait is painted, but only a few months later will she join the other angels in Heaven.

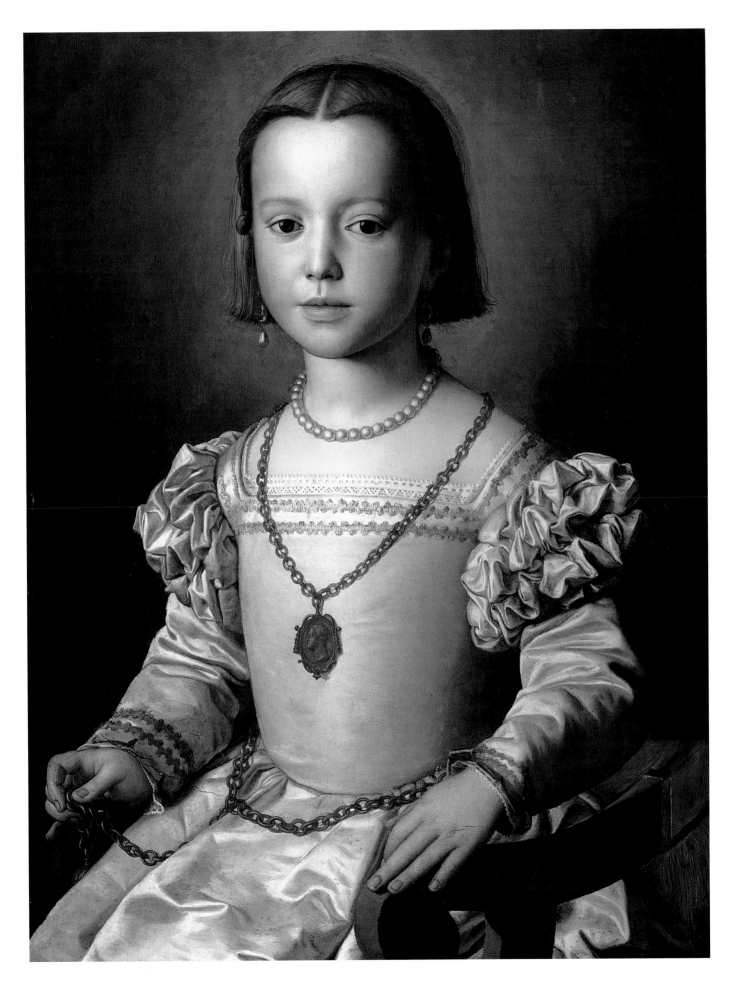

Giovanni de' Medici

1545

Bronzino

(Florence, 1503–1572)

Tempera on panel, 58 × 45.6 cm

Galleria degli Uffizi, Florence

*I*n 1539, under the Spanish occupation, Cosimo de' Medici marries Eleonora de Toledo, daughter of Charles V, in Florence. Bronzino is asked to create the set for the wedding and becomes the painter of the duke's family.

Giovanni is the second son of Cosimo and Eleonora. This big baby is two years old, has only two teeth and weighs too much. He is full of life and laughter, and nearly bursts out of his clothes. With or without coral amulets, he is immune to illnesses. He holds in his hand a round goldfinch and it is belly against belly that they babble together.

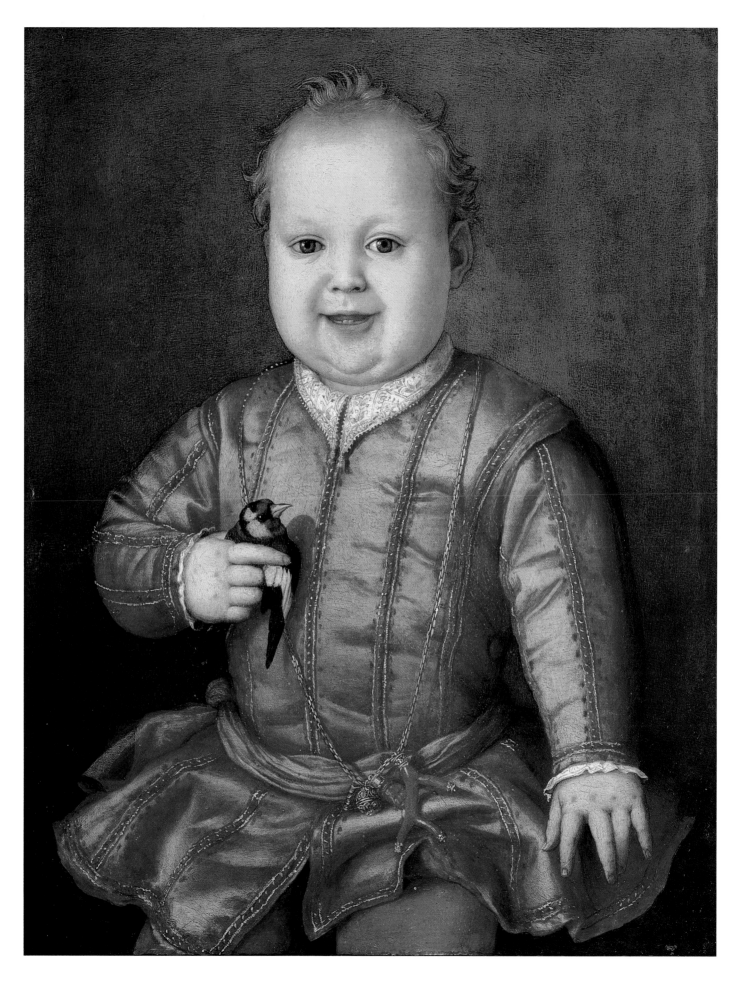

Girl Opening a Door
Veronese
(Verona, 1528 – Venice, 1588)
Fresco
Villa Barbaro, Maser

*W*hat is the purpose of a house? To give one a roof of course, but also an abode, a home where one feels comfortable and at peace. Seeing the trees of the garden growing, one contemplates one's life and what has become of it. Eventually, it is a wealth one transmits to one's children; it is as well a way to exhibit one's riches.

When summer came, the rich Venetian families escaped the lagoon and its pestilential stench for the foothills of Asolo, centre of the Trevisan march also called "march of love" by poets. There, an architect in love with Antiquity, Andrea Palladio, and a painter in love with myths and reality, Paolo Veronese, will build together the Villa Maser, sunny Olympus dedicated to the cult of life.

With the hill in its background, the villa stretches out. Its façade follows a rhythm of columns, pillars and frontons, but the inside abounds with allegories on hedonism, of well-meaning gods and goddesses protecting the wealth and the life of its owners, Marcantonio and Daniele Barbaro.

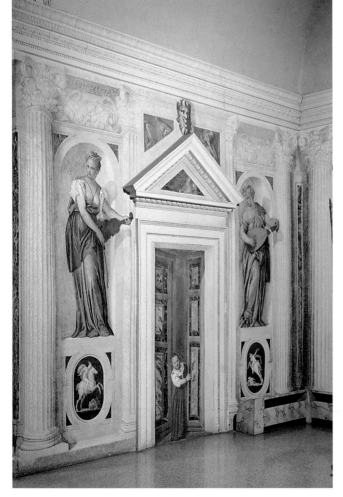

This home is of rare elegance and sophistication. It wishes to choose its guests and will not allow vulgar or narrow-minded people to stay.

Palladio and Veronese are not in the least influenced by the crisis of the Reformation or the political strife of their time. Harmony is the only preoccupation of the architect. The Epicurean painter does homage to the beauty of life. He plays tricks on us with his famous still-life deceptions. He opens imaginary doors and shuts real ones. This magician paints the illusion of a young country girl saluting us, or of an obliging marquess and a handsome hunter waiting at the end of a corridor.

Veronese makes us giddy; we enter a dance where unreal becomes real and vice-versa.

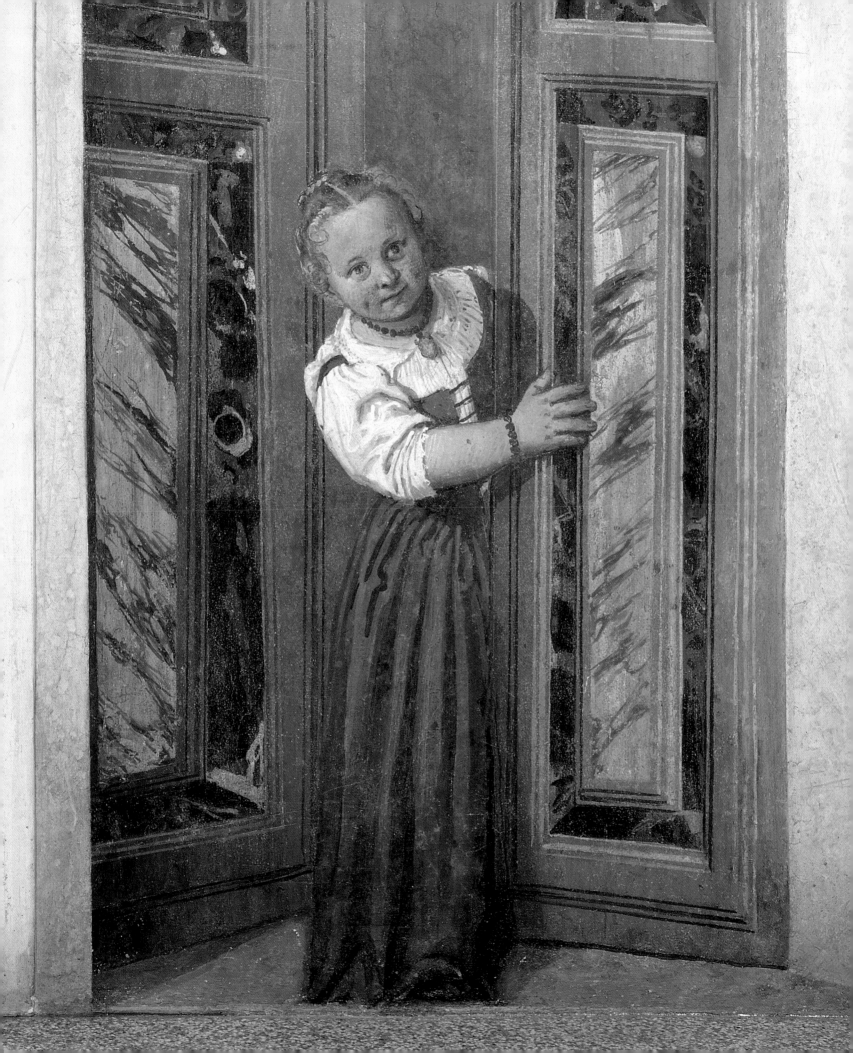

The Martyrdom of Saint Matthew

1599–1602

Caravaggio

(Milan, 1571 – Porto Ercole, Grosseto, 1610)

Oil on cancas, 323 × 343 cm

Contarelli Chapel, San Luigi dei Francesi, Rome

*G*od and the Devil dwell inside Caravaggio. His paintings smell of sulphur but the light in them makes them saintly. Cruelty and goodness are there side by side. Shadows and light wrestle; they shape bodies, glide over the skin, crease the drapes and make the mouths scream. Wild and murderous, this artist is in the grip of violence but under the thumb of his art. Torn asunder by these two tyrants, his genius explodes and beauty becomes the ultimate and indestructible trophy. Painting for Caravaggio is a straightjacket.

Before his conversion, Matthew is a publican, a tax collector. He is opposed to the wedding between the pagan King Hirtacius with his own Christian and virgin niece. Furious, the king has him decapitated. Matthew is the first evangelist, patron of bankers and tax collectors.

1600 is a holy year and Rome expects over half a million pilgrims. It is the Cardinal del Monte, patron of Caravaggio, who obtains the commission for two paintings for the Contarelli Chapel in the church of San Luigi dei Francesi. The twenty-seven-year-old artist will deliver these two huge compositions six month late.

Often, people are equally terrified and attracted by horror. The martyrdom of Saint Matthew becomes the theatre of cruelty where the executioner, the light flashing on him, becomes the main actor. Transported with rage, this bloodthirsty giant holds

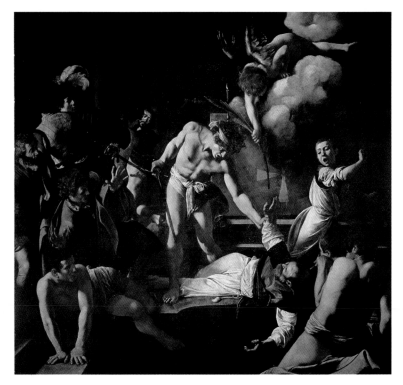

in one hand the old man and with the other the executor's sword. Scattered by the wind of terror, naked or clothed men run away but they all observe the barbarity of the spectacle. A child flees in front of such atrocity, he screams with pain and flings his arms towards a ghost, who should be the ghost of life, if good triumphed over evil. A tormented Caravaggio hides behind his painting. His genius transforms horror into beauty and makes us doubt forever about the intentions of Heaven.

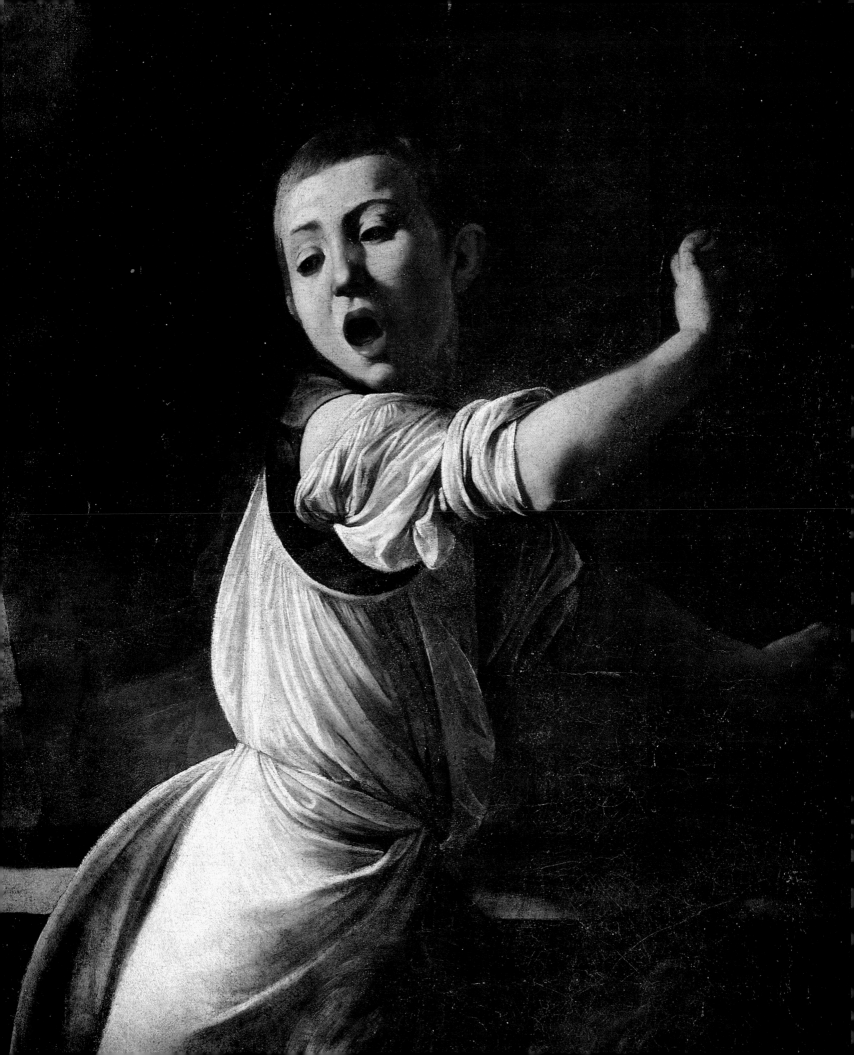

The Investiture of the Duchy of Francony to Bishop Harold

Giambattista Tiepolo
(Venice, 1696 – Madrid, 1770)
Fresco, 400 × 500 cm
Residenz, Würzburg

o to Würzburg, visit the Residenz and you will be on a different planet, Tiepolo's planet. Remain there if you can!
Giambattista Tiepolo needs space; he pushes it and dilates it to take his creations close to the Creator. Condescending, God allows him to astound and stagger us in the whirl of his pictorial acrobatics. This artist is a gymnast of shapes, he invents a world without gravity where magnificent colours shine. His brushes unearth architecture and reshape cathedrals to the glory of the gracefulness of bodies and the superiority of minds.
After his marriage to Beatrice of Burgundy in Würzburg,

Frederick Barbarossa gives the investiture of the duchy of Francony to his Prince Bishop Harold. This politico-religious alliance is useful to both parties: the emperor annexes a very rich princedom and the Church benefits from the emperor's protection, which increases her power.
In this fresco, the artist composes a sumptuous symphony of soft and velvety blues singing with nacre and ivory whites. These colours are joined by deep reds, which, little by little, whisper with faded roses. The two little pages bring to the bishop the cope and the crown of the Great Elector, which are the symbols of spiritual and temporal powers.

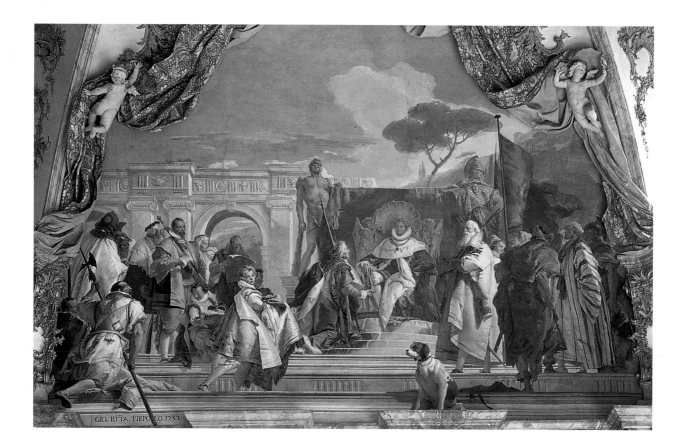

The Mandarin's Walk

1757
Giandomenico Tiepolo
(Venice, 1727–1804)
Fresco
Foresteria, Villa Valmarana ai Nani, Vicenza

*J*ust outside Vicenza, on the verdant Berici hills, the Venetian Count Giustino Valmarana builds his villa. There, he retires to taste the delights of country life and to flee the narrow-minded and mean provincial society of Vicenza. Giambattista decorates the *palazzina* (main house) and his son, Giandomenico, the *foresteria* (guest pavilion). Giandomenico has always been a loyal assistant to his father, but this commission will enable him to mark his own style.

By the 18th century the Serenissima is tired: she prefers the commerce of bodies and minds to that of spices and goods! *Chinoiseries* are fashionable and the European courts cover the walls of their castles with porcelain, silk and lacquer. On the walls of the *foresteria*, Giandomenico paints the mandarin out for a stroll. This superb potentate, half-Chinese, half-Venetian, walks in the shadow of his parasol. He stops to look at us and continues preceded by a little Pekinese harlequin.

The artist greets the count's guests with warm colours, which make one cheerful and please the eye. His marvellous imagination does not hesitate to plant a magnificent acanthus in a pleat where it blooms at ease!

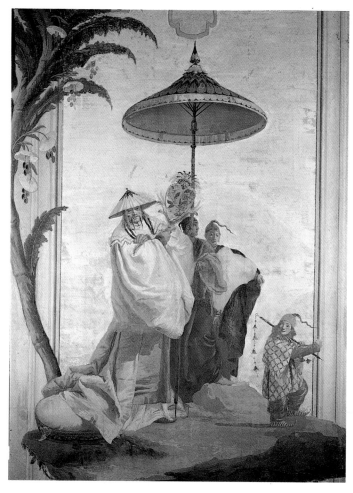

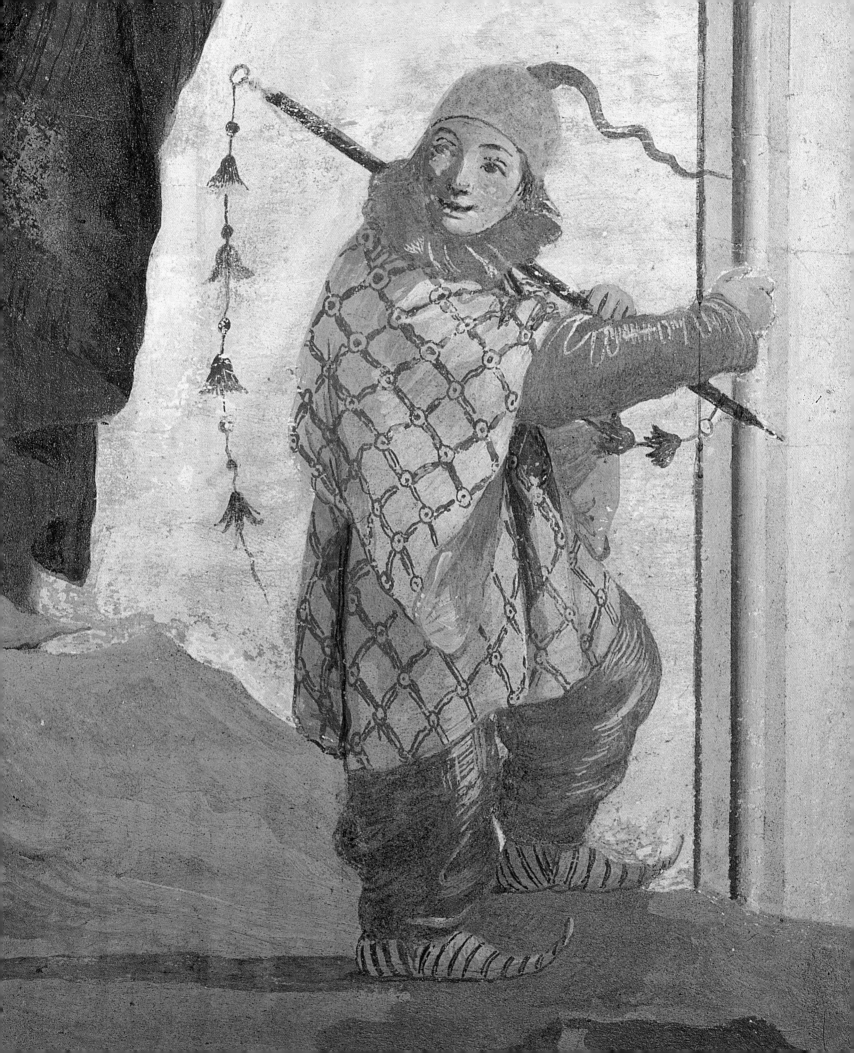

German Painting

The Garden of Delights

c. 1410
**Master of the "Jardinet de Paradis", also called
Master of the Middle Rhine**
(c. 1415–1473)
Oil on panel, 33.4 × 26.3 cm
Städelsches Kunstinstitut, Frankfurt

*I*t is only around 1200 that the art of ornamental gardens reappeared in Northern Europe. Albert the Great, theologian in Cologne, recommends to lay out a small lawn, full of scented flowers, where the wanderer can rest by a fountain of pure water, source of life. He adds: the trees must not be too close together to let a light breeze blow, necessary for one's well-being…

It is in this garden of delights that the painter welcomes the Virgin, her Child and the court of saints accompanying her. The crowned mother sits amidst smooth stemmed red roses and blue irises, she flicks through the Bible. According to the legend, Saint Dorothy picks fruit. On the road to her martyrdom, she promises the young jurist Theophile to bring him apples and roses, and at that very moment an angel descending from Heaven hands her a basket with three apples and three roses. Saint Barbe draws water from the fountain to water the plants. Saint Catherine gives a psaltery lesson to a very attentive Baby Jesus. The birds' concert accompanies him and the angel dozes, lulled to sleep by the music. Discreet and grinning, the Devil is there, sitting amongst the anemones and the wild-strawberries. Is he waiting for a mistake? Who knows?… As marvellous as it may be, this garden is not the Garden of Eden.

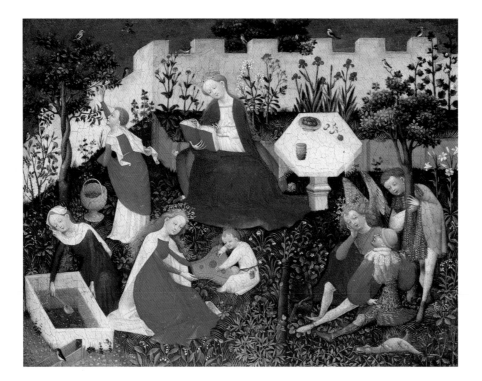

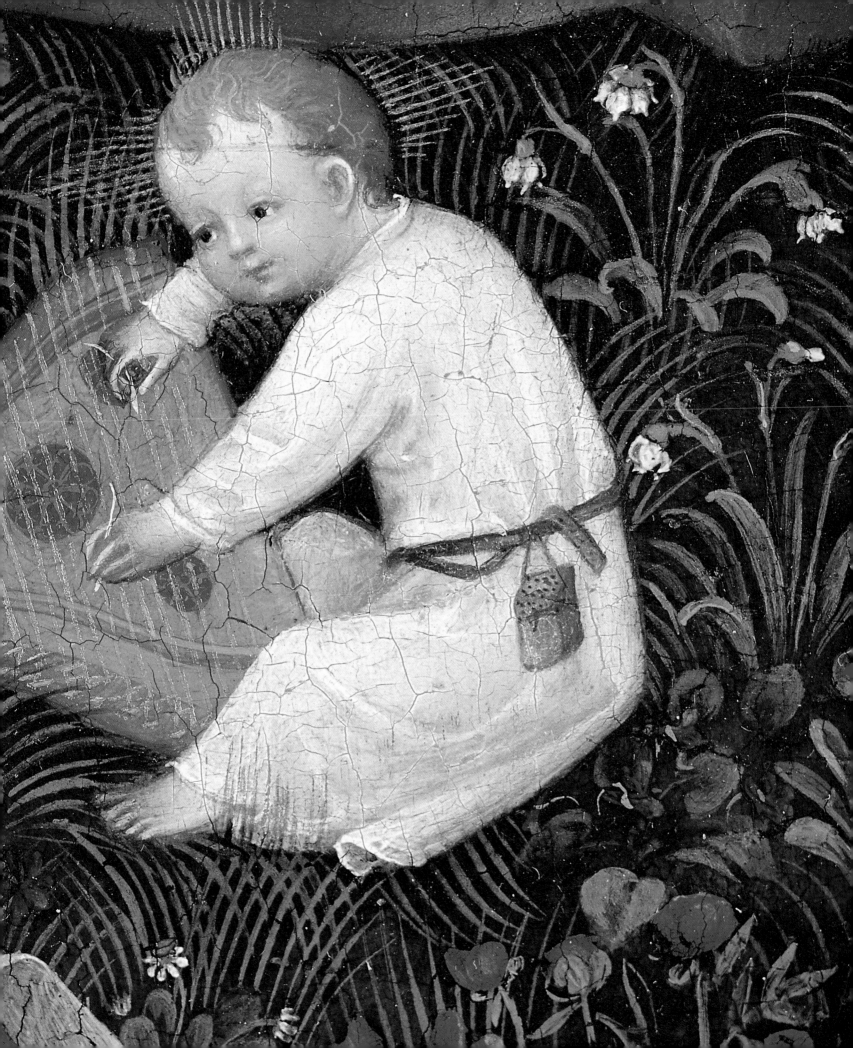

Saint Mary Cleophas and Her Family

1520–28
Bernhard Strigel
(Memmingen, c. 1460–1528)
Oil on panel, 125.4 × 65.8 cm
National Gallery of Art, Washington

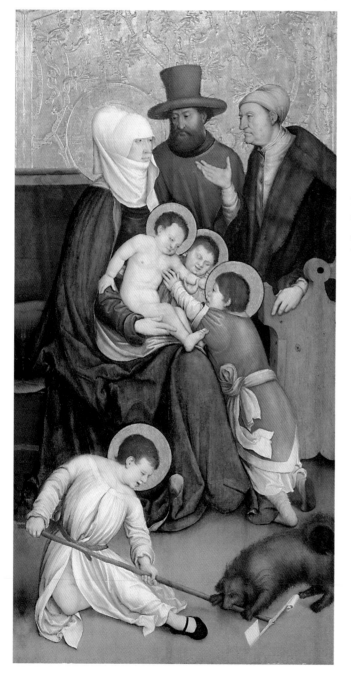

*B*ernhard Strigel is court-painter to the Emperor Maximilian I.

Mary is the wife of Cleophas. Saint John quotes her in his Gospel: she is one of the saints surrounding the Virgin at the foot of the Cross.

The saint's family is numerous and boisterous. The children fight for their mother's attention; her transparent complexion hardly contrasts with the immense white veil she wears as a scarf. Her placid features do not betray the tiredness of the holy lady due to all her babies, who are not angelic even if crowned with holy halos.

One of them, in an elegant gesture teases a dog with a stick. All this excitement does not impress Strigel who calmly paints full shapes and beautiful colours on a background engraved with gold. The artist likes these young troublemakers.

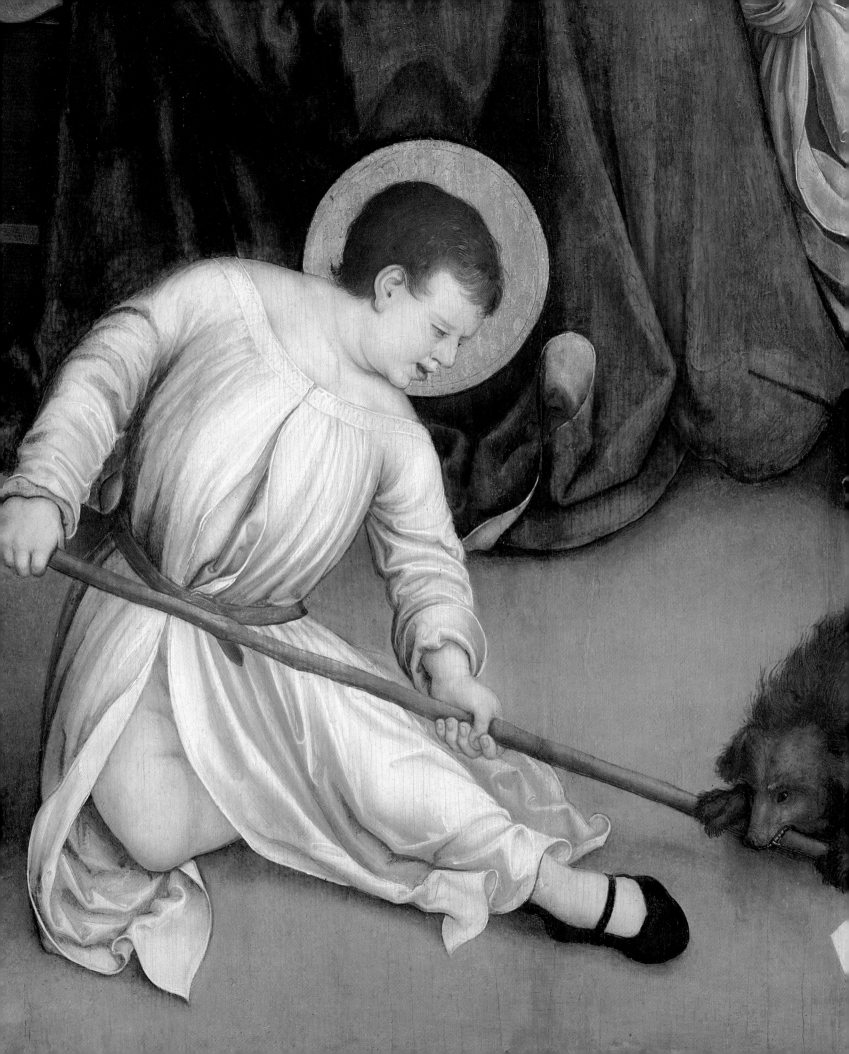

A Saxon Prince

Lucas Cranach the Elder
(Kronach, 1472 – Weimar, 1553)
Oil on canvas, 43.5 × 34.5 cm
National Gallery of Art, Washington

Cranach, this "church-goer", is mayor of Wittenberg. He is also a friend of Luther, the fighting monk with a thundering laugh. Around 1520, eroticism is fashionable with the Saxon princes: they have a taste of all these delights before the austerity of the Reformation will stamp out such vile actions.

Unlike Holbein, Cranach is a provincial artist. He observes and paints the little aristocrats as children who would have dressed up to pose for him. He forgets the seriousness and the importance of their rank. He brings them closer to the commoners. This young prince is the natural son of George the Bearded. He wears a coat, probably his brother's, that is too big for him, and the unsteady crown of pearls on his head is probably his sister's. Thus attired, he presents himself to Cranach. The artist discovers the cheek of this younger brother, who will not be reprimanded for taking things which are not his: this is an injustice left to the elder one.

Cranach's good provincial humour gives this portrait an authenticity and a quality which are more difficult to find in his nudes: their tortuous eroticism is at times ridiculous.

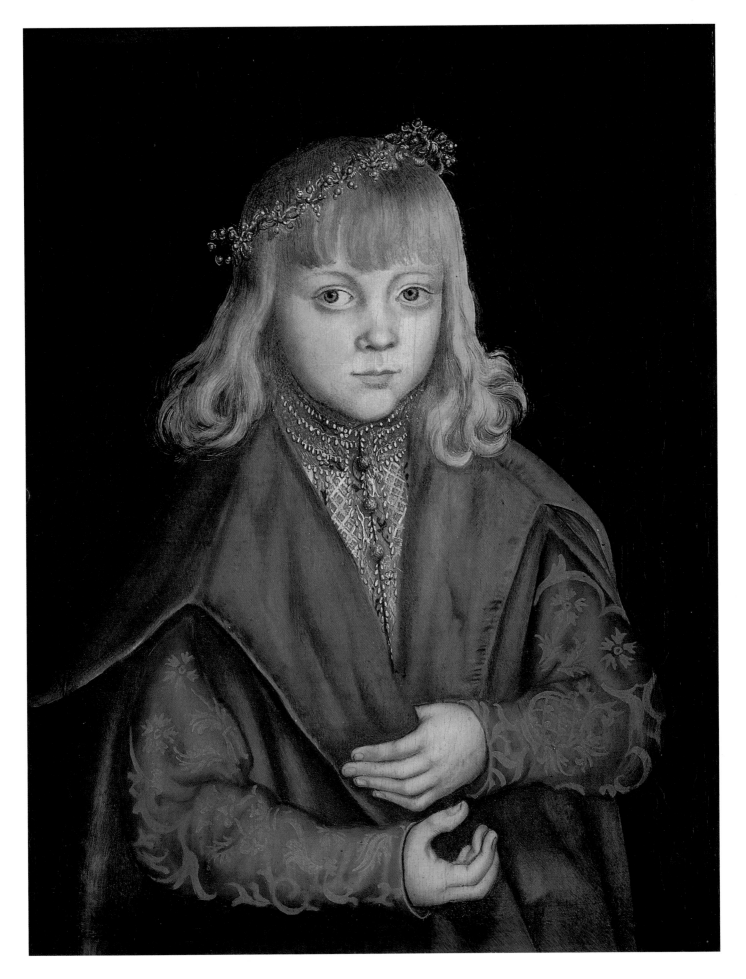

Edward VI as a Child
Hans Holbein the Younger
(Augsburg, 1497/98 – London, 1543)
Oil on panel, 57 × 44 cm
National Gallery of Art, Washington

*H*ans Holbein the Younger works in Switzerland. He paints frescoes in Basle and Lucerne; he draws cartoons for stained-glass windows and creates magnificent retables for the cathedrals of Fribourg and Soleure. The Reformation overthrows beliefs and orders the destruction of all religious paintings. In 1531, the artist leaves definitively for England where his fame takes him to the court of Henry VIII, whose official painter he will become.

The English royal babies are not as smiley as their Italian equals. The awe of their future power weighs on their slight shoulders. Edward is already a monarch in spite of his feathered hat and his chubby cheeks. From the height of his two years of age, he looks down on his subjects: with one hand he waves at them, while in the other he hides a rattle, witness of a childhood stolen away by royal duties.

In the scroll at the bottom of the picture, the highest dignitary of the Church, Cardinal Morison, directs him to follow the example of his illustrious father, which he will be unable to do: he will die at the age of fifteen.

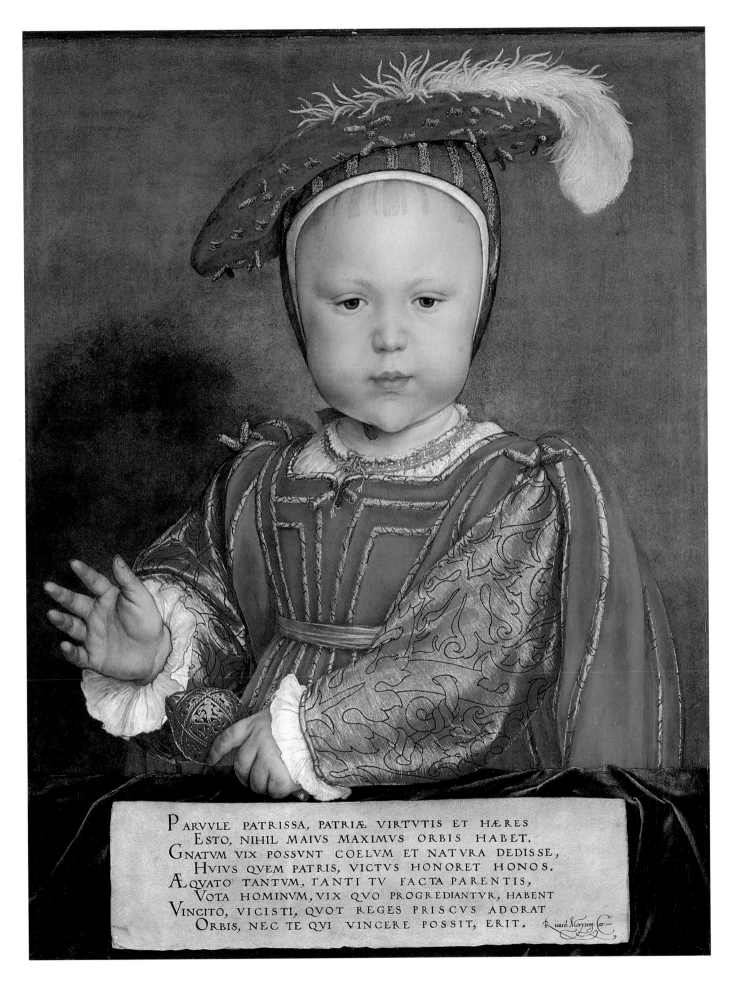

PARVVLE PATRISSA, PATRIÆ VIRTVTIS ET HÆRES
ESTO, NIHIL MAIVS MAXIMVS ORBIS HABET.
GNATVM VIX POSSVNT COELVM ET NATVRA DEDISSE,
HVIVS QVEM PATRIS, VICTVS HONORET HONOS.
ÆQVATO TANTVM, TANTI TV FACTA PARENTIS,
VOTA HOMINVM, VIX QVO PROGREDIANTVR, HABENT
VINCITO, VICISTI, QVOT REGES PRISCVS ADORAT
ORBIS, NEC TE QVI VINCERE POSSIT, ERIT. Ricard: Morysin: Car:

The Church of Graupen in Bohemia

Adrian Ludwig Richter
(Dresden, 1803–1884)
Oil on panel, 56.7 × 70.5 cm
Niedersächsisches Landesmuseum, Hanover

*B*efore the crown of Bohemia became hereditary to the Habsburgs, the kings of this western part of the old Czechoslovakia were enlightened and tolerant monarchs. Their riches excited the envy of their neighbours and rivals, the Austrians. Prague welcomed the finer spirits, the audacious architects, the genial musicians and the talented painters and sculptors. Today the sumptuous crystal and porcelain of this region still make us dream.

Pupil at the Fine Arts Academy of Dresden, Ludwig Richter is a gentle romantic who has travelled his home land of Sax and Bohemia and delights in painting its landscapes.

After having travelled through magnificent forests, the great buckle of the Elba bends through green valleys, where deep lakes lie sleeping. It is in one of these bucolic landscapes and behind the greenery of an oak that the church of Graupen hides. Before going to pray a young mother has a chat with her children. The dog listens and the geese quack.

This charming painting is only intended to make us appreciate the simple and peaceful pleasures nature offers us.

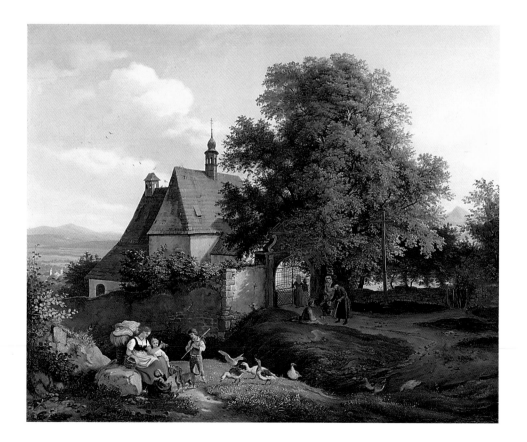

Portrait of Maria of Liechtenstein, Aged Two

Friedrich von Amerling

(Vienna, 1803–1887)

Oil on canvas, 33 × 27 cm

Collection of the Prince of Liechtenstein, Vaduz

*S*he is love, tenderness and innocence. The light brushes her curls with gold. Under no circumstances must a child's slumber be disturbed: I will therefore stop writing and let this little angel sleep!

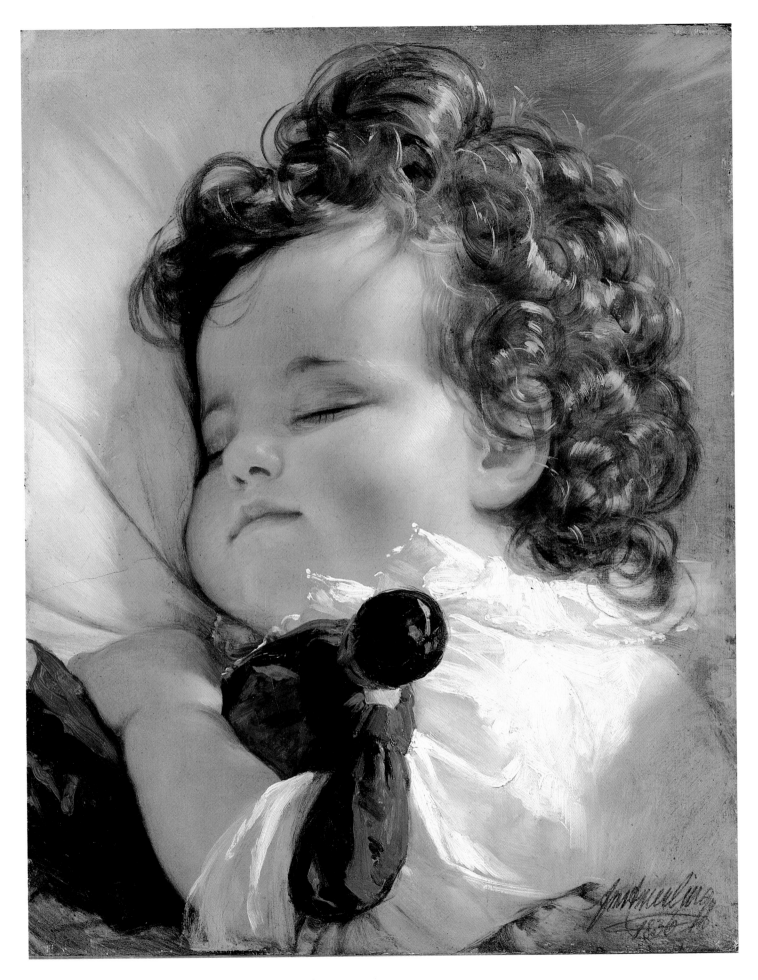

Dutch Painting

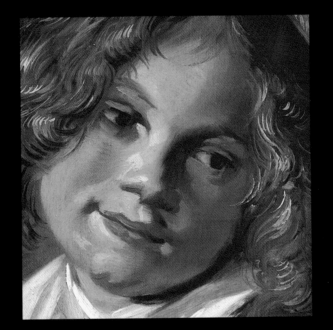

The Taste
(Boy with a Glass)

Franz Hals
(Antwerp, c. 1580 – Haarlem, 1666)
Oil on panel, diam. 38 cm
Gemäldegalerie, Staatliches Museum, Schwerin

Franz Hals is strong and healthy and so is his painting. He devotes seventy years of his life to his art and dies aged eighty-six. He is older than Rembrandt and sees the birth of Vermeer. His painting is the reflection of his health and vital energy. His portraits are happy and joyful. His women are truculent and succulent; his child musicians drink like their parents. The ruffled hairs of his brush run in all directions, curling the hair and hardly slowing down to mark the features of a face, which is always smiling and laughing. Hals does not suffer from anxiety, he loves life and life will be generous to him. His technique is ahead of his time: Manet will be inspired by it and the Impressionists will make a style of it.

Is this child tasting or drinking? Pleased with himself, he drinks avidly and the result is not what one would expect from water. His cheeks are pink, his lips are wet and his eyes are shining. All this confirm a state of happy inebriation!

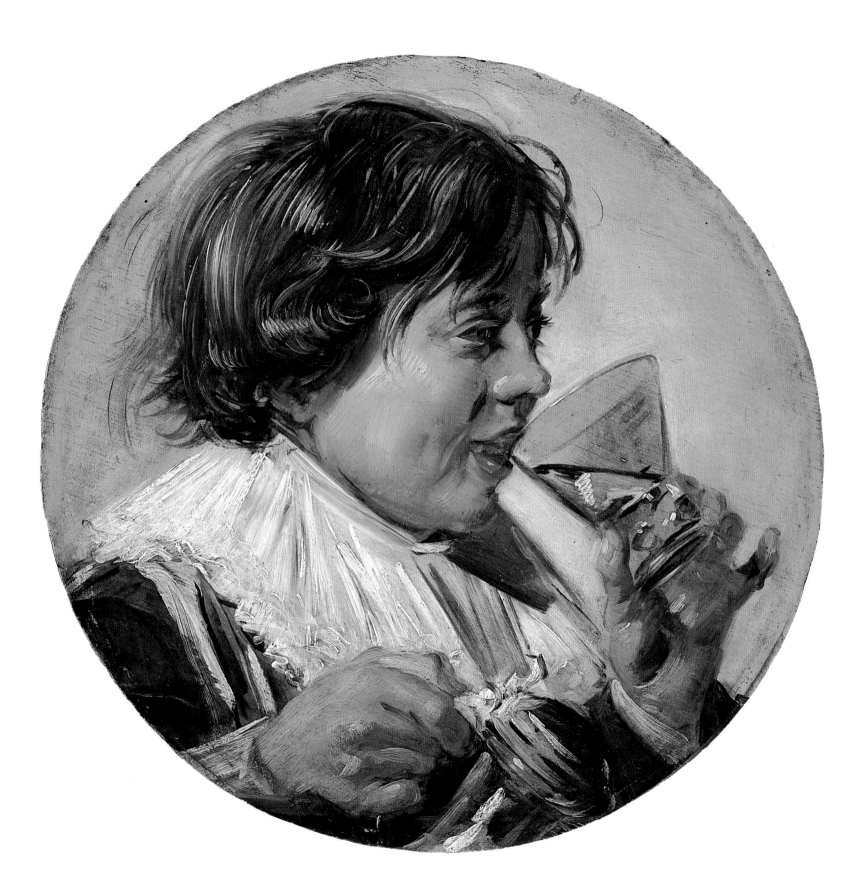

91

The Abduction of Ganymede

1635

Rembrandt Harmenszoon van Rijn

(Leyden, 1606 – Amsterdam, 1669)

Oil on canvas, 177 × 129 cm

Gemäldegalerie Alte Meister, Staatliche
Kunstammlungen, Dresden

Unlike Correggio, Rembrandt is revolted by Ganymede's fate. To be kidnapped by a god who is directed only by his lust, and thus uses and abuses his powers, is unacceptable to the Dutchman.

The artist takes his revenge on the god by representing him as an old and violent predator.

The child is frightened to death and screams with pain. He pees on the world of the living who remain indifferent to his cries for help.

Rembrandt is not moralizing but his healthy and pragmatic genius refuses to accept the abnormality of a god, who for him is violently mad.

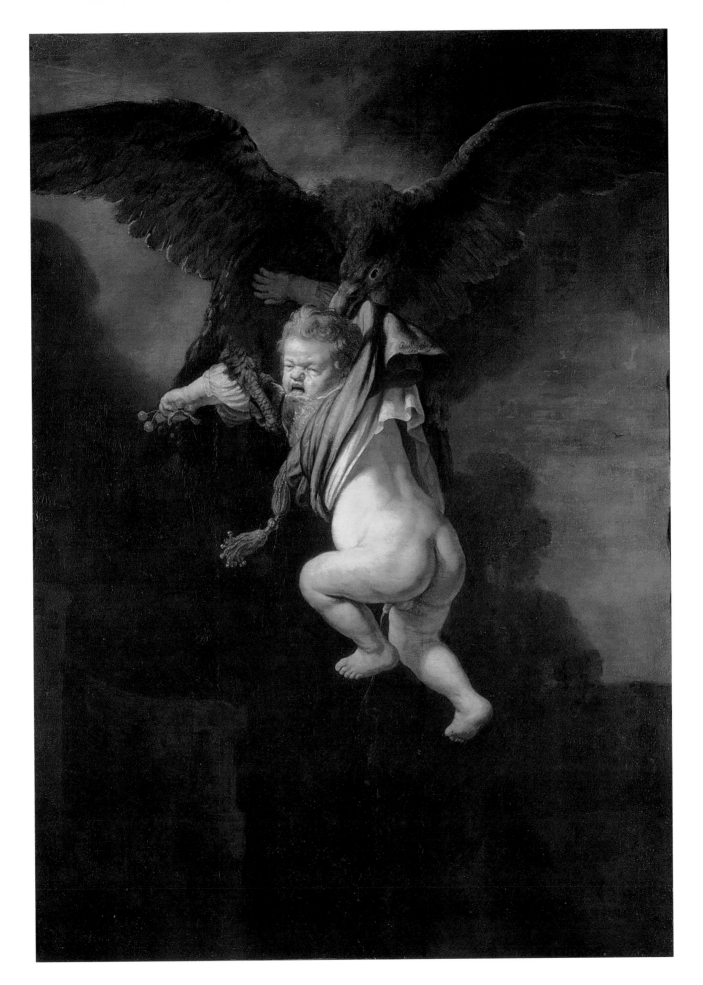

Titus at His Desk

1655

Rembrandt Harmenszoon van Rijn

(Leyden, 1606 – Amsterdam, 1669)

Oil on canvas, 77 × 63 cm

Museum Boijmans van Beuningen, Rotterdam

*R*embrandt was terribly distressed by the death of his two young daughters both named Cornelia. Titus is his third child, his first and only son. The artist sees his boy growing up and makes numerous sketches of him, even on the back of a death cerificate.

In this portrait Titus is not yet fifteen, his features are not the ones of a teenager. Leaning on his desk, he thinks, he dreams or, maybe, he watches his father working. Rembrandt sees through his son. He lights up the depth of his handsome eyes, he interrogates his half-open mouth, he bends his thumb under the chin and allows him a moment of thought during his homework.

The artist's technique is disconcerting. With great strokes of his brush, he spreads his rough paint and throws onto his canvas pieces of colour with an incredible precision. He thus builds forms and shapes structures by the light, which obeys his aesthetic and spiritual requirements

A l'ombre des grands arbres, rien ne pousse (In the shadow of great trees, nothing grows). Titus will not inherit the genius of his father but he will inherit his mother's business abilities, but eventually this will satisfy the whole family!

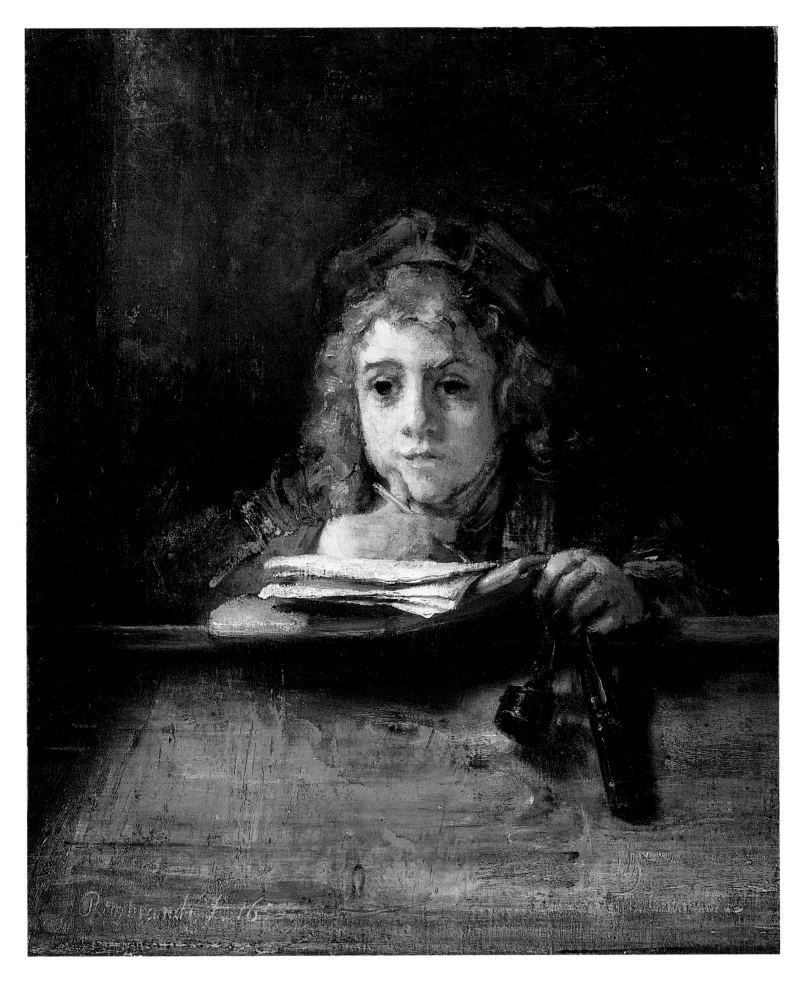

Head of a Girl

1630–40

Judith Leyster

(Haarlem, 1609 – Amsterdam, 1660)

Oil on panel, 36.2 × 31cm

Collection of Doctor Rau, Paris

*J*udith Leyster is a woman and an artist. Women have an insignificant place in the world of painting. This is often for mistaken reasons. Women transform themselves into domestic goddesses who look after their children, dry their tears and educate them, or welcome and offer board and lodging to their guests. They wash, they scour, they polish both their homes and their children. All this heavy work has the unavoidable consequences of shrinking their brains and burying their talents.

Far be it for me the idea to invert the roles of man and woman in society. But, between the house-slave and the creator, there is the wife, the lover, the mother who thinks that she can replace knitting and sewing by painting and sculpture. Mentalities change, habits are lost, let us beware of the consequences of being too radical. Judith is woman, wife, mother and painter. She is gifted and proves it in this sunny portrait.

Bathed in light, the young girl is wrapped up in warm colours. The sun gilds her curly hair and she protects herself from its rays under an elegant straw hat. We melt in front of such tenderness; she blushes, beams, smiles: the artist makes it a masterpiece of happiness.

The Dooryard Cottage
1673
Adriaen Van Ostade
(Haarlem, 1610–1684/85)
Oil on canvas, 44 × 39.5 cm
National Gallery of Art, Washington

It is good to live within a loving family under the shelter of a cottage where time follows the sequence of the seasons. It is spring: a big, fat cloud fills up the sky and the green ivy cascading down the roof blocks the holes of the birdhouse. The father is back but nobody notices. The mother is absorbed in peeling the vegetables. The elder daughter cuddles the youngest one and the son plays with his jumping dog. Sitting on the ground, the young girl should take care not to soil her lovely blue blouse, inspired by Vermeer.

Adriaen van Ostade paints numerous country scenes, all charming and tranquil. We feel like saying: "All is well… thank you!"

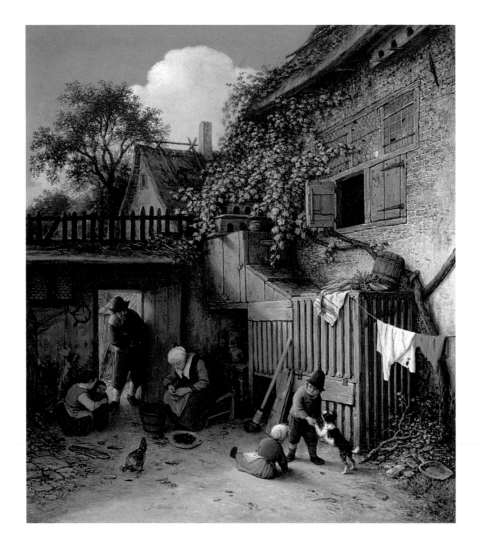

The Apple Peeler

Gerard Terborch or Ter Borch
(Zwolle, 1617 – Deventer, 1681)
Oil on panel, 36.3 × 30.7 cm
Kunsthistorisches Museum, Vienna

*I*nstinctively, Gerard Terborch does not like to paint land-scapes. He prefers the privacy and the intimacy of family life. In his paintings one can often see children playing and filling their home with the warmth of a simple happiness, of which the artist is so fond.

This lady is very elegantly dressed to peel apples. Her cape of black organdie is probably a sign of her widowhood. Dignified and worthy, she continues to satisfy the greediness of her lovely daughter, whose cheeks are round as two apples. But she looks concerned: children do not like to see their parents sad.

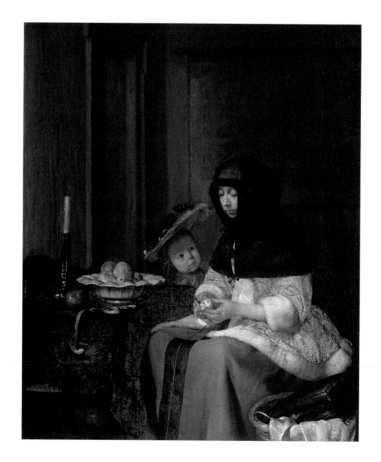

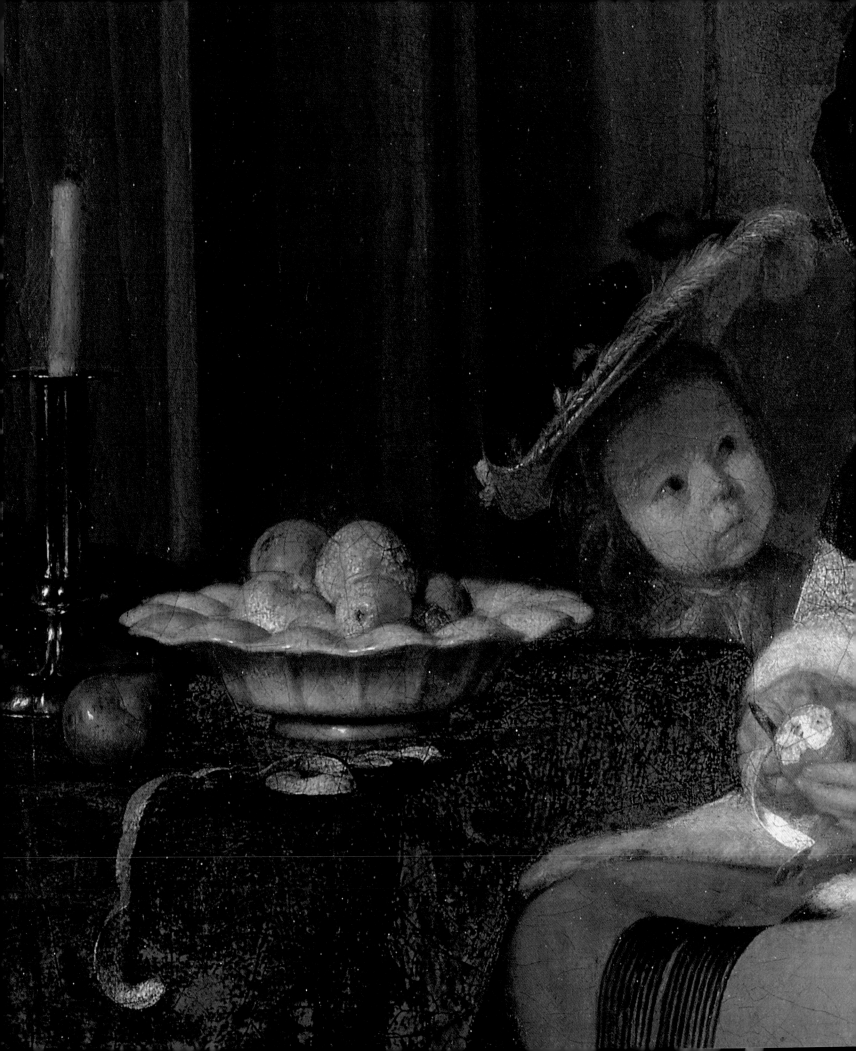

The Schoolmaster

Jan Havickzoon Steen
(Leyden, 1626–1679)
Oil on canvas, 109 × 81 cm
National Gallery of Ireland, Dublin

School is compulsory, but the bad moments are quickly forgotten and only the good memories remain. There, children must learn to read, write and count. They discover friendship and suffer their first betrayals. They are taught discipline and obedience. They learn the values of truth. School fertilizes the young minds. The best pupils work hard to remain top of the class, while the dunces are, at least, the best at amusing themselves. Luckily, life offers surprises: later in life, bad pupils can excell in their professions.

Jan Steen's schoolmaster is cross and he punishes the naughty boy who has failed his exercise. He has done it all wrong, and this seems to amuse the cheeky young girl next to him. Behind him, a good student seems very sure of himself and nothing is more annoying to the ones who find it difficult.

The lesson of this little painting is unfortunately one that life teaches us: the punishment of some becomes the reward of others.

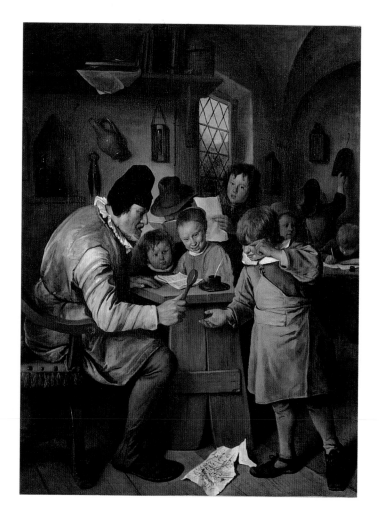

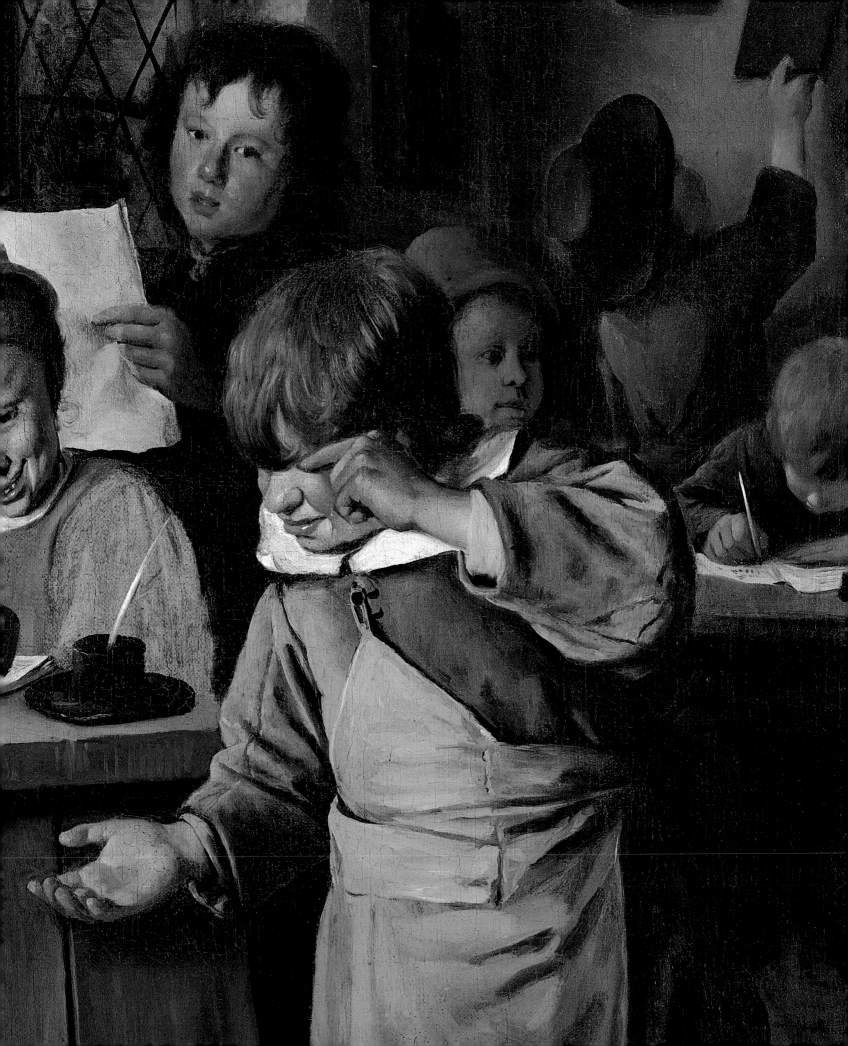

Courtyard of a House in Delft

Pieter de Hooch
(Rotterdam, 1629 – Haarlem, 1681/84)
Oil on canvas, 74 × 60 cm
National Gallery, London

Holland in the 17th century is clean: the shutters are painted every year, the pavement is washed, the courtyards swept and the homes smell of wax. Tidiness is the motto of every town and of every house, where cleanliness rhymes with wealth.

Pieter de Hooch's painting is a witness of his time. On the shiny flagstones Oriental rugs are laid out, silk dresses glide and ladies are surrounded by their impeccable children and servants.

Brick is the predominant building material used in Holland. Pieter de Hooch uses it to create coloured mosaics with reds, ochres and browns gleaming under the sunlight, disappearing down corridors and re-appearing at the other end on the façades of the neighbouring houses. In the courtyard, freshly swept by a visibly used brush, the servant and the little girl are accomplices; a sweet affection unites them, while the mother observes what is happening next door.

On the plate over the door, the artist has written his moral: "There lies the valley of Saint Jerome, for who desires to retire and try his patience and humility: whoever desires to rise must stoop first." This motto is still engraved on the wall of a garden in Delft.

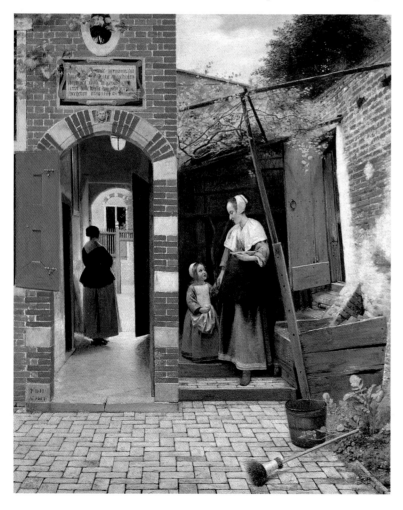

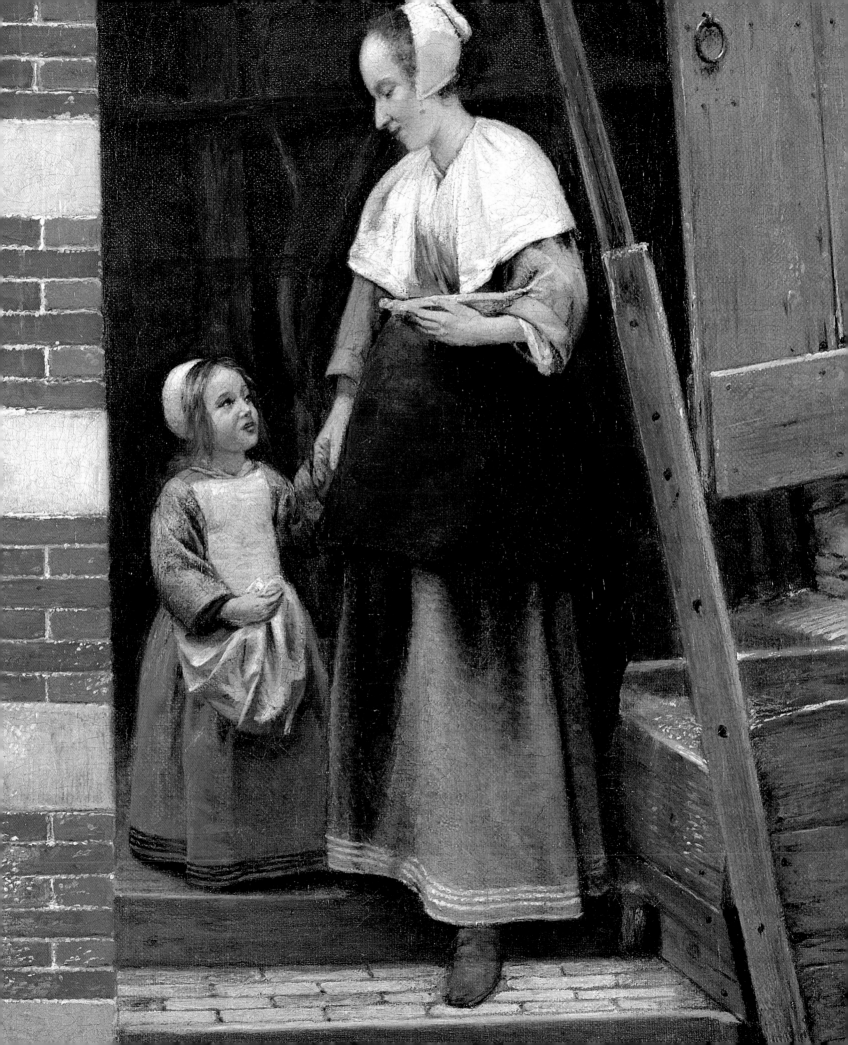

Family, Probably the One of Jan Gerritsz

1638

Anonymous

Oil on panel, 87 × 178 cm

Portret van Enkhuizen, St. Verzameling Semeijns
de Vries van Doesburgh

*H*ealth and hygienic conditions in the 17th century are disastrous. Epidemics of plague, smallpox and typhus are rife. Many women die giving birth, new-borns risk infections and child mortality is very high.

This litter of nine little red riding hoods is tenderly tucked in their moses baskets. Crowned with lace, the new-borns do not set their eyes on the whiteness of their fine sheets. Most of them are asleep, they all pose in front of their parents and two elder children. This picture is especially moving because all the babies will die only a few weeks after the picture was painted.

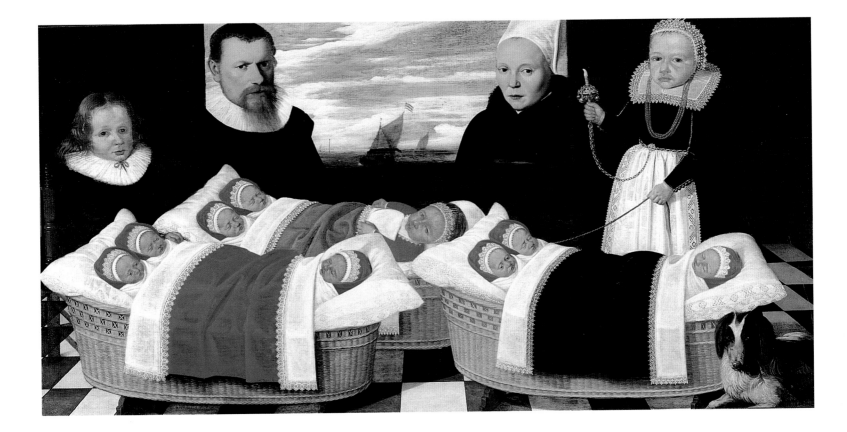

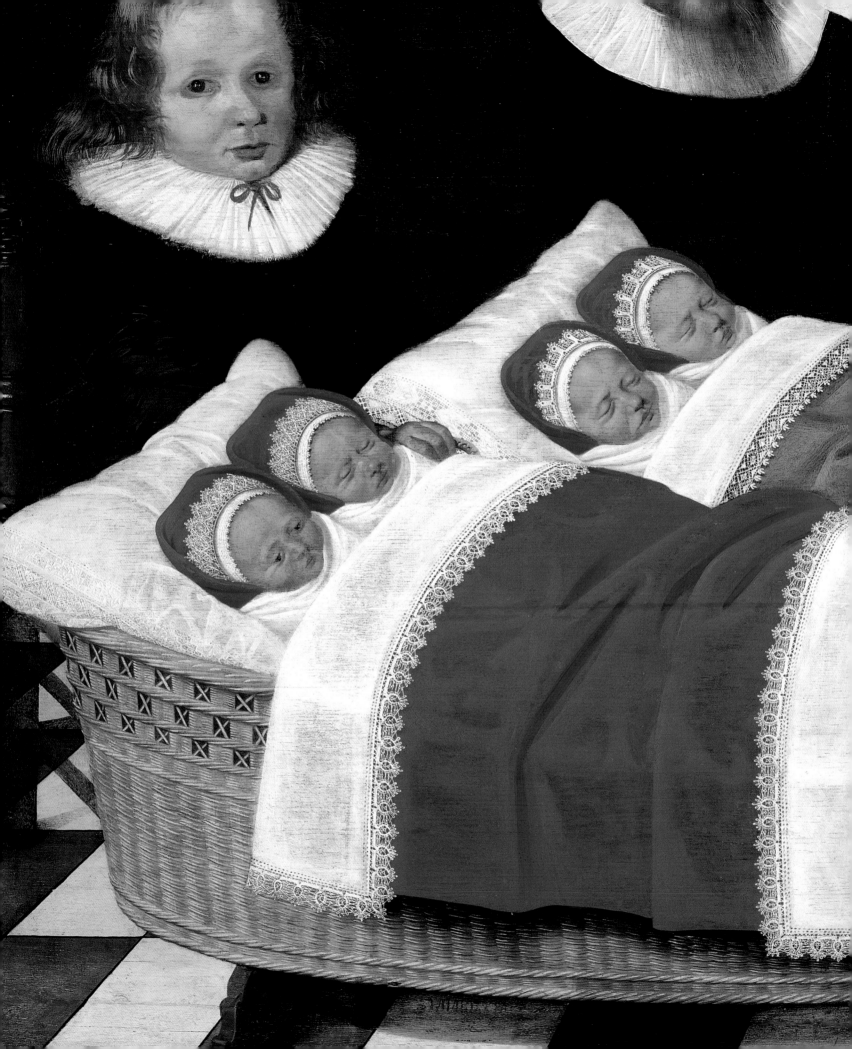

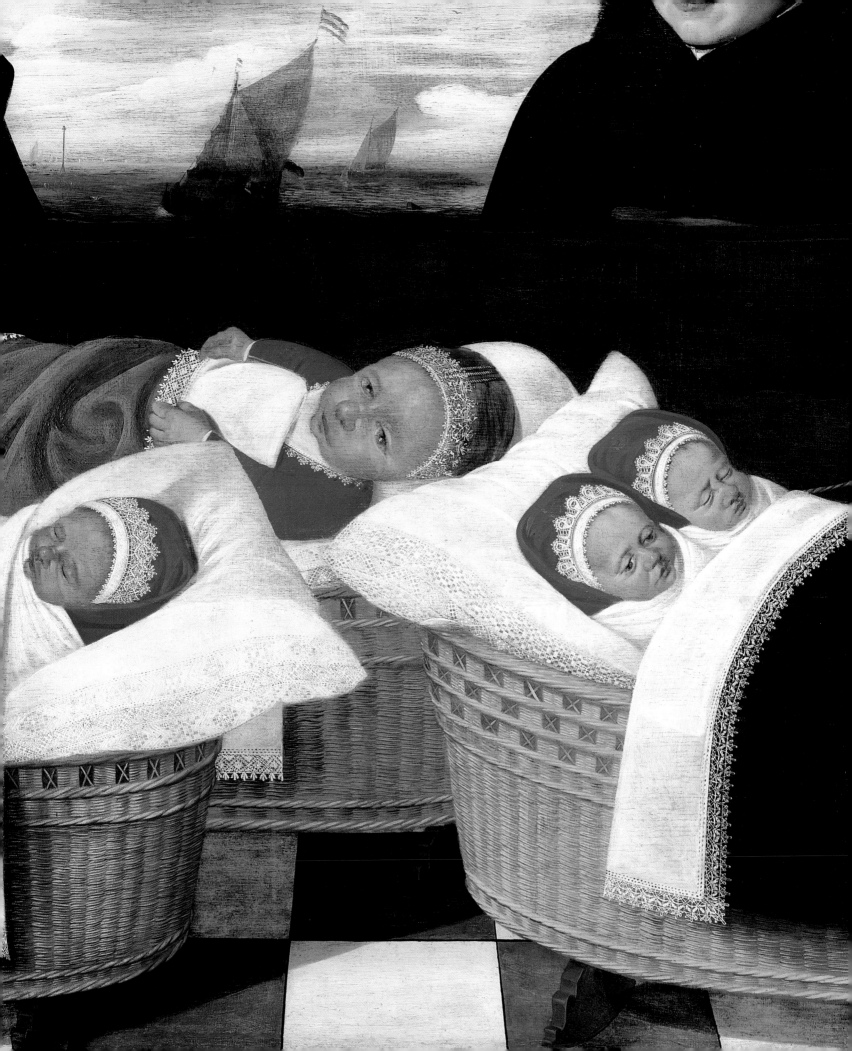

Flemish Painting

The Virgin with the Canon Van der Paele

1436

Jan Van Eyck

(Maastricht?, c. 1390 – Bruges, 1441)

Oil on panel, 122.1 × 157.8 cm

Groeningemuseum, Bruges

There are two types of beauty: the arrogant beauty, which despises ugliness; and there is Beauty, mysterious and inscrutable like Faith. This Beauty exists and Van Eyck has captured it. In his painting, Earth and Heaven meet, the miracle is accomplished under our very eyes and we are astounded. His technique and the incredible freshness of his colours provide poetry and rational spirituality. Through his amazing capacity of observation, he manages to show the invisible. There is no need for fuss; this great Art is tranquil, measured so as to reach the perfection of the mind and soul.

Eventually Van Eyck will settle in Bruges, but before that, he is for ten years chamberlain and painter at the court of Philip the Good. The canon Van der Paele commissions this painting for the old church of Saint Donatian.

For the artist nothing is too beautiful, too precious to celebrate the glory of the Virgin and her Child. Like a queen sitting on her throne in the company of her naked baby, she gives audience to the canon. Behind him, Saint George wearing a fabulous coat of armour introduces him to the Lady. As a sign of good breeding, he removes his helmet. This happy gesture enables the artist to pay his homage to the Virgin. Unfortunately, the serious Donatian cannot follow the example; a heavy cross and the wheel with the candles of his martyrdom occupy his hands. The Child King is naked. An ignorant hand had covered his sex with a white cloth, but Van Eyck's genius is far above this pettiness. He is cautious and puts a cloth under the baby's bottom. In one hand, Baby Jesus holds his parrot and with the other one he offers flowers to his Mother.

It is unnecessary to describe minutely every element of this painting. If you cut out a piece of the rug, of the red cloak, of the bishop's chasuble; if you take the spectacles of the canon or cut a lock from the Virgin's hair or Saint George's hand; be aware: all these pieces are absolute masterpieces on their own. Van Eyck puts together the pieces of this jigsaw and creates a beauty, which only a superior being can imagine.

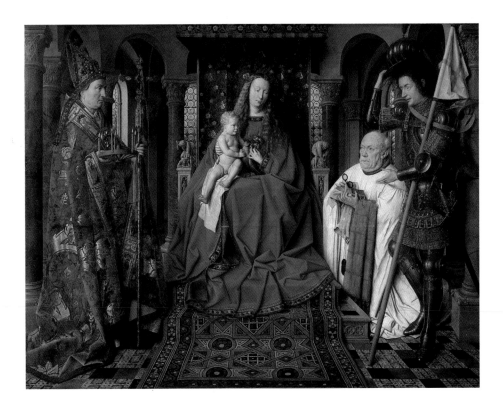

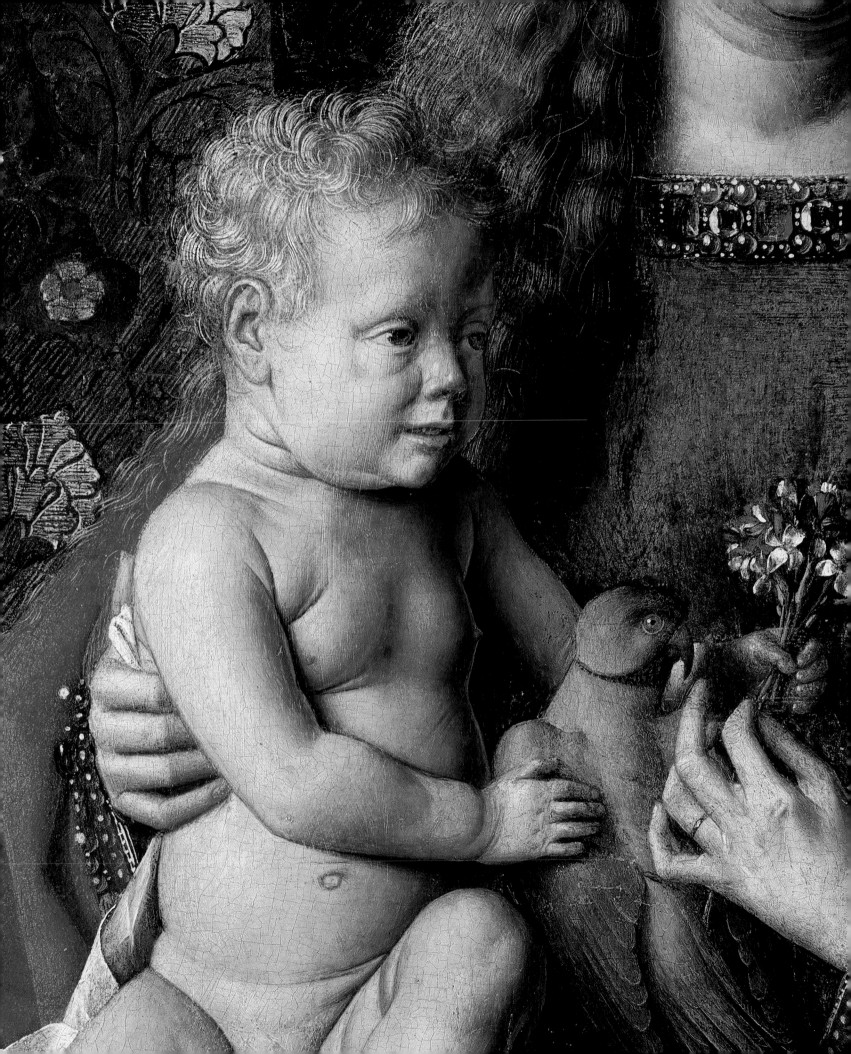

Triptych Moreel

1484

Hans Memling

(Seligenstadt, 1435/40 – Bruges, 1494)

Oil on oak, central panel: 121.1 × 153.4 cm, left wing:
120.7 × 69 cm, right wing: 121 × 68.6 cm
Groeningemuseum, Bruges

Artistic heir to Rogier van der Weyden, Hans Memling is one of the great masters of painting. His workshop is always full of pupils and is amongst the most famous ones of Bruges. His privileged position in society gives him the support of the aristocrats, of the Italian bankers and of the art-loving Church. Master of colour, he wraps his characters with warm red cloaks, framed by deep blacks and bordered by pure and fault-less whites. He organizes with extreme precision his actors against a set of fantastic landscape. Memling's world is not easy to reach and to appreciate but, once you are on the way, do not turn back: beauty, goodness, glee and truth are expecting you.

In 1484, the Moreels commission the building of an altar for Saint James' church in Bruges, which this triptych by Hans Memling will adorn.

Christopher is in Greek *Christos-Phoros* or Child-bearer. This is the thirteenth labour of this Flemish Hercules, dressed in red. Saint Maurus with his arrow and Saint Giles with his doe witness the exploit of this giant carrying the wriggling Baby. With one hand he holds on to the white headband of his porter and with the other he blesses quickly the saints and the Moreel family.

On the right, the mother, Barb van Vloenderbech, and all her pale daughters perform their devotions. They are under the protection of the very elegant Saint Barbe.

On the left, William Moreel and his sons smile meekly. Hands folded together, they pray on a marvellous carpet of leaves, where a cheeky flower of wild strawberry defies the weight of the heavy cloak. One of the boys seems troubled, even worried by the shadowy figure hovering by his father. A strange knight in armour, a black standard-bearer lays his frozen hand on the shoulder of his protégé. A bloody-eyed "Cerberus" hidden in the dark pleats of his cloak is ready to devour the righteous. He is the devil and a menace to the unstable affairs of the world at the end of the 15th century.

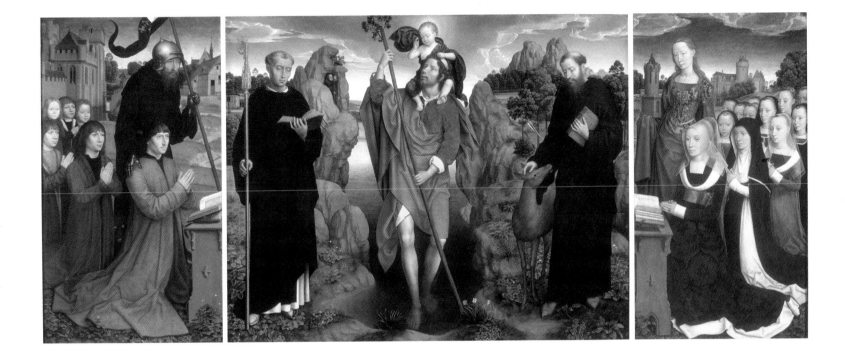

The Pickpocket

c. 1475

Hieronymus Bosch

(s'Hertogenbosch/Bois-le-Duc, c. 1450–1516)

Oil on panel, 53 × 65 cm

Musée Municipal, Saint-Germain-en-Laye

"Thou shalt not rob" is a commandment which has become obsolete. Robbery is a sport, a profitable hobby practised remorselessly and often without consequences. Its organization stretches all over the world and its causes are similar in the 15th and 21st century.

When Hieronymus Bosch worked in Bois-le-Duc, the city was growing and its wealth attracted what the tribunals call "everywhere dwellers", better called "nowhere dwellers". These wanderers were the homeless people of today. During the 15th century, they were buffoons; jugglers, ropedancers, barbers, surgeons and all of them were charlatans. They found their public and victims at fairs in larger cities. The smaller cities were spared from this calamity.

The composition of the picture is simple. The conjurer stands behind his table with his owl sleeping in a wicker pouch and his wicked monkey, symbol of cupidity. On the other side of the table, his victim vomits a frog over his marbles, goblets and magic wand. Meanwhile a pickpocket removes the victim's purse under the indifferent eyes of a nun, a lady and other passers-by. The artist has dressed his pickpocket in the robe of a Dominican. These monks used the Inquisition as a violent weapon and created the "anti-witch brigades" to sow terror amongst the population.

The humanist Erasmus of Rotterdam declared boldly that "the poet and the Devil are an invention of heresy". As for Hieronymus Bosch, he puts conjurers and monks in the same basket under the amused eye of his little accomplice.

Genius allows a total freedom of expression…

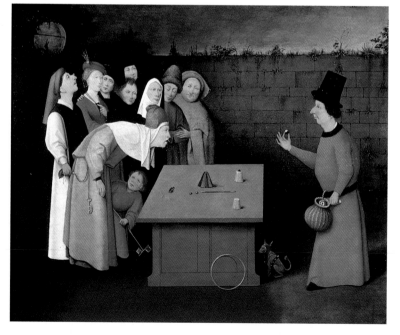

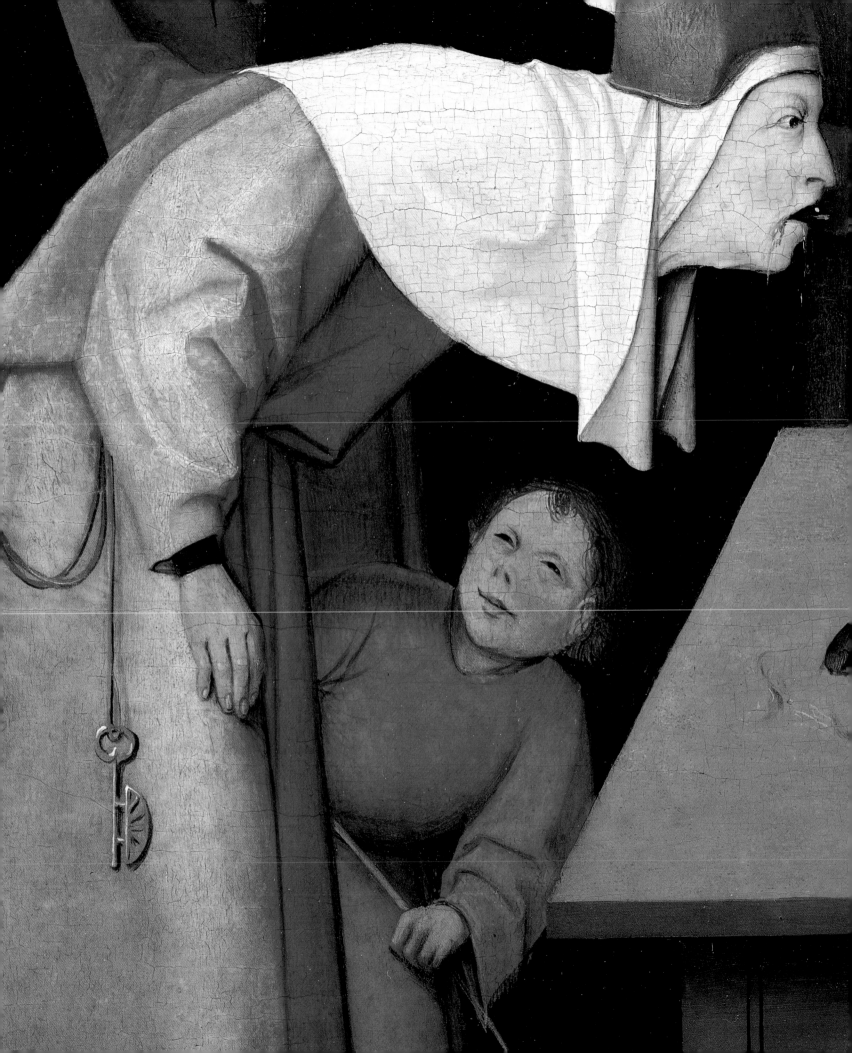

Virgin and Child with a Bowl of Pap

Gérard, or Gheeraert, David
(Oudewater, c. 1460 – Bruges, 1523)
Oil on panel, 33 × 27.5 cm
Aurora Trust, New York

During the 16th century, the Flemish art market changed and new commercial strategies emerged. The foreign art patrons were bored with religious scenes and began to demand scenes of everyday life.

Gérard David responds to the wishes of his customers. In this picture, he mixes the holy and the profane. The Virgin acts like any mother: she feeds her baby. In the room where they sit, he has opened a window, but the draught does not seem to bother them. In her comfortable home, the Virgin has taken the care of putting on a little bit of make up: a dusting of powder, rose on her cheeks and red on her lips. This coquettishness is quite acceptable for a mother who has weaned her baby! She has prepared for him a good thick pap but it does not seem to tempt him half as much as the juicy cherries, which he nearly crushes in his chubby hand.

The artist's Virgin is more a mother than a saint, but this should satisfy the Church and the art merchants!

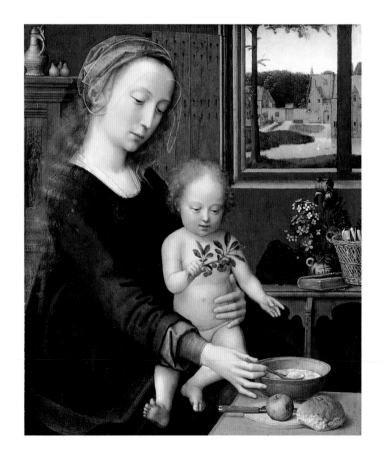

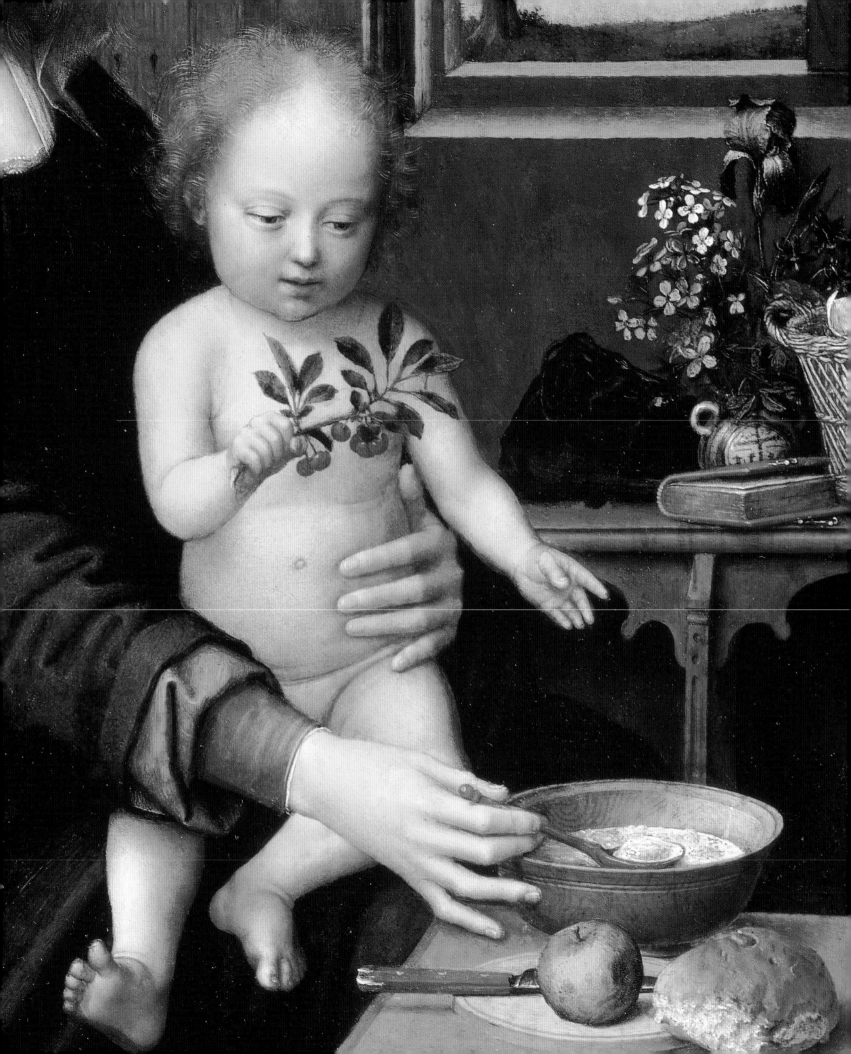

The Last Supper

1548
Pieter Pourbus
(Gouda, 1523 – Bruges, 1584)
Oil on panel, 46.5 × 63 cm
Groeningemuseum, Bruges

*N*ot only is Pieter Pourbus a draughtsman, a cartographer, a land-surveyor and an engineer, he is also a great and famous painter in Bruges during the second half of the 16th century. He has a beautiful house and opens a workshop, which will become the envy of his fellow-painters.

Pourbus' *Last Supper* is unique because it is a simple meal ending up in general chaos. The traitor Judas is found out and runs away knocking down his chair, which is quickly grabbed by a frightened child. A disciple holds him back by the cape but death, with its bony skull and its sharp claws, is arriving to take him away. Jesus tries to remain calm and to temper the spirits of his disciples who are not plunged in meditation!

Pourbus forgets about the tradition of the Last Supper being a calm and serious meal. With his concert of shapes and colours, he dares what no one had ever attempted before.

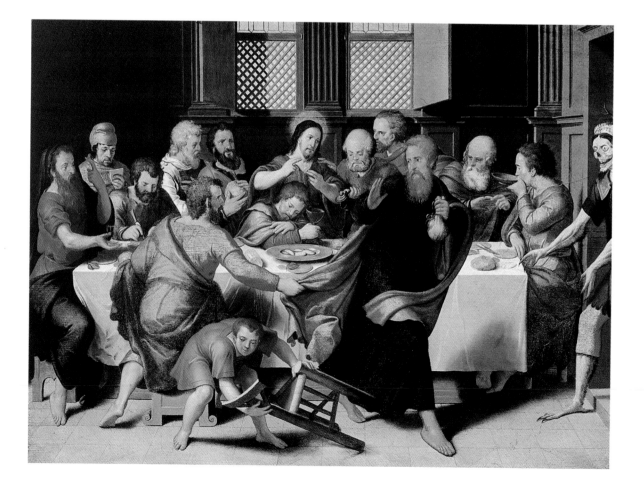

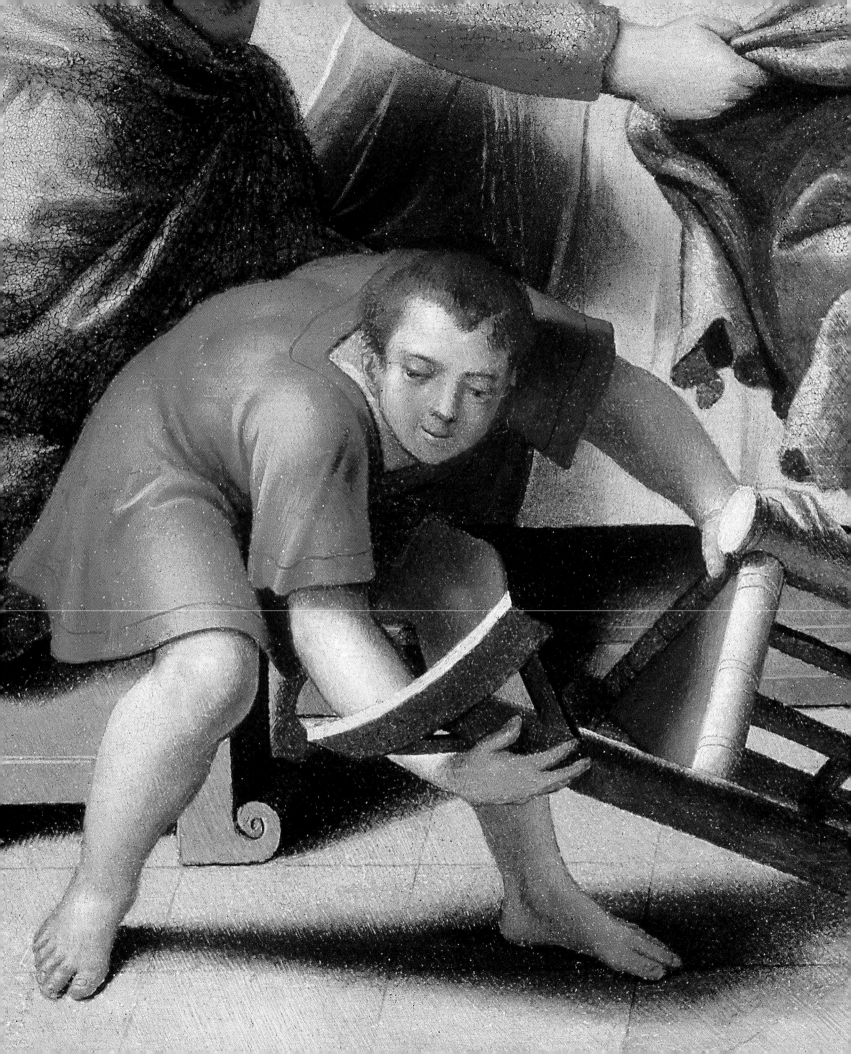

Children's Games

1560
Pieter Bruegel the Elder
(Bruegel, c. 1525 – Brussels, 1569)
Oil on panel, 118 × 161 cm
Kunsthistorisches Museum, Vienna

*I*n this vast playground two hundred and thirty boys and girls play ninety-one different games! They play at knucklebones, at leapfrog, at blindman's-bluff; they play with marbles and with dolls… Some do handstands, some play roly-poly, and others do exercises around a beam. Some play hop-scotch, some spin with their tops, some twirl like dervishes by the river where others paddle and learn to swim. A chubby little one and her fiancé for the day get married right in the centre of the painting where the diagonals cross. Bruegel's message is clear: without marriage, no children!

Too many plausible or implausible symbols have been attached to this picture, but who cares? All that matters is that the children's world is lively, cheerful, spring-like and summer-like and that Bruegel's colours – reds, blues and pinks – sparkle around these wriggling figures. They are alive, they play and they are happy. Is it not the most wonderful message the artist can give us?

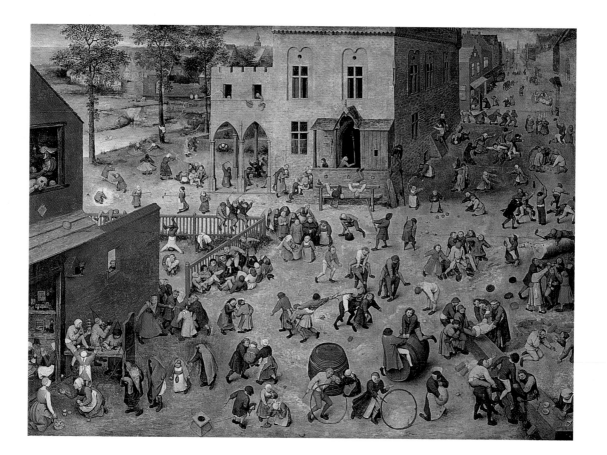

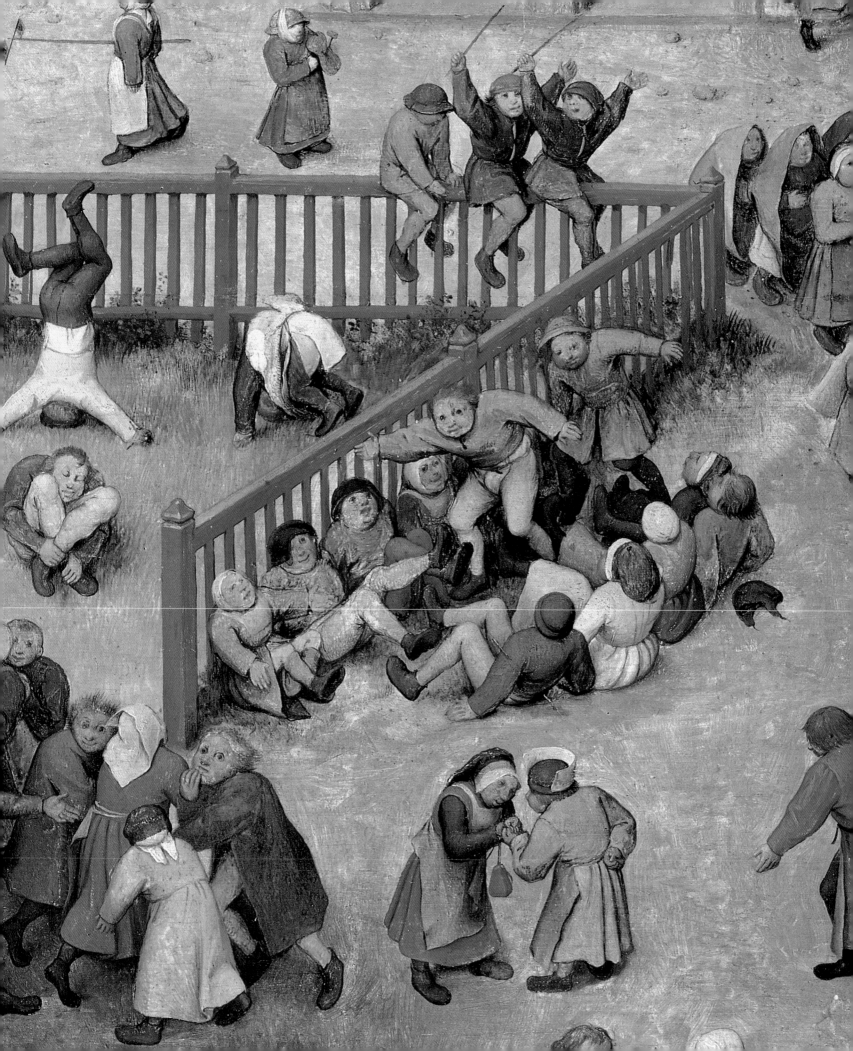

Erichthonios in His Basket

Peter Paul Rubens
(Siegen, 1577 – Antwerp, 1640)
Oil on canvas, 218 × 318 cm
Collection of the Prince of Liechtenstein, Vaduz

The sexual appetites of the Greek gods are voracious. They rape and copulate in acrobatic fashion. Hephaistos, fascinated by the beauty and the virginity of Athena, tries to rape her but she resists and the divine sperm is spilled on Gaia, the Earth. The fruit of the vexed embrace is Erichthonios, whose legs finish in snake tails.

Rubens' genius, which feeds off the female flesh, does not hesitate to set the scene in a bucolic brothel. Its signboard is the goddess of Ephesus with her numerous breasts. The brothel-keeper bows behind the best specimen of her Olympus. The three callipygian goddesses, Aglauros, Erse and Pandrosos, are the daughters of Cecrops. These generous receptacles of maternity, these triumphant and fleshy, fullbreasted goddesses inflame desire and wake up the sleepiest senses. These ladies move among flowing cloaks and are hardly surprised by the slightly monstrous baby, who does not enjoy being tied up in a basket.

In the background Pan laughs at the scene. This mad sexual maniac does not worry the three goddesses. Rubens, as a fine and cautious connoisseur, fossilizes him. He loves women and life too much to waste energy on monsters he does not like.

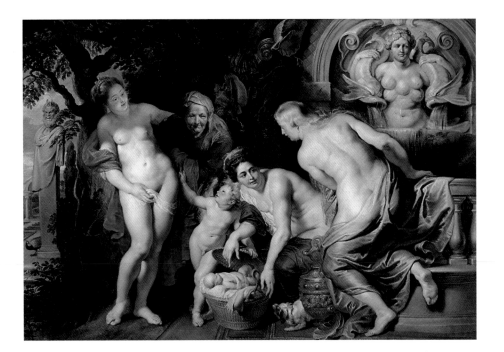

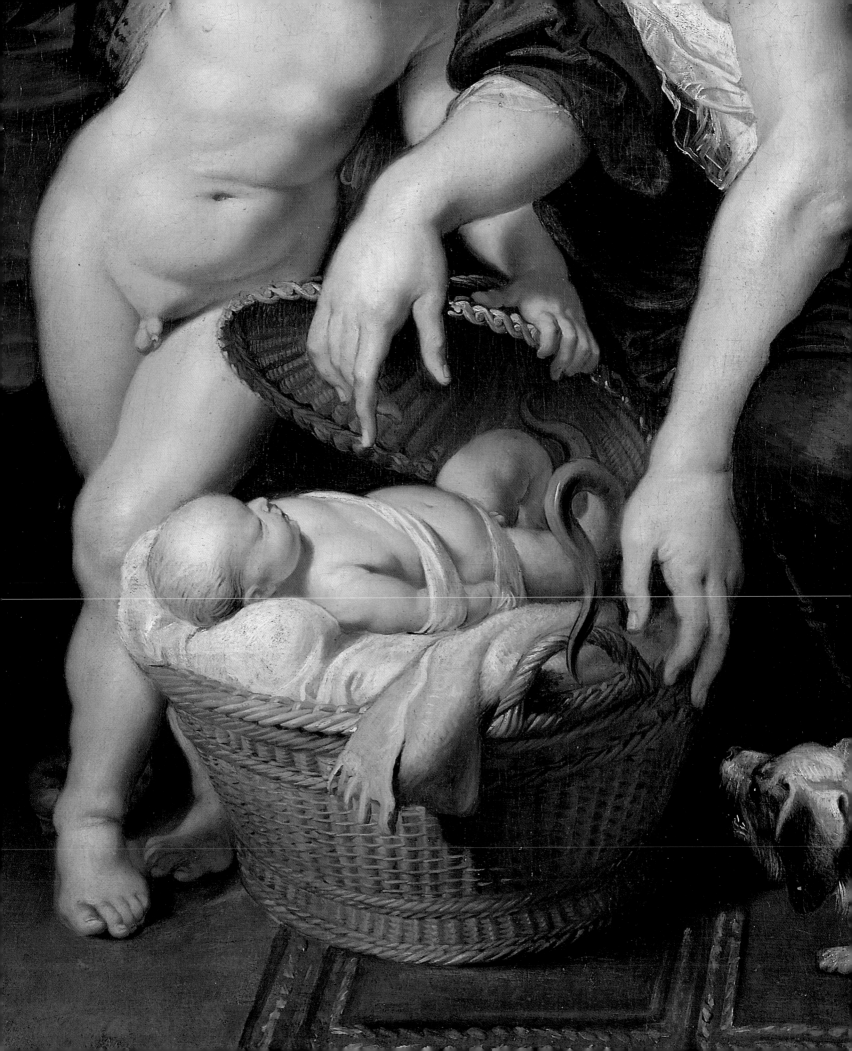

Clara Serena Rubens

Peter Paul Rubens
(Siegen, 1577 – Antwerp, 1640)
Oil on panel, 33.5 × 27 cm
Collection of the Prince of Liechtenstein, Vaduz

Clara Serena is the daughter of Peter Paul Rubens. She is five years old and looks like her mother, Isabella Brandt. With no artifice, the artist brushes her golden hair and puts a sparkle in her loving eyes. He colours her little smiling red lips and caresses her burning cheek with the dazzling light of her white collar.

Rubens adores his daughter and one can see it, feel it and breathe it in all the hairs of his brush. The artist keeps the best of his art for his child.

The King Drinks

Jacob Jordaens
(Antwerp, 1593–1678)
Oil on canvas, 156 × 210 cm
Musée d'Art Ancien, Brussels

This epicurean painter has a lecherous spirit. He likes to eat, to drink, to burp, to fart and to vomit with kings and with rustics. Jordaens' art is about celebrating, it loves the noisy scatology of those fond of good living: it is one of its sources of inspiration. These bad manners vex and shock the narrow-minded and the close-fisted, but it is these people who should look at this painting: they would get rid of their inhibitions and burst out laughing.

In Flanders, Epiphany is a feast: the guests raise their glasses and exclaim: "The king drinks!" Then, they empty their glasses and bow to one of the guests dressed as a king. They are cheerful, tipsy and full of intoxicating fumes. This picture is not in favour of alcoholism but it encourages parties, real ones, without undue sophistication. Only the child cries: he cannot find his place among these noisy excesses.

Dear distinguished intellectuals, forget your complicated phrases and their obscure messages: drink to the health of Jacob Jordaens and his art!

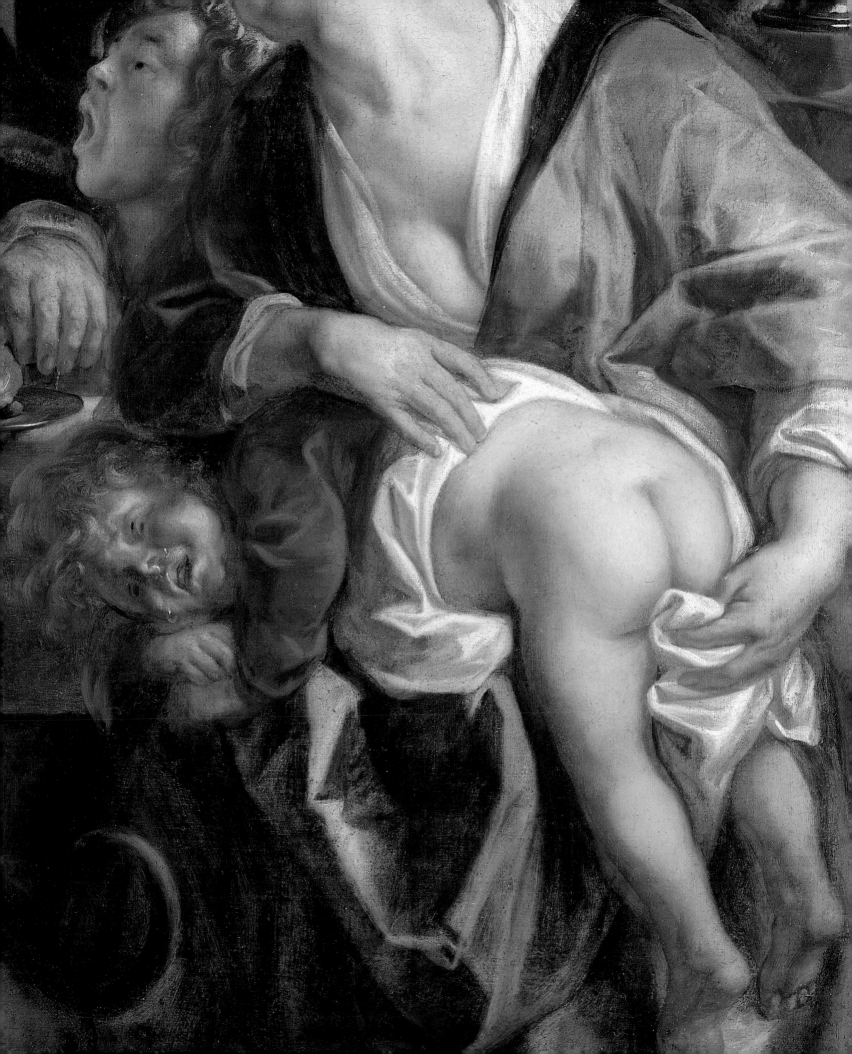

Woman and Child

c. 1621

Anthony Van Dyck

(Antwerp, 1599 – Blackfriars, near London, 1641)
Oil on canvas, 131.5 × 106.2 cm
The Trustees of the National Gallery, London

*V*an Dyck is a child prodigy: "Peter Paul Rubens was very famous in Flanders when he welcomed in his workshop in Antwerp a young boy, who through his talent and the delicacy of his manners promised to add distinction and splendour to painting. [...] This youth was no other than Anthony Van Dyck, born in Antwerp in the year 1599" (Giovanni Piero Bellori, *Le vite de' pittori, scultori e architetti moderni*, Rome, 1672).

Van Dyck's art is refined and always of exquisite elegance. With superiority, he looks down on us from his immense talent and solves all the technical difficulties with great ease; he will have a shining career. He works quickly and without respite but still finds the time to travel and cultivate himself. From Antwerp to Rome, from Genoa to London, the aristocracy of these towns quarrel to obtain his services. Unfortunately, the loss of his mother when he is still a child and the financial problems of his father make him unsteady, incapable of settling anywhere. Nonetheless, later in life, he has a wife and daughter.

The mother has delicate features, a pale complexion and beautiful black eyes. She smiles at the artist but her child does not want to pose. She wriggles on her mother's lap, impatient to get down and play. She is alive and could not care less about posterity.

Yet, you have made a mistake Sir Anthony! The hands of this little girl are too big for a two-year-old. Even a genius can make mistakes, which is a great comfort to us less-gifted ones!

The Young Diana

Anthony Van Dyck
(Antwerp, 1599 – Blackfriars, near London, 1641)
Intervention of Jan Roos in the still life in the bottom
left-hand corner
Oil on canvas, 145 × 110 cm
Private collection

The young Diana is the heiress to one of the great Genoese families, the Dorias. She has a strong character; she is proud and probably bad-tempered. All this can be read in the dark look that she gives us. She sulks and only has time for her greyhound. She strokes her and the bitch looks back at her as if she were the eighth marvel of the world!

The artist is without pity, he sees through this little girl. Haughty in her beautiful red dress, she is used to having her own way with the commoners we are. Still, we admire her with all her faults, as they have become qualities through Van Dyck's brush.

The Balbi Children

1625–27

Anthony Van Dyck

(Antwerp, 1599 – Blackfriars, near London, 1641)

Oil on canvas, 219 × 151 cm

The Trustees of the National Gallery, London

These handsome little aristocrats are called Balbi because this painting belonged to the collection of the Palazzo Giacomo Balbi in Genoa. These three children are in fact the sons of Gerolamo da Franci, whose brother Federico was elected doge in Genoa in 1623.

The elder with his huge collar looks at us and shows us his tame crows. On the highest step, the second one, fist on his hip and shoulders straight, protects lovingly his younger brother with chubby cheeks. He holds prisoner in his hand a bird that wants to fly away.

Van Dyck exults with these three brothers: they are handsome, rich and healthy. His paint twinkles, the faces come alive and his hand steadily obeys his piercing eyes.

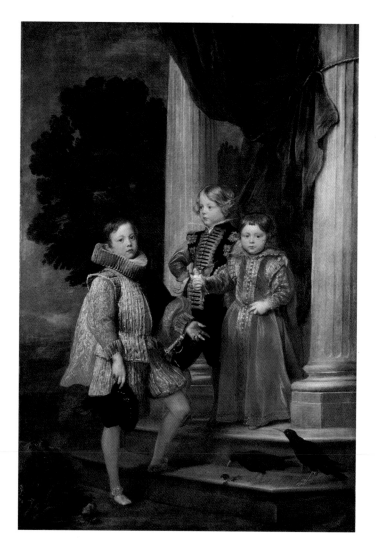

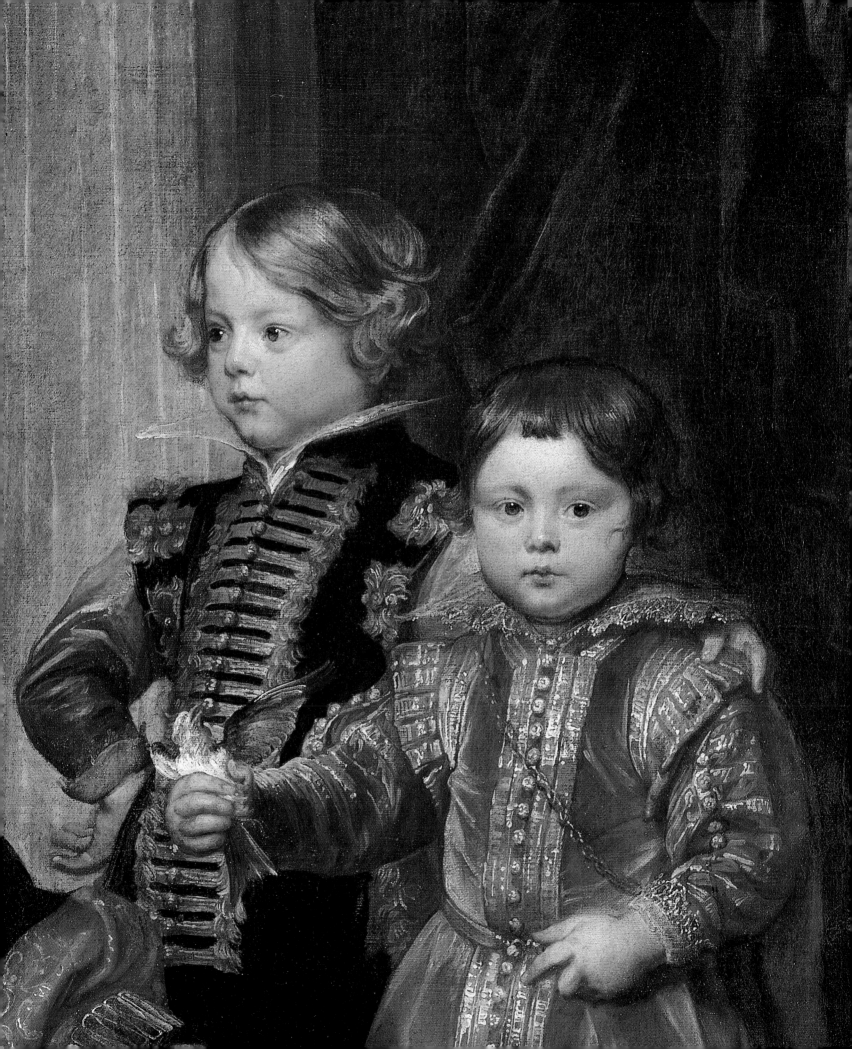

Spanish Painting

The Adoration of the Child

1533–35

Juan Correa de Vivar

(died in Toledo in 1566)

Oil on panel, 228 × 183 cm

Museo del Prado, Madrid

*H*istory is silent about the life of Juan Correa de Vivar. This great panel was probably in the monastery of Guisando in Avila.

This very Italian nativity is a feast. Everybody is active on Earth and in Heaven, gathering around the Infant, who is wriggling about on his makeshift couch. His indulgent mother dotes on him. The old father tries to calm him down before the arrival of the shepherds, who jostle their way through the pillars. The ass and the ox are not warming up anyone; they behave like attentive guests. The music-loving donkey stretches an ear to listen to the concert of the angels flying over the heads of the Holy Family. These little trumpet-players, guitar-players and drummers tune into a *Gloria in excelsis Deo* for eternity.

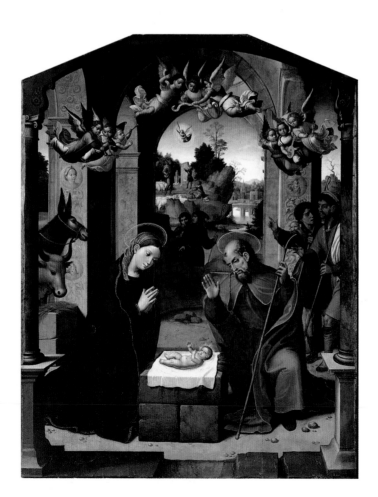

The Rest during the Flight to Egypt

1659

Francisco de Zurbarán

(Fuente de Cantos, 1598 – Madrid, 1664)

Oil on canvas, 121 × 97 cm

Szépmüvészeti Múzeum, Budapest

*Z*urbarán has been unjustly overshadowed by his two prestigious successors: Velázquez and Goya.

In 16th-century Spain, religion tended towards superstition; its practice followed rituals where mystical suffering was mistaken for exorcism. Zurbarán refused to paint these religious masquerades. Some criticize him for representing mostly saints. This is true, but his saints seem to come from an outer world: they step out of the shadow, draped in light, and reach a sublime abstraction. Anyone would sell their soul in front of the majestic beauty of Saint Casilda, Saint Lucy or Saint Apolonia. His still lifes reveal the transformation of simple objects exposed to the reflections of the light: they become mysterious forms welded together by the secret of the artist's colours.

In a dream, an Angel of the Lord counsels Joseph to flee to Egypt with the Mother and the Child that Herod wants to kill. It is a long and arduous trip of various days: the Holy Family must stop to rest and feed the Infant.

She is young and ravishing, he is handsome and charming. Both, without halos, bend tenderly over their lovely baby. With his little nose turned up, this plump baby sucks his mother's breast: it is a real treat and he will not let go. They are wrapped up in white, red and blue. Zurbaran paints here a "source of human vitality".

The Virgin Child Asleep

Francisco de Zurbarán
(Fuente de Cantos, 1598 – Madrid, 1664)
Oil on canvas, 109 × 90 cm
San Salvador Cathedral (former collegiate church),
Jerez de la Frontera

*I*s she really asleep this little Queen of angels? Or is she only toasting her lovely face to the soft rays of the sun? In any case, both ecstasies suit her well.

The little girl has become a brilliant treasure under the artist's brush. He arranges delicately three flowers in a vase: a lily for innocence and purity, a rose for love, and a carnation, symbol of filial love. The artist offers her this little bunch of flowers and steps out quietly, leaving behind a masterpiece of serenity and tenderness.

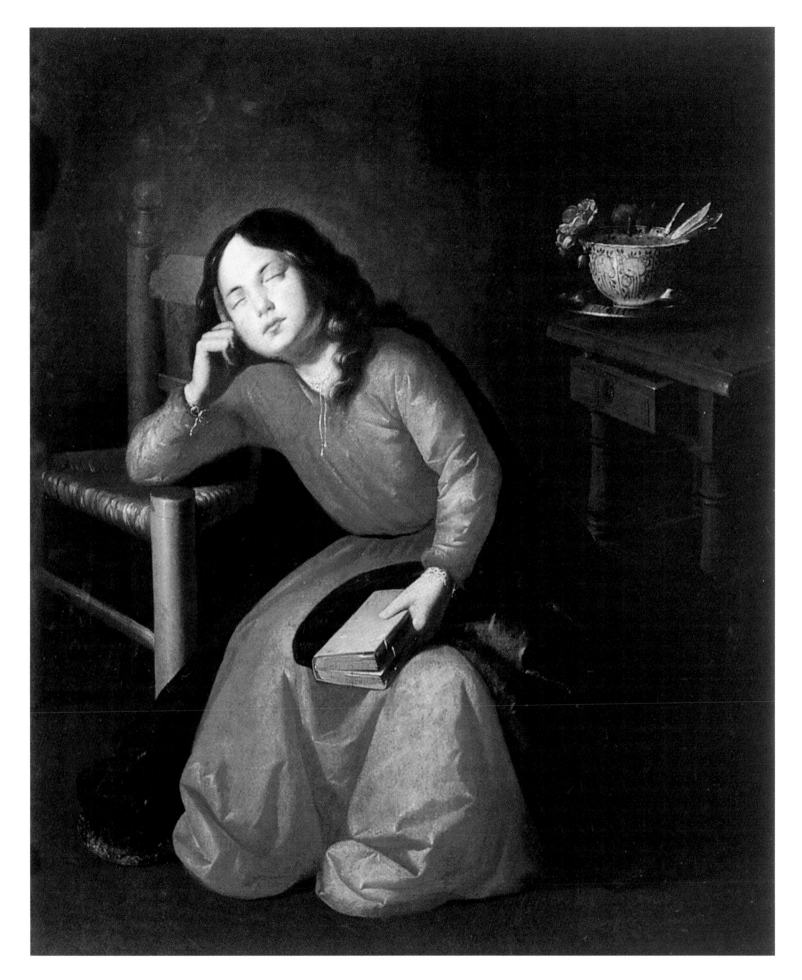

Las Meninas or The Family of Philip IV

1656

Diego Rodriguez de Silva y Velázquez

(Seville, 1599 – Madrid, 1660)

Oil on canvas, 318 × 276 cm

Museo del Prado, Madrid

*L*ooking at this gigantic painting, one loses one's bearings. Pushed by curiosity, I want to go beyond the threshold of this composition and find the answers to all the questions which are plaguing me. What is the object of the painting? How could the artist be at the same time in the picture, facing the king and queen, behind the princesses and paint everybody? All these people look at us and stand behind him. Astounded, I remain speechless and without answers.

It is impossible to find geometrically the viewpoint of this picture: one has an intuitive idea of it, which does not require proof. The two blushing ladies-in-waiting are attracted by little Margarita, who acts as a luminous magnet. She captures the eye, makes the dwarf even uglier, distracts the attention of the duenna and clouds the reflection of her parents. Velázquez alone keeps his proud composure and lets the turbulent pageboy play with the Belgian shepherd dog. The dog remains unmoved: he is the guardian of the picture, the guardian of the artist. He keeps away the intruders who sneak to discover the enigmas of this vast canvas.

We are forced to admit that the ultimate secret of a masterpiece remains unexplainable. On the other hand, it is looking at this little infant that Renoir discovered his style.

Doña Antonia de Ipeñarrieta y Galdós and Her Son Don Luis

Diego Rodriguez de Silva y Velázquez
(Seville, 1599 – Madrid, 1660)
Oil on canvas, 215 × 110 cm
Museo del Prado, Madrid

*V*elázquez is snowed under with commissions: he paints fast, very fast, too fast. This explains sometimes the many unfinished corners in his paintings. But here there is no hurry, the genius is calm and observes his two models with great care.

His geometrical composition is reduced to two cones: a great black one for Doña Antonia and a little white one for Don Luis. The two figures fit together. At the top of the triangle, the pale

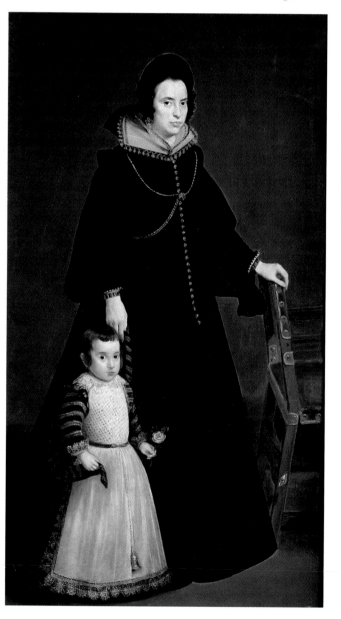

face of the noble lady. Sulky, she dresses in her long sad dress, on which the artist places a rosary of pretty buttons. She holds her son on a leash. The little boy is so intimidated by the artist that his little bell remains silent in the pleats of his apron. Mother and son seem so deeply bored that the little white rose is fading in the hands of Don Luis.

Velázquez can sulk or be sad in front of his models, but he is never indifferent. He idealizes their state of mind and his genius brings them to the level of virtue.

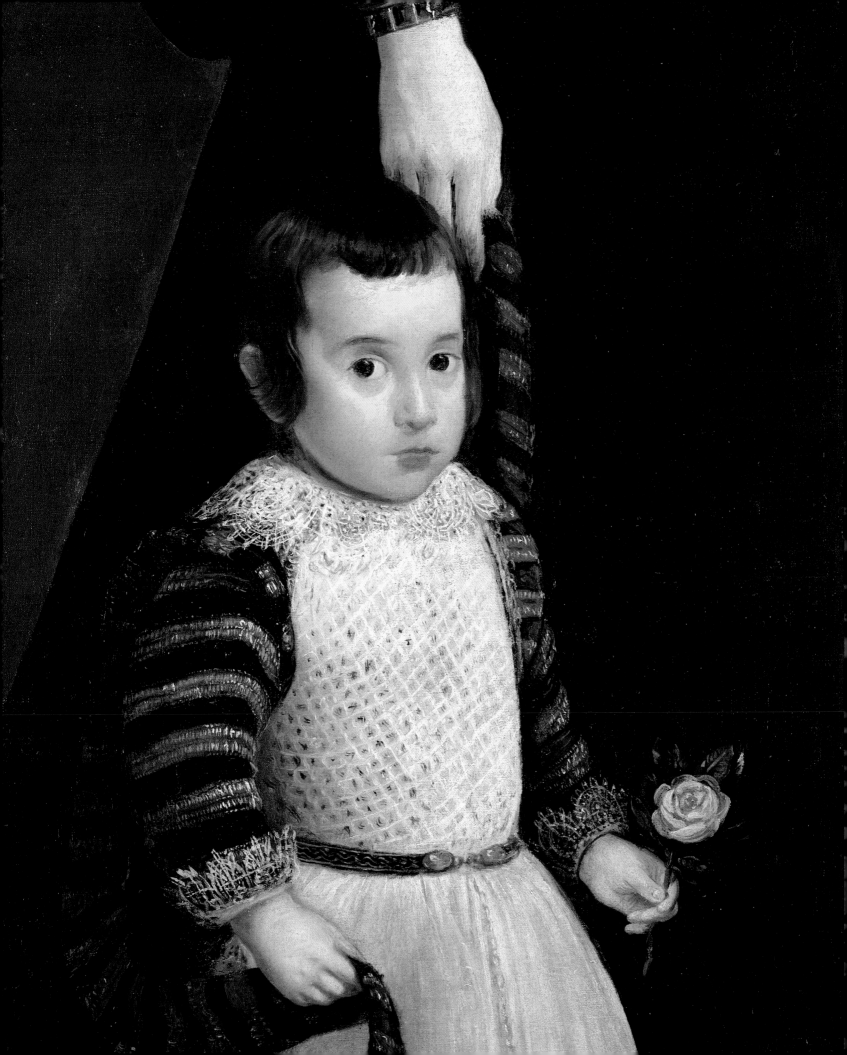

The Holy Family

Bartolomé Esteban Murillo

(Seville, 1618–1682)

Oil on canvas, 144 × 188 cm

Museo del Prado, Madrid

During the 20th century, Murillo was considered the painter of sugary religious scenes only worth illustrating souvenir cards for first communions. They ended as page-markers in missals left to gather dust in a forgotten drawer.

One must give back to Bartolomé Murillo the place he deserves in the history of painting. Family is everything to him; it is sacred and there is no need of a halo to sanctify it. Holiness has to be found elsewhere. One finds it in the rhythm of ample and fluid shapes revived by a warm combination of ochres contrasting with the purity of the whites. Holiness is in the Virgin's tender and indulgent eye while she gazes at Jesus. The little dog is all excited by the prospect of being given the bird held tight in the Child's hand, but the naughty boy is only teasing him and has no intention of letting go. Holiness is love and protection offered by a Father melting in front of his Child.

Murillo makes us dream of a harmonious home, where little things become great moments of tenderness, which seal the love between parents and children.

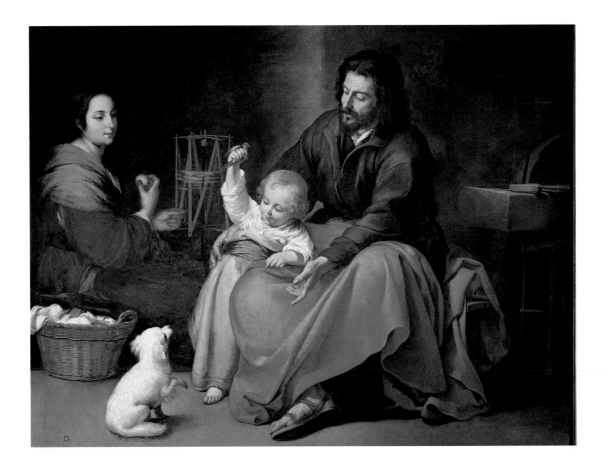

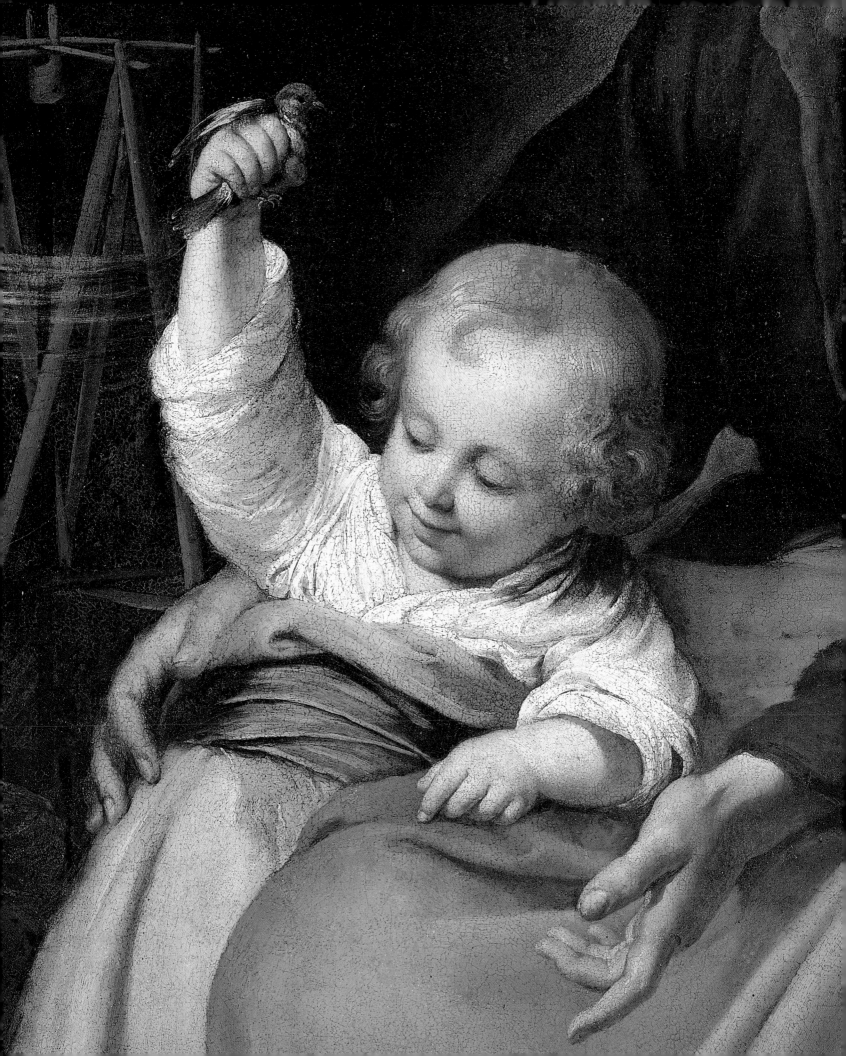

The Pie Eaters

1662–72
Bartolomé Esteban Murillo
(Seville, 1618–1682)
Oil on canvas, 146 × 104 cm
Alte Pinakothek, Munich

*D*ressed in dirty rags, these two boys eat a pie with their fingers, which will be followed by a crusty loaf of bread and fruits ripened in the sun. These poor children are feasting, filling up their bellies, and their dog patiently waits to join in. Bartolomé Murillo paints poverty without misery, and this picture is the illustration of Oscar Wilde's later observation: "It is hard enough to be poor, if on top on that one should abstain!"

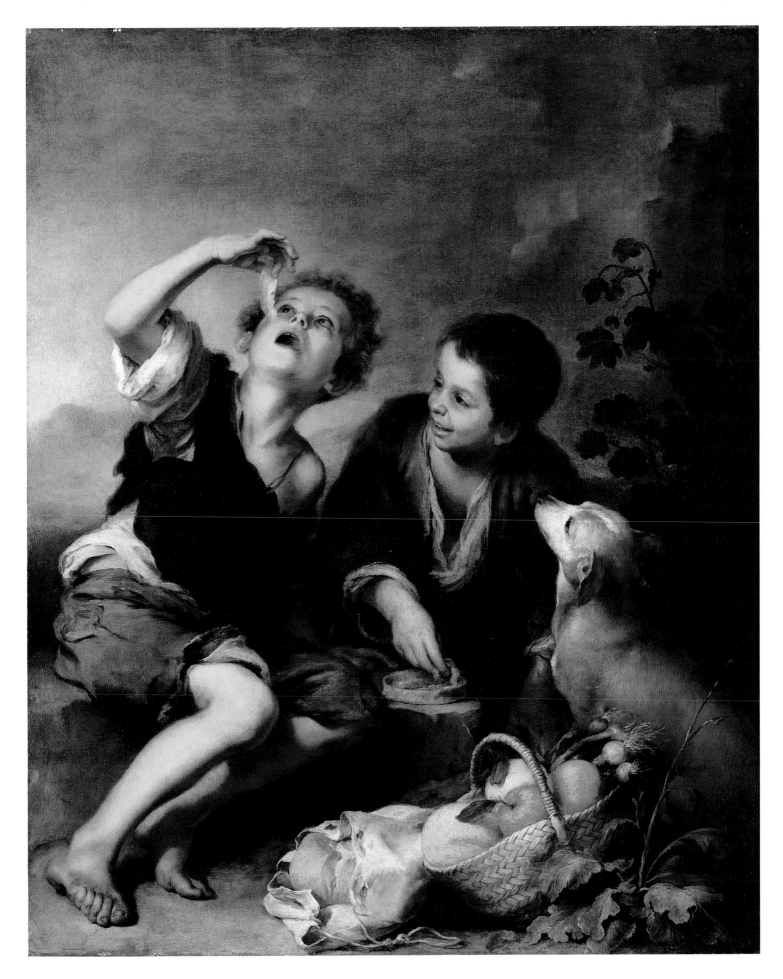

The Duke of Osuna and His Family

1788

Francisco Goya y Lucientes

(Fuendetodos, Zaragoza, 1746 – Bordeaux, 1828)

Oil on canvas, 225 × 174 cm

Museo del Prado, Madrid

Goya's art is complex, disconcerting and violent. He can be under the charm of *The Countess of Chinchón* or become a scandalous *voyeur* in front of his *Maja*. He is religious in *The Holy Family* and bursts out violently in *The Third of May*. The king and the aristocrats claim his services and he responds by painting their portraits without complacency. The artist throws himself again into the horrors of the civil war, dips his brushes in blood and brandishes them as the standards of a crescendo of violence against the person he calls "the tyrant of Europe". Goya pulls to pieces academism and rejects the classic rules. He paints hideousness, vulgarity, blood and makes them correspond, with no scruples whatsoever, to force, vitality and brutality. This genius achieves a masterly result: he proves that ugliness is beautiful and that horror serves greatness. Picasso understood this but never pulled it off.

Goya's art excels when depicting muslin, transparencies or anything light and vaporous. His brushes vibrate under the countess's skirts, flutter in the lace, dance in the hair, leave a few hairs on the dog, but come to a halt in front of the four children. All red-haired, they open wide their eight golden eyes, which light up their ivory-like complexion. The little sweetheart sitting on his cushion has particularly attracted the attention of the artist, who did not dare to remove his favourite carriage from his hands. This little Pedro de Alcantara later became one of the first directors of the Prado museum: good foresight for a painter, who will be one of the pillars of this temple of Spanish painting!

Face to face with this angel, the tormented and violent artist becomes the most beautiful mirror where all his tenderness is reflected: he is under the spell of the gentle innocence of early childhood.

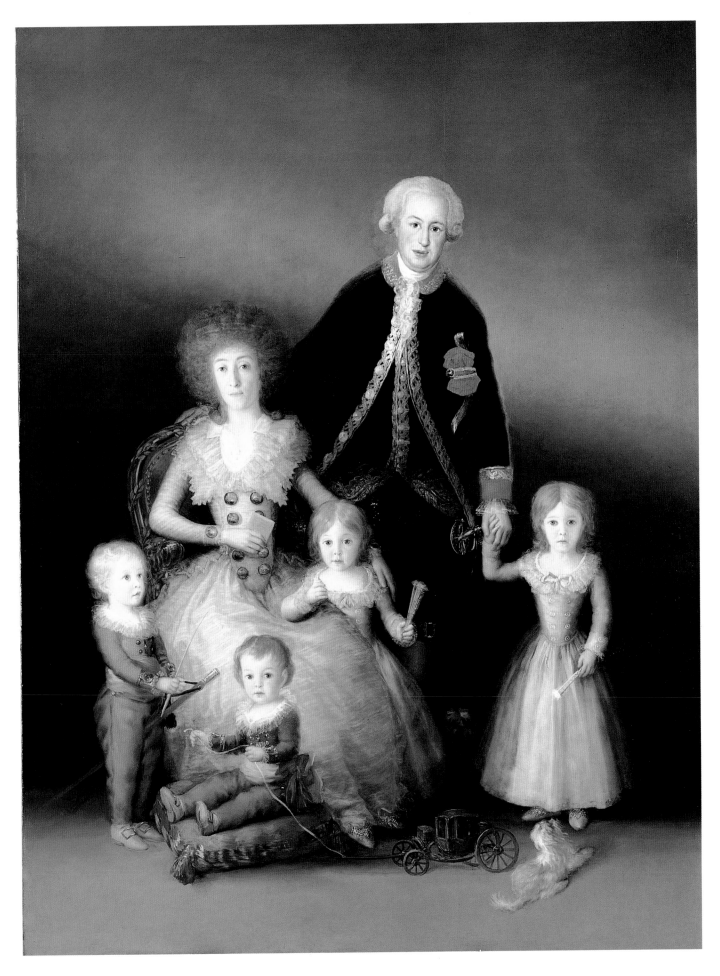

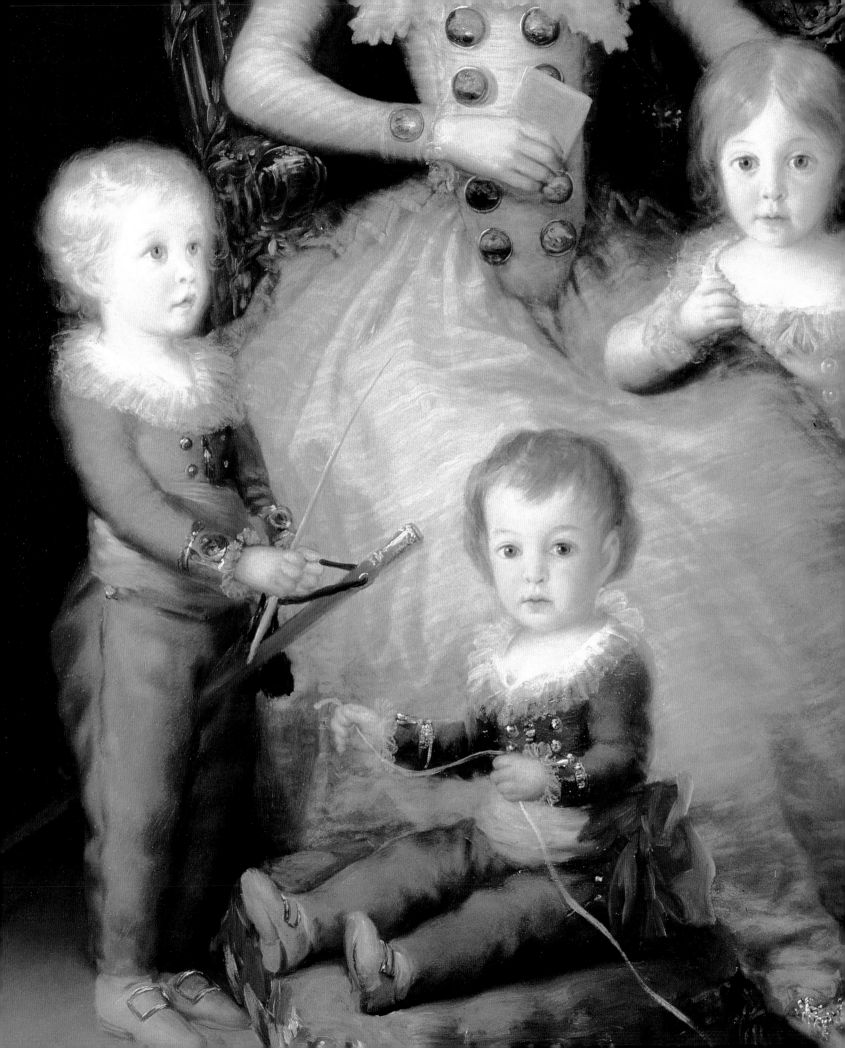

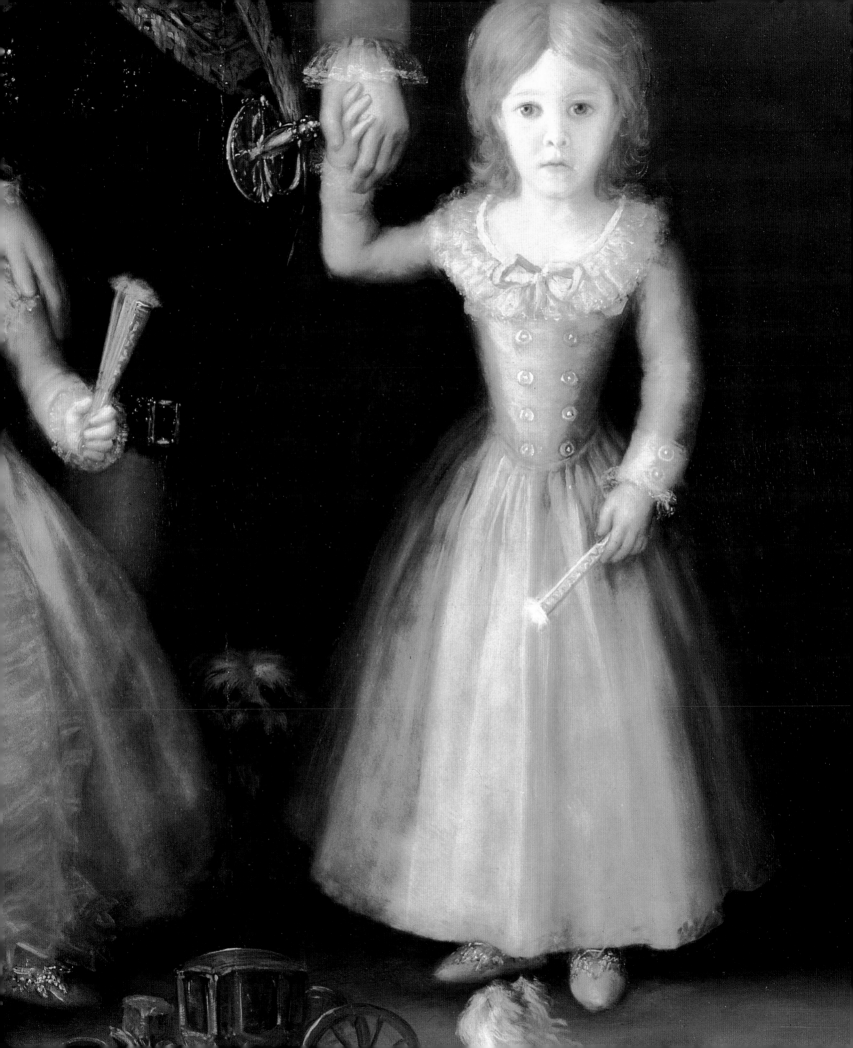

The Countess of Chinchón

1783

Francisco Goya y Lucientes

(Fuendetodos, Zaragoza, 1746 – Bordeaux, 1828)

Oil on canvas, 134.7 × 117.5 cm

National Gallery of Art, Washington

*G*oya is the official painter of the Spanish court and the commissions are so numerous that he cannot rest. His patrons are very generous but he does not flatter them. After his stroke in 1792, which left him deaf and nervously fragile, the artist seems to have lost all his goodness, his sympathy and his gentleness. The lovely Countess of Chinchón with her innocence and purity seems the only one able to touch him and make him forget his harsh cynicism for the duration of the sitting. He opens his heart and lets the tenderness flow out for María Teresa Vallabriga de Borbón.

It is during his stay at the palace of Arenas de San Pedro, in the province of Toledo, home of his patron Prince Don Luis de Borbón, that Goya paints the first portrait of the heiress. She poses like a Castillan doll, she is chubby and full of life, and she charms the man who sees it all. Her high forehead stretches over two black beads, two round eyes full of mischief. Her little nose shines like a marble, her round mouth opens up like a rose bud. Her lovely face, so open and so fair, is in total contrast to her little four-legged companion. His hairs are all ruffled and hide his eyes; he stares, he smells the artist, who depicts him so well. With only a few brushstrokes, the master captures the funny side of the little animal. The genius of the artist is able to express all the beauty and the happiness of this young pair.

Later on, life will be cruel to the lovely countess. Aged eighteen, she will be made to marry Manuel Godoy, her aunt's (Queen María Luisa) lover. This debauched Prince of Peace will humiliate her continuously, preferring to her beauty and youth, the ugliness and riches of the queen and others.

Goya will always be the tender admirer of the pure María Teresa: he will paint her again aged eighteen (Galleria degli Uffizi, Florence) and once more three years later (Museo del Prado, Madrid). These portraits are amongst the most extraordinary and the most moving that the artist has left us.

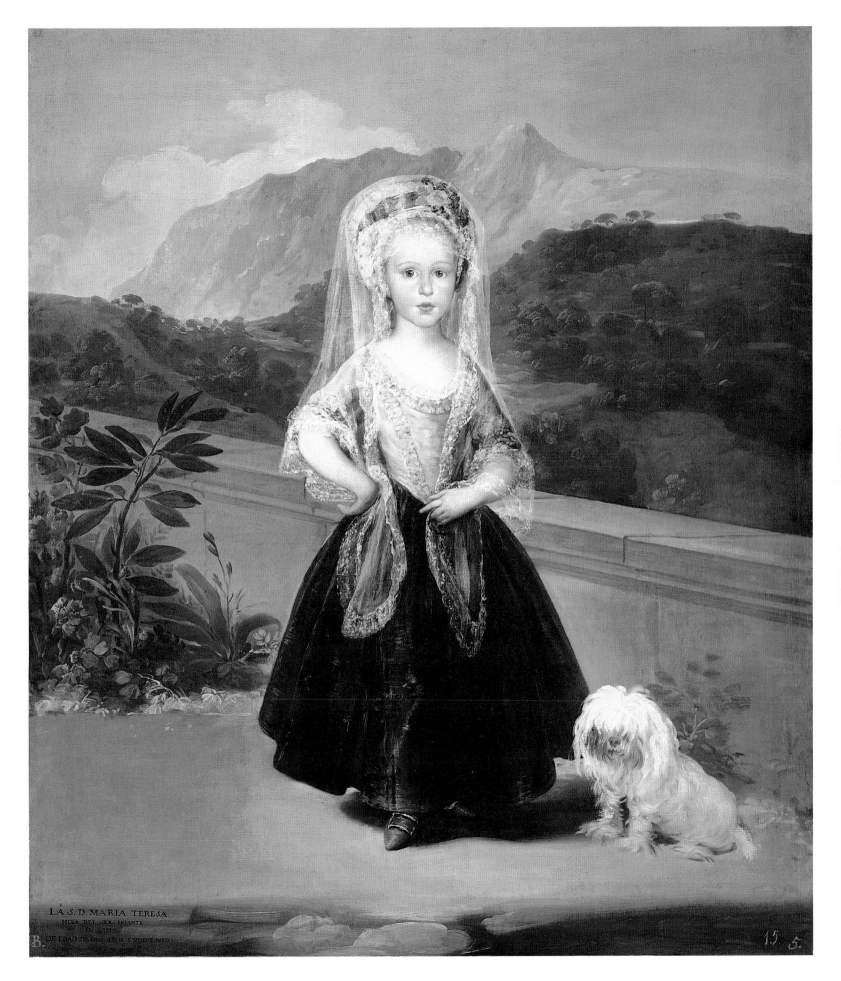

LA S. D. MARIA TERESA
HIXA DEL SR. INFANTE
D. LUIS
B. DE EDAD DE DOS AÑOS Y NUEVE MESES

15 5.

Children on the Beach
1910
Joaquín Sorolla
(Valencia, 1863 – Carcadilla, 1923)
Oil on canvas, 118 × 185 cm
Museo del Prado, Madrid

*J*oaquín Sorolla is a happy painter; happy to paint, to live from his art and to live in a beautiful house surrounded by his family. At last, an artist free of problems and gifted with happiness. His art shows that it is not necessary to be mad, deformed or misanthrope to have talent and genius.

His colours are joyful. His brushstrokes are endlessly lying in the warm sand, surfing in the waves and splashing the bodies of young children. He wets them and covers them with a varnish that will protect them from the sun.

Sorolla sees *la vie en rose*, in purple, blue and yellow. He floods his torrid art with coolness, which is the most convincing publicity for happiness.

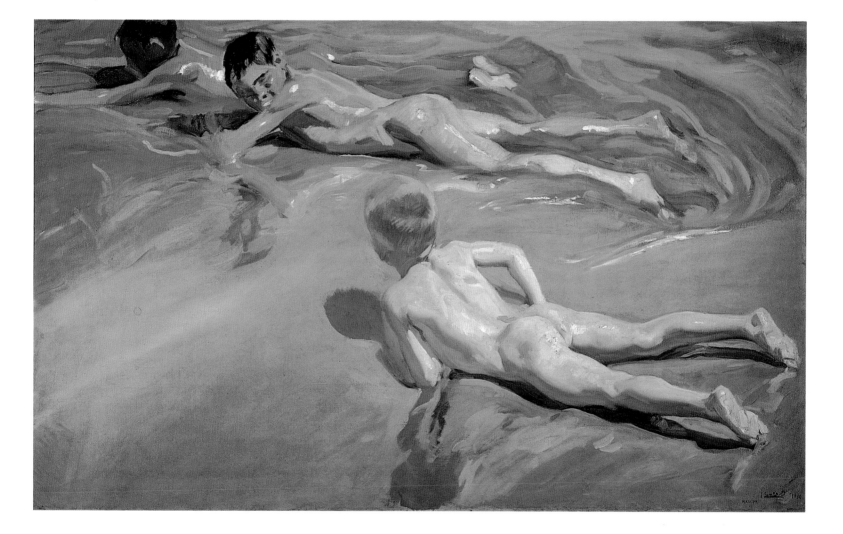

First Communion

1896
Pablo Picasso
(Malaga, 1881 – Mougins, 1973)
Oil on canvas, 166 × 118 cm
Museu Picasso, Barcelona

*I*t is a fifteen-year-old adolescent who paints this picture. His father, painter and drawing master, moves to La Coruña in 1892. He teaches at the La Guarda art school and signs up his son for lessons there. The pupil's apprenticeship follows all the steps of the strict classical school.

To draw is to have the intelligence to understand shape, to bring it to life and to give it character and yet to represent it exactly. This discipline requires modesty and a permanent recognition of one's own weaknesses; it must be worked at continuously because the art of drawing is never granted. The 21st century teases and rejects academism, but this is due to ignorance: one can understand the essence of this belief, but it should not apply to the actual execution and its rules. Even rejecting academism artists need a vocabulary and a grammar to express their personality.

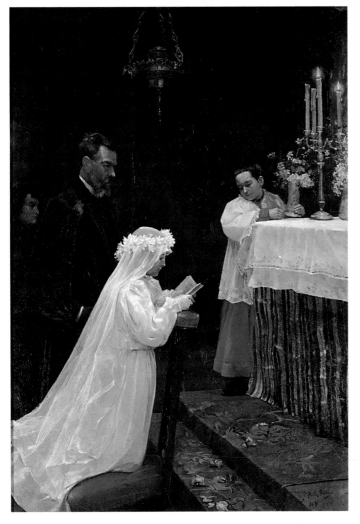

Picasso is a deformed academic but still is an academic. He knows shapes by heart and reproduces them with brio. He draws a figure or articulates a hand faultlessy: his potential is unlimited. But still he tires and tortures bodies before eventually killing them.

This young girl belongs to a youth and an education, on which the future master is still dependent. The picture is religious and calm, the rules are well applied and if the colours are uninspired, the white is sufficiently luminous for the celebration not to turn into a funeral.

This was when the sacred monster was still tame…

Paul Drawing

1923
Pablo Picasso
(Malaga, 1881 – Mougins, 1973)
Oil on canvas, 130 × 97.5 cm
Musée Picasso, Paris

*I*n this picture, the young Paul is still sheltered from the great temper and the harsh treatment inflicted by his famous father.

The child is attentive and concentrated on his scribbling. His father does not expect him to have inherited his talent. The artist fixes his son on his canvas, he screws him to his chair, and the table pinches his ribs. Two overly bright red bandages cut his feet. The face of the young Paul is cleaned and then slurred by the brushes of a tyrant who only leaves him the dim hope of escaping towards the blue sky with his toy dog.

Alas, he is prisoner of the artist, prisoner of his art!

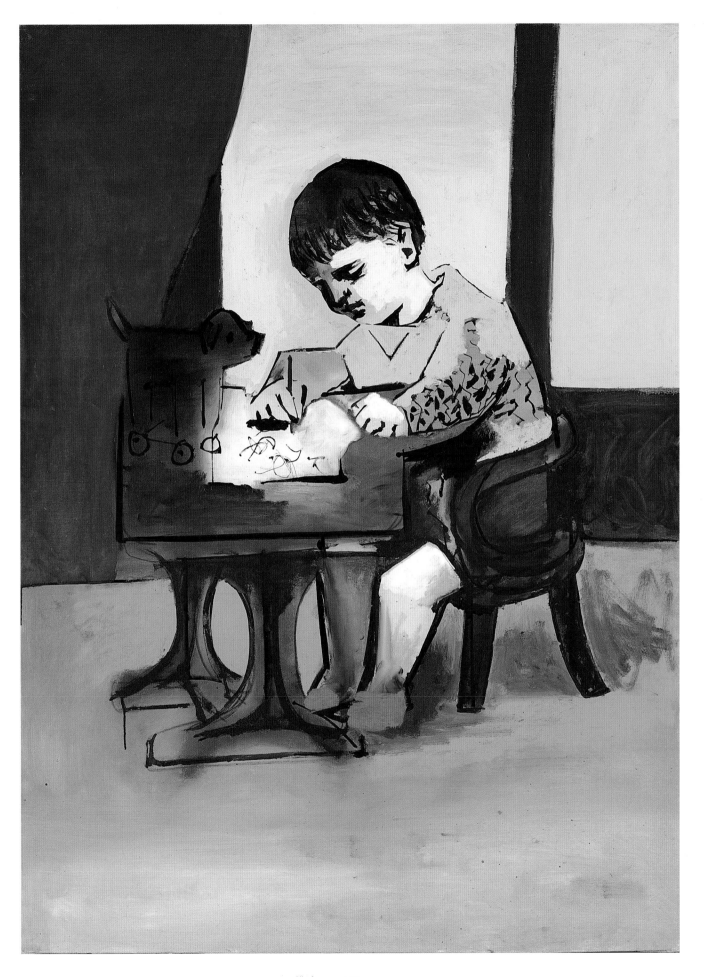

English Painting

Conversation at Ashdon House
Arthur Devis
(Preston, 1711 – London, 1787)
Oil on canvas, 195.6 × 138.5 cm
National Gallery of Art, Washington

*A*rthur Devis was a modest provincial painter. In 1742, he decided to try his luck in London. He became the favourite painter of the middle class and of the lower ranks of aristocracy. They all commissioned him conversation pieces.

This conversation takes place at Ashdon House between two brothers and their younger sister. The two boys have just swum in the river and are getting dressed. The younger one is still naked and slowly pulls up a sock while the elder one, more modest, finishes buttoning up his jacket. Meanwhile, their little sister is taking her time: she is just undoing her dress and has not decided yet to follow the sporty example of her brothers.

The parents have left the children in the good care of the artist and he will return them safe and sound.

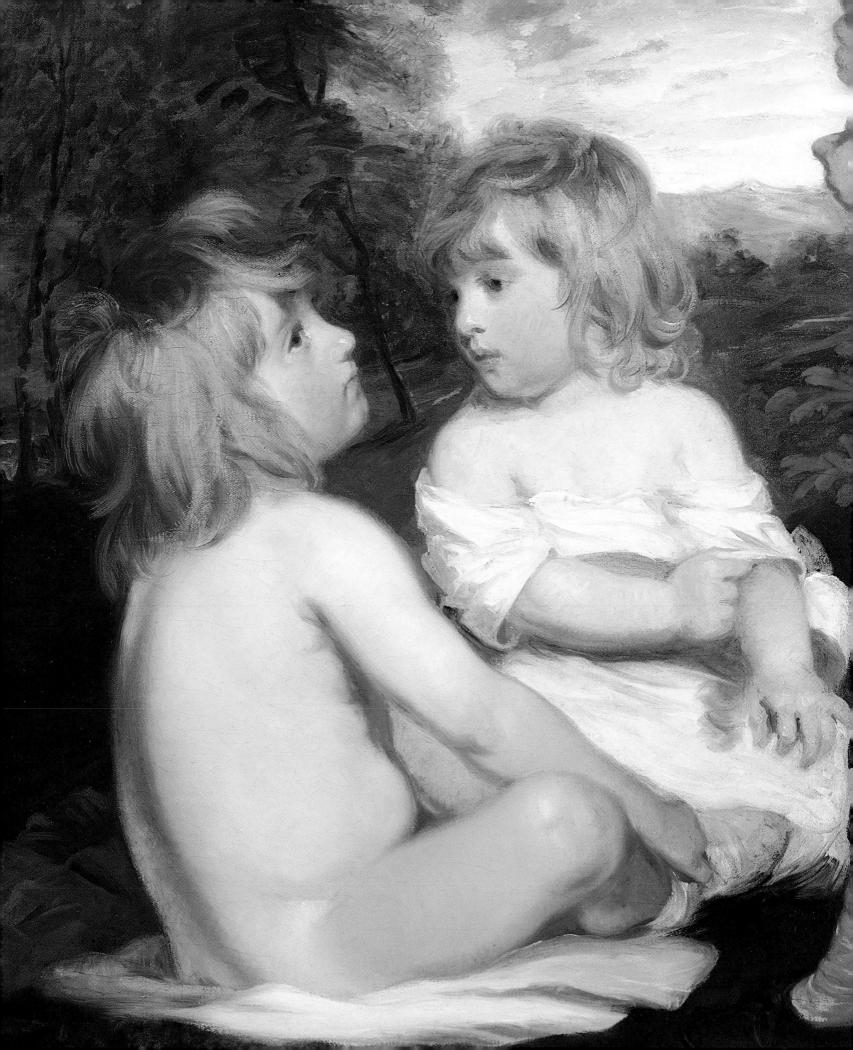

Lady Caroline Howard

1778
Sir Joshua Reynolds
(Plympton, Devonshire, 1723 – London, 1792)
Oil on canvas, 143 × 113 cm
National Gallery of Art, Washington

Aged twenty-seven, Joshua Reynolds left Great Britain for Italy, where for two years he was to study the "great style". Back in London, he quickly understood that he must enlarge his social circle if he was to make a living from his painting. He found his clientele in various classes of a society undergoing profound change. Not only aristocrats, but also navy officers and intellectuals posed for him. He became famous and was to be the first president of the Royal Academy. His fifteen *Discourses* signalled revolutionary ideas, which are difficult to make out in his art.

Against a close sky, Lady Caroline Howard is melancholic. She sits in a badly painted landscape and stupidly picks a crumpled rose from a bush growing in a shapeless and dirty pot. The artist has thankfully taken more care with the black silk of the cape. The reflections are beautiful and the folds open gracefully onto the dress.

This portrait is acceptable, yes, but is it beautiful? No. Beauty is more demanding and Reynolds cannot give it what it needs: genius.

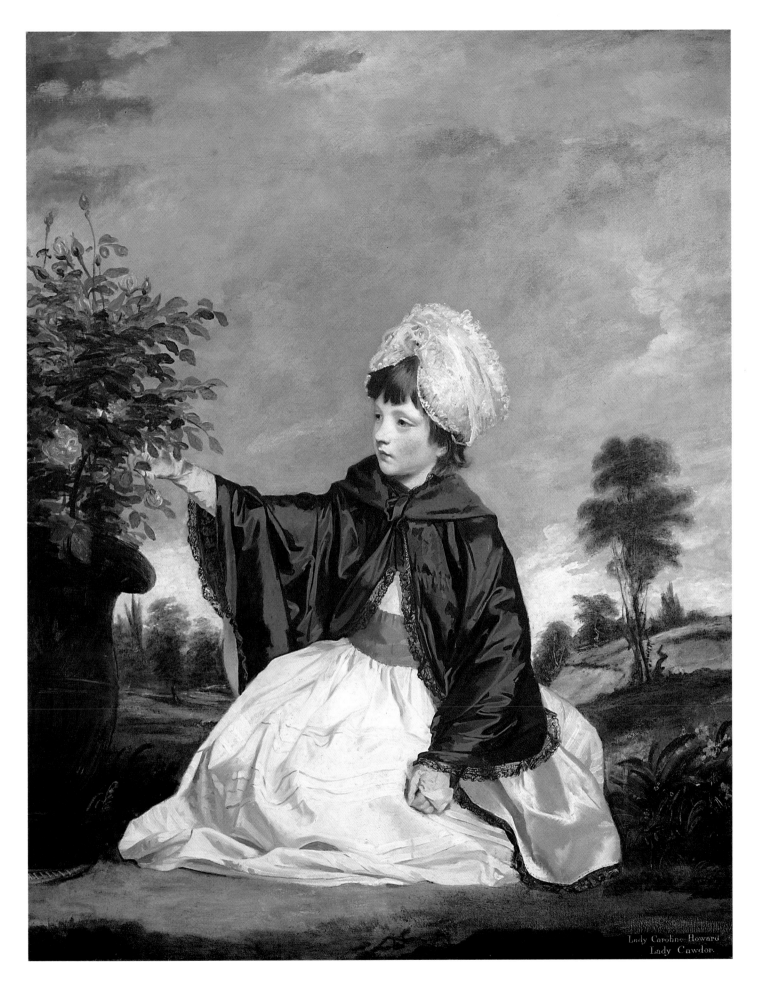

Lady Caroline Howard
Lady Cawdor.

John Heatcote

1770–74

Thomas Gainsborough

(Sudbury, Suffolk, 1727 – London, 1788)

Oil on canvas, 127 × 101.2 cm

National Gallery of Art, Washington

The English people like nature, they love their landscapes where they design and plant the most fabulous gardens. It is an art where the violet and the oak are both the object of meticulous love and devotion. Landscapers, gardeners and horticulturists create a multicolour vegetal world, which they plant around velvety lawns, so green that the foreign visitor is livid with envy. Thomas Gainsborough loves landscapes and wishes to paint them, but portraits are more profitable and he happily takes to their art form. He is a fine man and takes his work, which he enjoys, seriously. His heroism is not in his art but in his daily life, where he has to bear a wife who has never got over being the natural daughter of the Count of Bedford. Crabbed, mean and miserly, she harasses her husband, who, nonetheless, provides her a very comfortable life.

John Heatcote is quite determined to look straight in the eyes of the artist, who is, just as the little poser, full of mischievousness. Gainsborough is annoyed by his feminine attire and does not take much care when painting it. He is disappointed that the little boy is not wearing trousers, which would have made him much more touching.

This is an example of a ridiculous fashion, which condemns virility: virility does not like ambiguity.

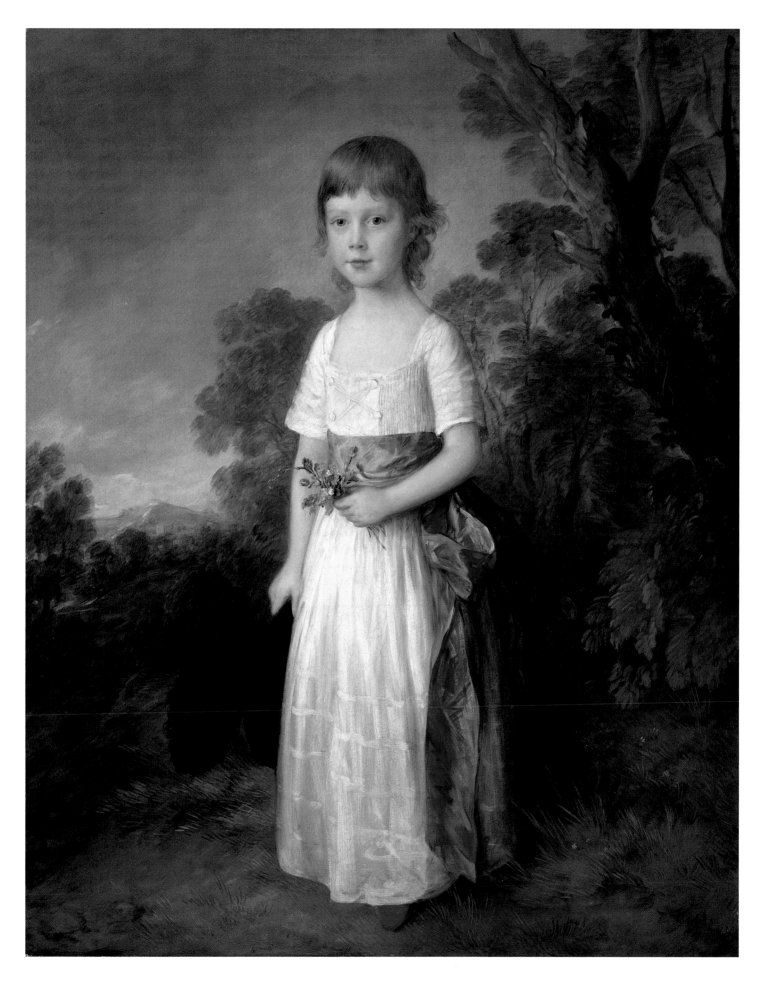

Philosopher Giving a Lesson
on a Table Planetarium

1764–66
Wright of Derby
(Derby, 1734–1797)
Oil on canvas, 147.3 × 203.2 cm
Derby Museum and Art Gallery, Derby

The 18th century was marked in England by the Enlightment, a period of great scientific discoveries and of the beginning of the Industrial Revolution. The Luna Society was an institution, a club where the most eminent intellectual figures of the country met. The famous members of the prestigious society included James Watt, inventor of the steam-engine, Josiah Wedgwood who discovered a new manner to produce his very beautiful china, the astronomer James Ferguson and finally the great philosopher, mathematician and physicist Isaac Newton.

Son of a solicitor, Joseph Wright is a member of the gentry, which contributed to the advance of industrialization and helped the United Kingdom to become the leading economic and political power of the time.

Science is the purpose of this painting and the artist helps us to understand it. The protagonist is an "orrery", named after his inventor, the Count of Orrery, who had financed its construction at the beginning of the 18th century. This planetarium reproduces the journey of the planets around the Sun. One can distinguish clearly the Earth, the moon and Saturn with its rings. The great philosopher in his red robe looks amazingly like Isaac Newton. He dominates the other participants and explains the orbits of the planets. The artist draws the light on the two affectionate children: the little girl passes a protective arm around the little boy's neck. Both fascinated, they try to understand the movements of the planets by looking through the celestial machine.

These experiments are a wonderful learning experience where young children can understand even very complex things if they are presented adequately. Thanks to this method, the English universities have become models for tuition. Wright's art recognizes their work.

John Tait and His Grandson
1793
Sir Henry Raeburn
(Stockbridge, 1756 – Edinburgh, 1823)
Oil on canvas, 126 × 100 cm
National Gallery of Art, Washington

May the Scots forgive me for allowing Sir Henry to mix with the English painters, but let us assume that art does not recognize the frontiers between the country of "tea time" and the one of "malt whiskey".

Henry Raeburn was the portraitist of Edinburgh's high society. His style was inspired by Reynolds'. He represented kindly the faces of his customers, whose only requirement was to be advantageously depicted for posterity.

John Tait was a satisfied man: satisfied with his life and with what he has achieved. Obediently, Raeburn painted him as he wished. The old man died before the picture was completed and before his grandson has had time to pose with him. For a bit more money, the artist agreed to include the child in the picture. Unfortunately, it is noticeable. If the rules of anatomy were respected, the grandfather's left hand could not lie where it has been painted. It falls shapelessly on the oversized hand of his heir. Meanwhile, the child has to lift his arm like a ballerina and shake some sort of a rattle. This picture is as pleasant as it is inconsistent, and peace be to the mediocre art of Sir Henry Raeburn!

Child Gardeners

1807

Sir Thomas Lawrence

(Bristol, 1769 – London, 1830)

Oil on canvas, 184 × 149 cm

Gemäldegalerie, Berlin

This artist was precocious; he painted watercolours at the age of eleven in Bristol, Oxford and Bath. He continued his formation in London in the highly prestigious Royal Academy. Very soon, Thomas Lawrence became famous and succeeded Joshua Reynolds. The Waterloo Chamber in Windsor Castle contains series of his portraits of kings and queens, princes and generals, all of them allies of Britain during the Napoleonic Wars.

Why are these four young gardeners not in a beautiful English garden by daylight? The painter invents an evening representation in a theatre where the protagonists act a comedy entitled: "Chubby baby and her spade". The little girl has red cheeks thanks to the effort she makes to dig a hole with a tool too big for her. Her elder sister comes to the rescue while her brother proudly sweeps the ground. Another lovely sister admires him but is not interested in the play. The spade will probably bring the little girl to the ground where she will cry of frustration… and so farewell to Sir Thomas and his art!

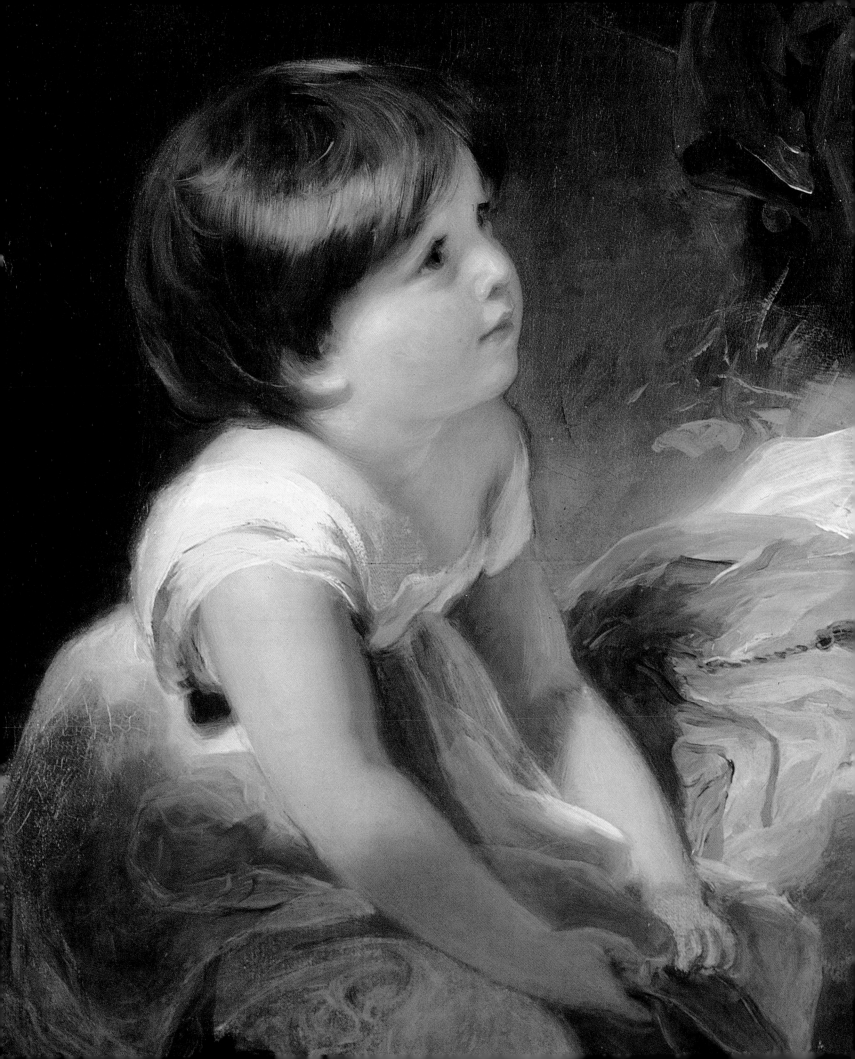

American Painting

The Copley Family

John Singleton Copley
(Boston, 1738–1815)
Oil on canvas, 184.4 × 229.7 cm
National Gallery of Art, Washington

Three generations are crammed together in this picture. The father of Mrs Copley, Richard Clark, his daughter, his son-in-law and his four grandchildren. All of them have a comfortable life in Boston not only thanks to Mr Clark's fortune but also to his son-in-law's, whose painting has been very successful with New England's select society.

The grandfather is not moved by the sweet laughter of his granddaughter, but neither do father and mother seem touched by the many cuddles their children give them. The eldest, better behaved and serious, poses for her father, who stands at the back of the composition.

Thanks to the bustle created by the children, we are not asphyxiated by the stiff conservatism of John Copley's art.

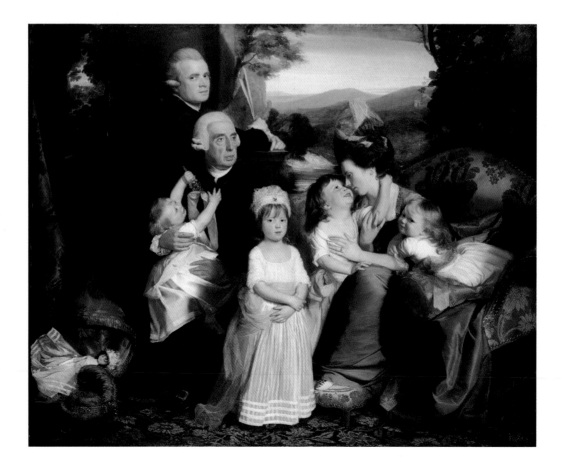

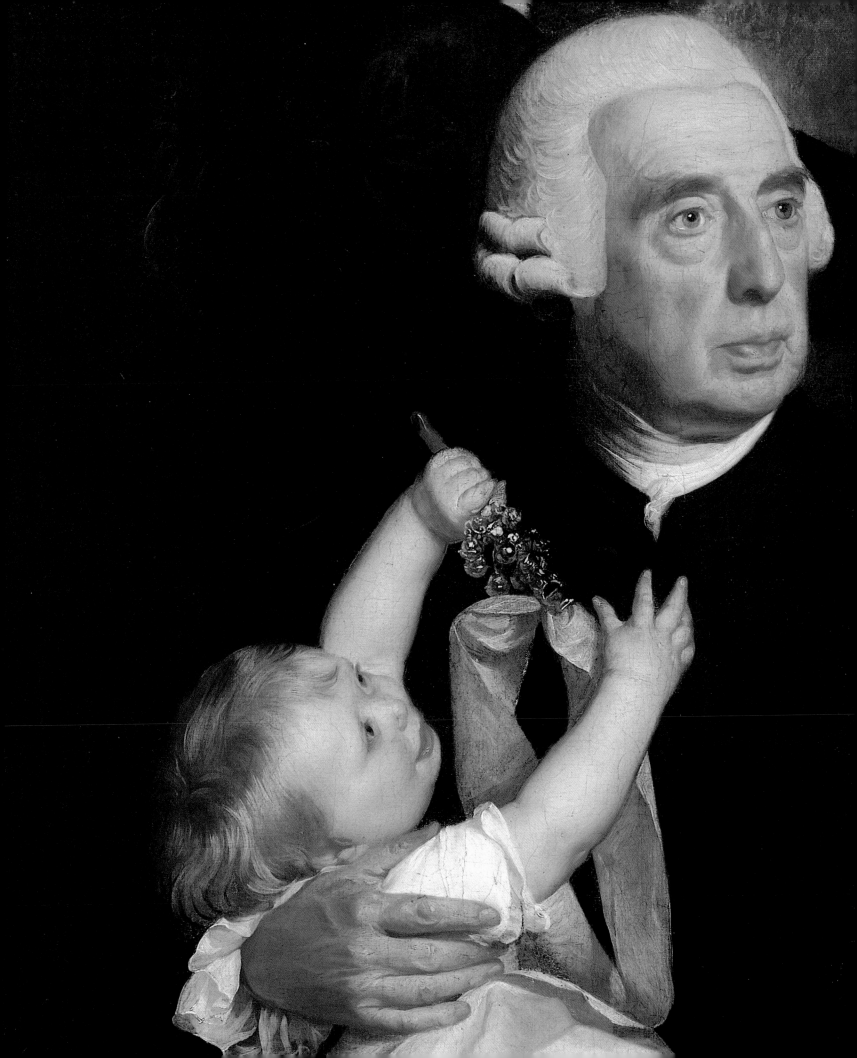

Baby Playing

1876
Thomas Eakins
(Philadelphia, 1844–1916)
Oil on canvas, 81.9 × 122.9 cm
National Gallery of Art, Washington

A young child playing must not be disturbed. His imagination transports him to a world of dreams, of reflexion and of freedom, where he can experiment with his own limited means. He or she amuses him or herself with building or pulling down a castle, with driving a car, with dressing or undressing a doll. As they grow up, everything becomes more complicated because games now involve other people. There is then a winner and a loser. One exults and the other sulks: claiming unfairness, he threatens and even hits his opponent. More than anything, he is unhappy to have lost, but this is the educative role of play. The adult continues to play, to win, to cheat, to lose and so on, until the end of his life.

Young children spend most of their time discovering. Thomas Eakins observes a baby fully concentrated on his wooden blocks. The painted letters intrigue him but he is too young to make anything of them yet. He uses his toy horse and carriage to transport his blocks and builds two superposed arches: a technical feat of which he is unaware.

Thomas Eakins is a very good observer. Sensitive, he catches the precious moments of childhood, which will fly away. The message and the technique of his painting are simple and clear: these are two essential qualities of his art.

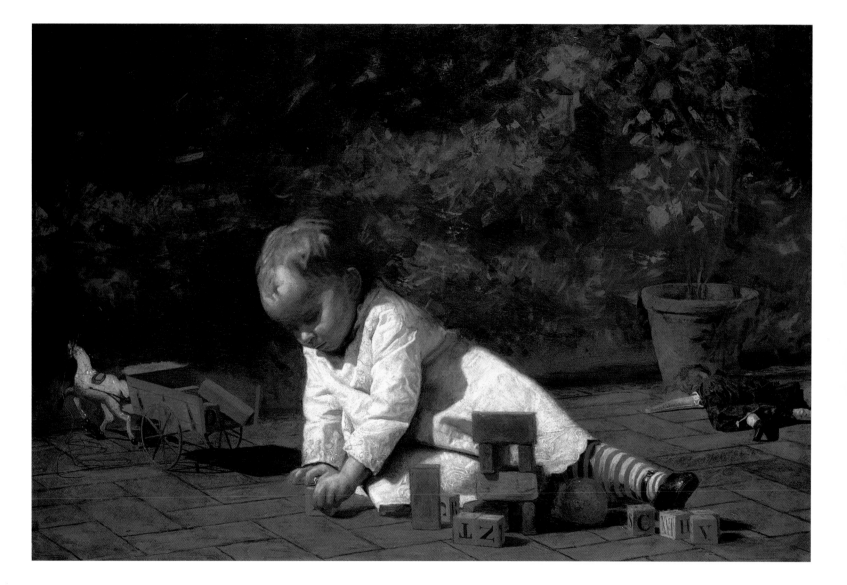

Two Children on the Beach

Mary Cassatt

(Pittsburgh, 1845 – Château de Beaufresne, Oise, 1926)
Oil on canvas, 98 × 74.5 cm
National Gallery of Art, Washington

*M*ary Cassatt came to Paris to complete her apprenticeship. Her great friend Edgar Degas discovered her painting and made her join the Impressionists' group. She participated in their exhibitions and became well-known. Her success increasing, she exhibited in Chicago and New York, and became an excellent business woman. In the United States, Mary organized a distribution network for European painting and gave sound advice to the great American collectionists. With her fortune made, she returned to France, in her castle at Beaufresne, where she died.

Contrary to what people usually think, Impressionist painting is conventional and Mary Cassatt's art does not escape this connotation. She is gifted, she does her job well but her eye is not revolutionary. These two little chubby girls playing in the sand with their buckets and spades are touching, but this is no more than a charming anecdote. It is pleasant, but one would expect more…

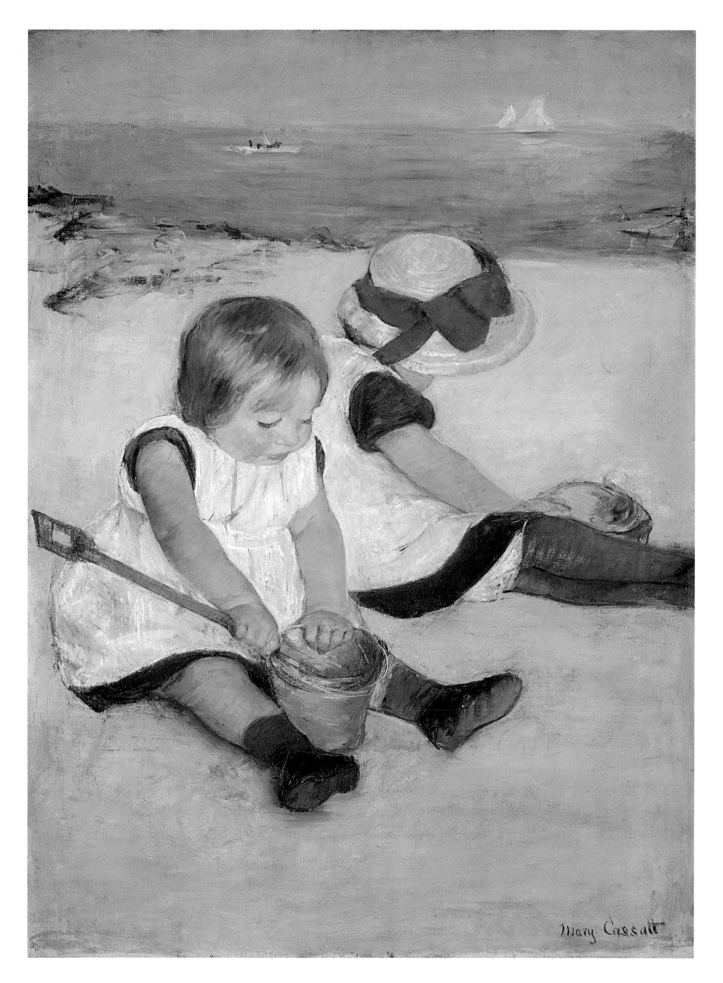

Catharine

1913

Robert Henri

(Cincinnati, Ohio, 1865 – New York, 1929)

Oil on canvas, 61.3 × 51 cm

National Gallery of Art, Washington

At the end of the 19th century and at the beginning of the 20th century, Paris was "the" cultural centre of the world. Fashions were made and unmade. No artist resisted the attraction of the brilliant capital where ideas took shape before being admitted and recognized. Like all the others, Robert Henri left his native Ohio to come and follow the lessons of the Julian Academy. The Paris of painters welcomed him, but a few years later he broke free and returned to his home country. In New York, he created his own school. His energetic teaching was soon recognized and all the American artists met there.

Catharine is very attractive and the artist likes her rebellious attitude. Her clothes are an excuse for him to practice his rapid technique. On the other hand, he takes care when painting her face. The big black eyes of this little girl are beautiful and full of intelligence; they correspond to the willful, scarlet-red mouth.

This painting is beautiful, vivid and slightly unconventional just like the adorable model.

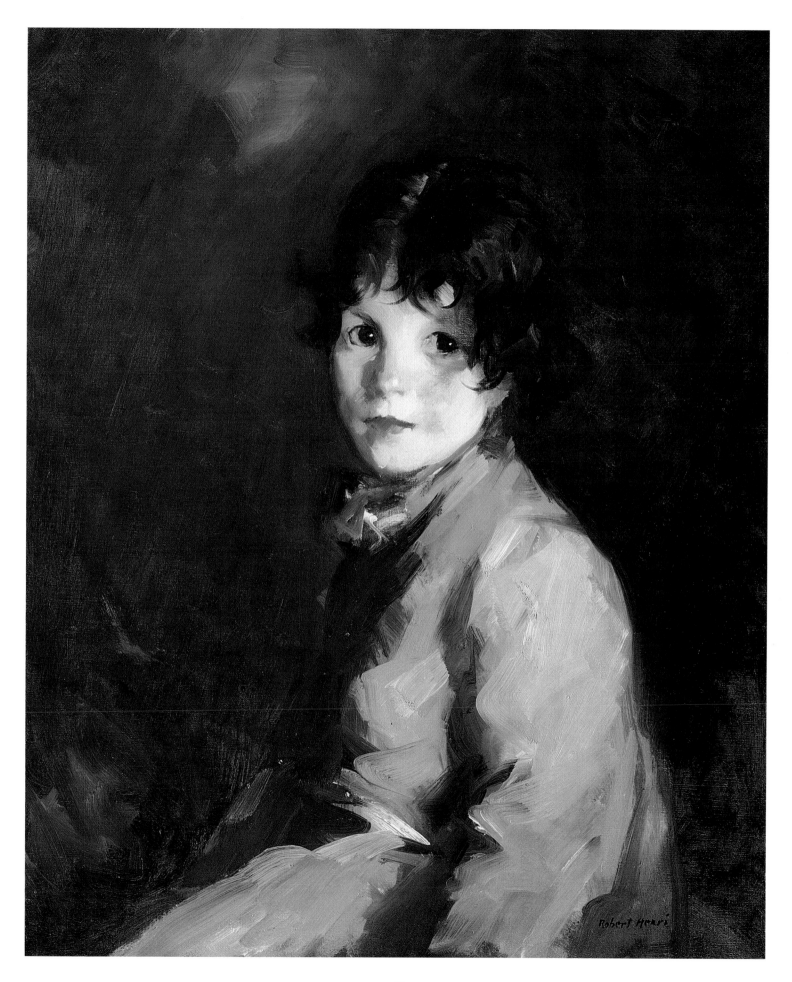

Swiss Painting

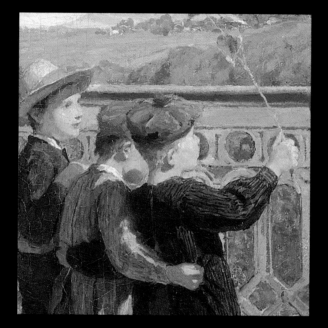

Bocion and His Family Fishing

1877

François Bocion

(Lausanne, 1828–1890)

Oil on canvas, 32 × 48.5 cm

Musée Cantonal des Beaux-Arts, Lausanne

Under the absurd assumption that happy nations have no history, Switzerland is reduced to be a secondary state, good enough to produce chocolate and cuckoo-clocks!

On the 1st August 1291, three men of the Uri, Schwytz and Unterwald valleys rebelled against the Habsburg domination and proclaimed their independence, founding the first European democratic confederation. It has been working as such for nearly eight centuries. It is an unchangeable system, on which all its political, legislative and judicial institutions rest.

The political lessons Switzerland can teach are many and are found in part of the French motto: Liberty and Equality. Jean-Jacques Rousseau, "father of the Revolution" and citizen of Geneva, defends these ideas vehemently and with courage. The philosopher was brought up in Geneva on the shores of the lake. He saw it again through Julie's eyes in *Julie or the New Heloise*: "The moment when, from the heights of the Jura, I discovered Lake Geneva, was a moment of ecstasy and ravishment. […] This unique scenery, the most beautiful that human eye can contemplate."

Lake Geneva is a passion, a need for its people. They never tire of contemplating it, of smelling it, of checking its level, of watching for its bursts of fury, of looking after its health and its beauty. They are the lovers of its shores and of its waters, where the sky, responsible for its temper, reflects itself. In rowing or sailing boats, they glide over its surface for hours. François Bocion is one of these bashful lovers of the lake, which is the inspiration for his art. His paintings are also a chronicle of the activity of the harbours of Ouchy and Vevey, where the tourists, who have arrived by steamer, are taken by carriage to the Lavaux.

The artist, like many other summer Sunday-afternoon wanderers, has gone fishing on the lake with all his family. Here, he paints the tranquil pleasures of such an afternoon. It is hot: a purple mist floats in the air and colours the mountains in the background. In one of the barges, Madame Bocion holds a fish by the tail, her son bends over the side of the boat to see if more fish are coming, and her charming daughter rests under the shade of her white hat. The artist, all proud in his Sunday attire, waits patiently for a fish to bite.

This picture has to be contemplated discreetly but with passion, just like the lake with which the artist is madly in love and ready to drown in, if necessary.

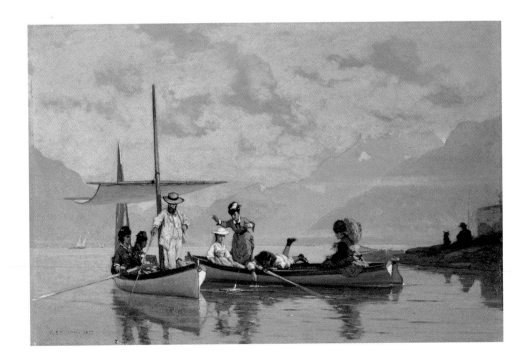

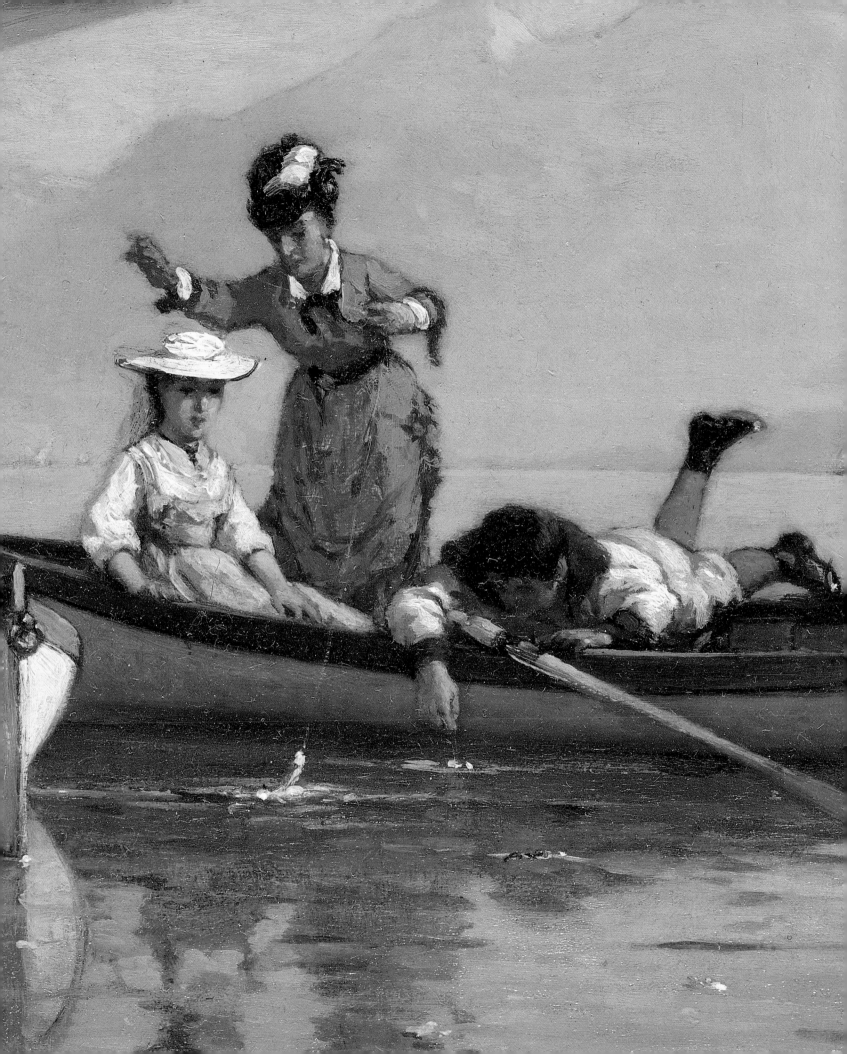

Sick Old Man and Fritz Gaschen
Reading to Him
1893
Albert Anker
(Anet, Canton of Bern, 1831 – Ins, 1910)
Oil on canvas, 63 × 92 cm
Kunstmuseum, Bern

The young reader is not being charitable nor is he doing duty. He is not making an obliging visit to a sick old man. The boy is reading a fascinating story to a grandfather comfortably arranged against soft pillows: he listens attentively, his handsome hands resting on the blanket. Generations meet: between them, a book, the link between youth eager to learn and maturity, which has learnt enough. The camomile tea will have to wait. This picture is an example to be followed by all grandchildren who love their grandparents.

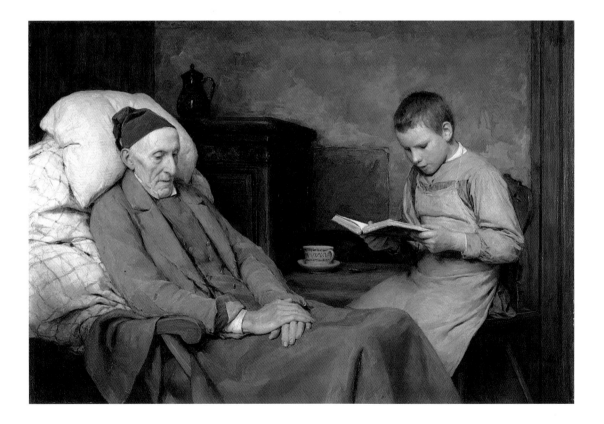

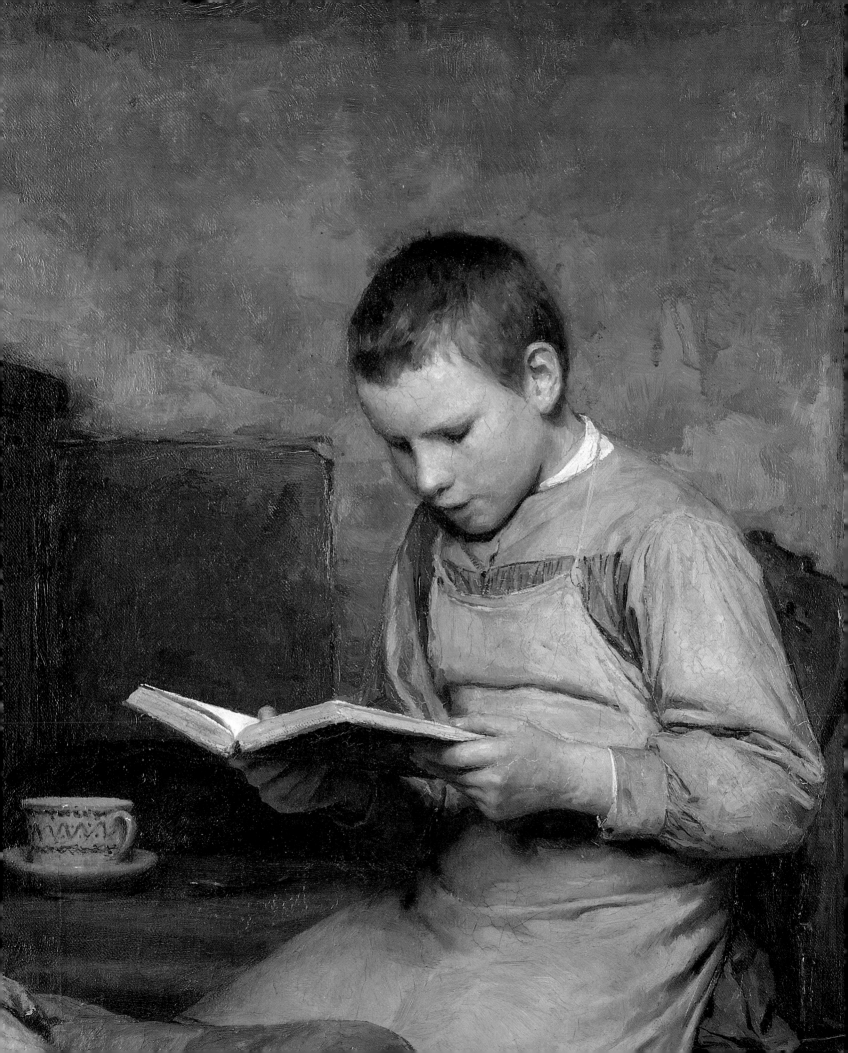

Promenade of the Nursery Children in Bern

1900
Albert Anker
(Anet, Canton of Bern, 1831 – Ins, 1910)
Oil on canvas, 76 × 127 cm
Kunstmuseum, Bern

Böcklin, Segantini, Hodler or Liotard are among the most renowned Swiss painters. Albert Anker is not interested in fame. He is an example of artistic honesty, of simple, true and deep love for his home country. His art reflects a loyal observation of a quiet world, a fraternal society lacking any sort of pretension. All his life, he paints effortlessly: he is solidity and honesty.

How can one not be moved by these free and happy children? How can one not be touched by the wrinkles of these good old people? How can one's mouth not water in front of his still lifes representing simple but generous meals? All these sensations arise from Anker's art and one cannot control them. The artist is a little master who is overwhelmed by a happiness, so simple, it is difficult for many to appreciate.

It is a warm and sunny summer day in Bern. The children have put on their straw hats and take a walk on the Kirchenfeld bridge, embossed with the town's crest: a brown bear, which before falling in the hole, lived in the thick forests surrounding Bern. The nanny pushes a wicker pram and the lovely procession follows the three jolly fellows in the lead.

Albert Anker's art is the beauty of the colours, the exactitude of the shapes; everything is simple, happy.

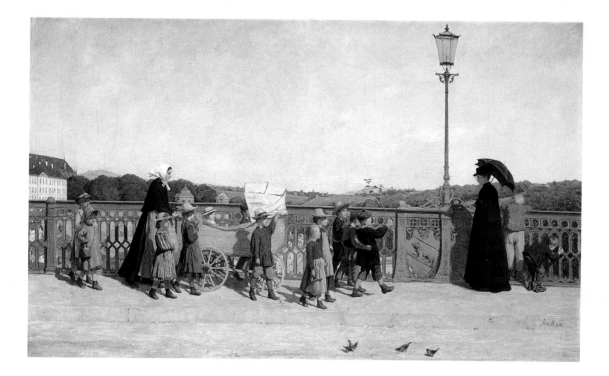

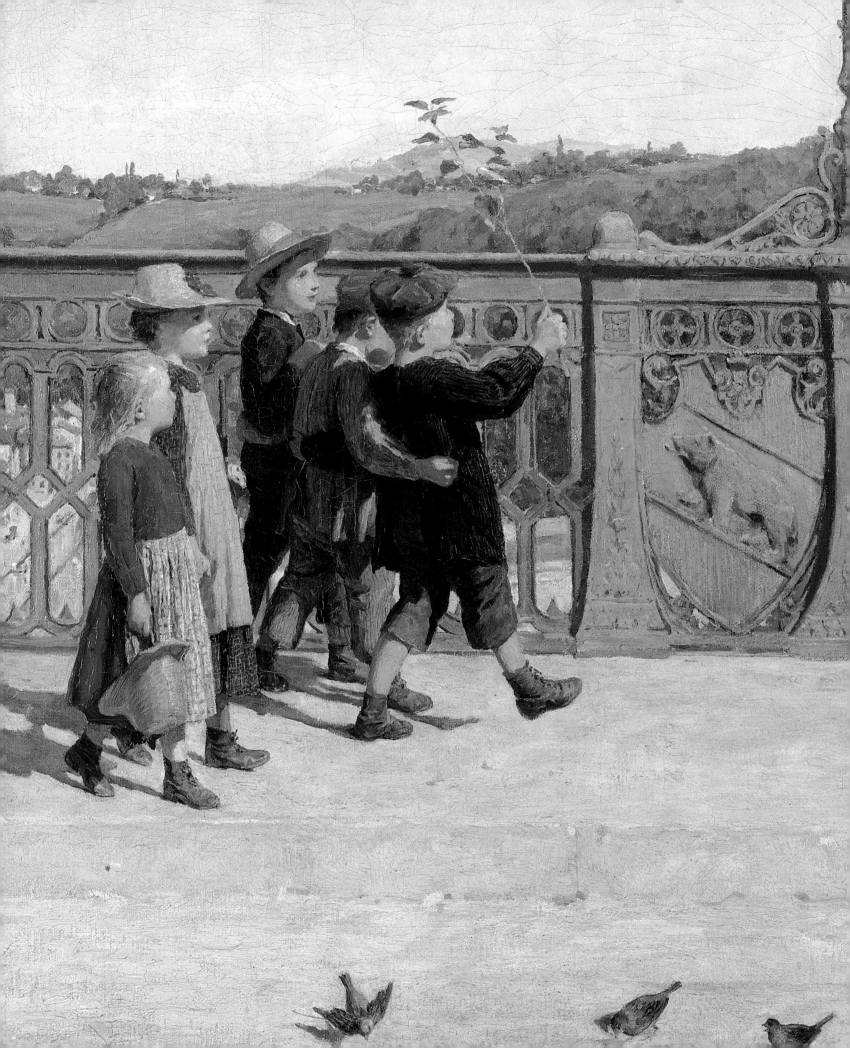

The Little Red Horse

Ernest Bieler

(Rolle, Canton of Vaud, 1863 – Lausanne, 1948)

Tempera on paper mounted on canvas, 92 × 68.2 cm

Musée Cantonal du Valais, Château Mercier, Sierre

There is the school of Barbizon and the school of Savièse. The first one is better known in the history of painting. Ernest Bieler founded the second one. Why was the artist so struck by Savièse, a small Valaisan village?

One Sunday after mass, the painter Raphael Ritz took Bieler to the little village of Savièse. All these peasants leaving church in their traditional costumes impressed the artist. He decided to establish himself there and to build a house and a workshop. Later, he became professor at the Ecole des Beaux-Arts in Geneva and received the French Légion d'Honneur. He invited all his artist-friends to Savièse and his workshop became the meeting point for his followers, all inspired by their master's art.

This picture is a perfect documentary of the *Valaisannes*: these strong women are accustomed to the harsh climate and the arduous work in the mountains. The young mother and her child have rosy cheeks from the fresh air. They wear their traditional costume but do not forget to put on the right shoes. The artist does not hesitate to depict a harmonious patchwork of checks, stripes and lace: all typical of the high valley of the Rhône, very proud of its traditions.

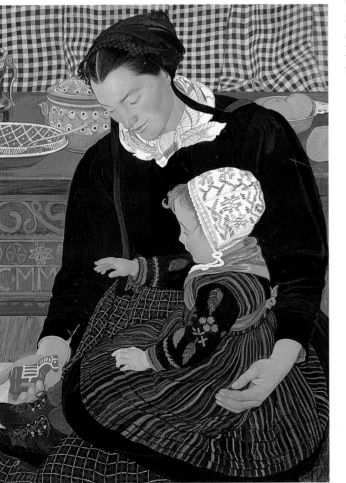

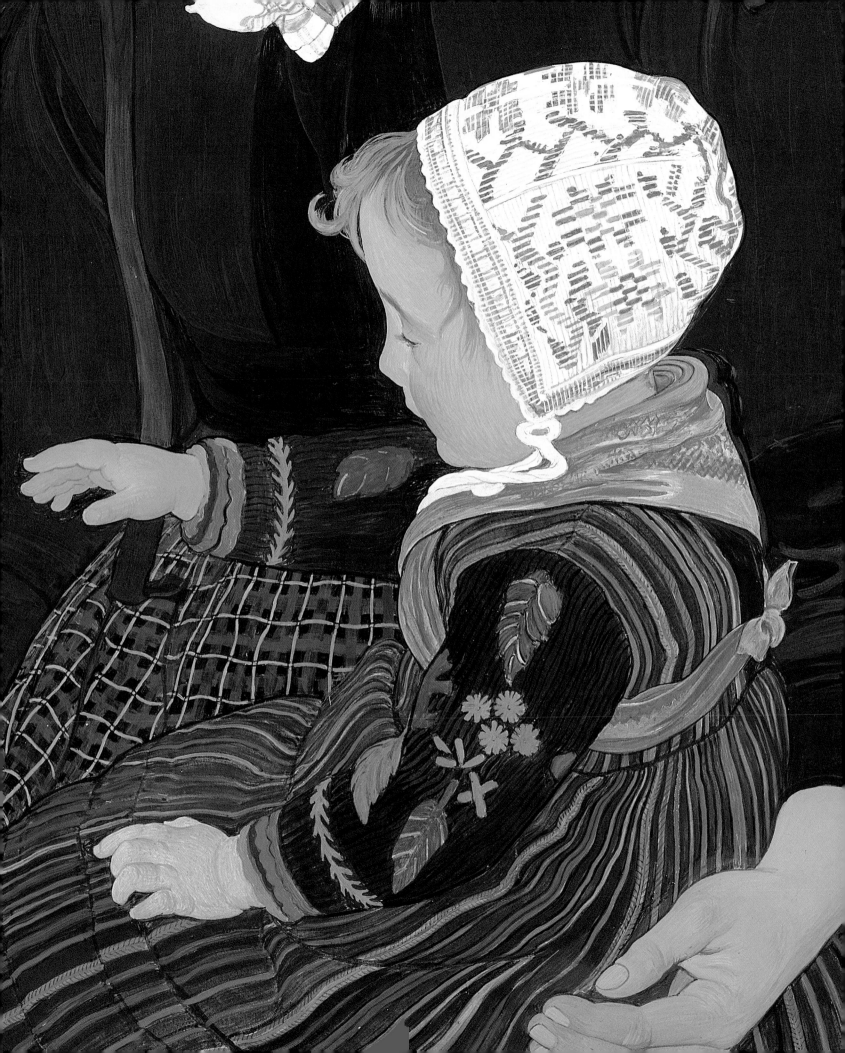

French Painting

Diane de Poitiers

François Clouet
(Tours, c. 1510 – Paris, 1572)
Oil on panel, 92.1 × 81.3 cm
National Gallery of Art, Washington

*W*omen use their bodies to seduce, to love, to convince and if necessary to derange the mind of men, who have become addicted to the pleasures of the flesh. When perverse sensuality is matched by intelligence, the powerful and the experienced lose their self-control. Diane de Poitiers, Duchess of the Valentinois, has all these dangerous gifts. Widow at the age of thirty-two, she takes for her lover the young Henry II, who has just turned thirteen! Magnanimous, the lady shares with the Duchess of Etampes the favours of François I. But Diane has cast a spell on the king, who will reject the latter and keep her until the end of his life. After his death, she remains all-powerful and rejoins a still loving Henry II. He will build for her the castle of Anet, which will be their love nest.

Clouet, painter at the court of François I, has the same taste as his master for women.

The red curtain is drawn and Diane appears: she is naked in her bath, but she seems to be at her window. She is young, proud and beautiful. She offers her gorgeous anatomy and her breasts highly perched with underdeveloped nipples. The artist caresses the body with his brush again and again until the flesh becomes warm and desirable. The children are supposed to be the ones

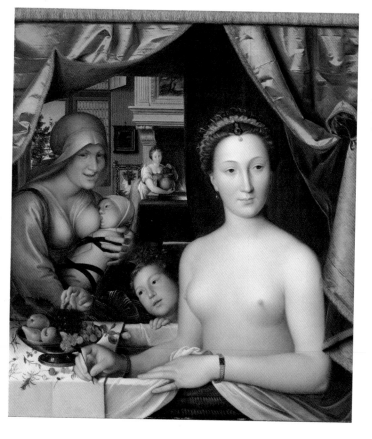

of Henry II. The elder steals some grapes while the newborn blows on the maid's nipple, about to burst from the excess of milk. In the background another maid tips some more hot water in the duchess' bath while the discreet unicorn, symbol of purity and virginity, looks away…

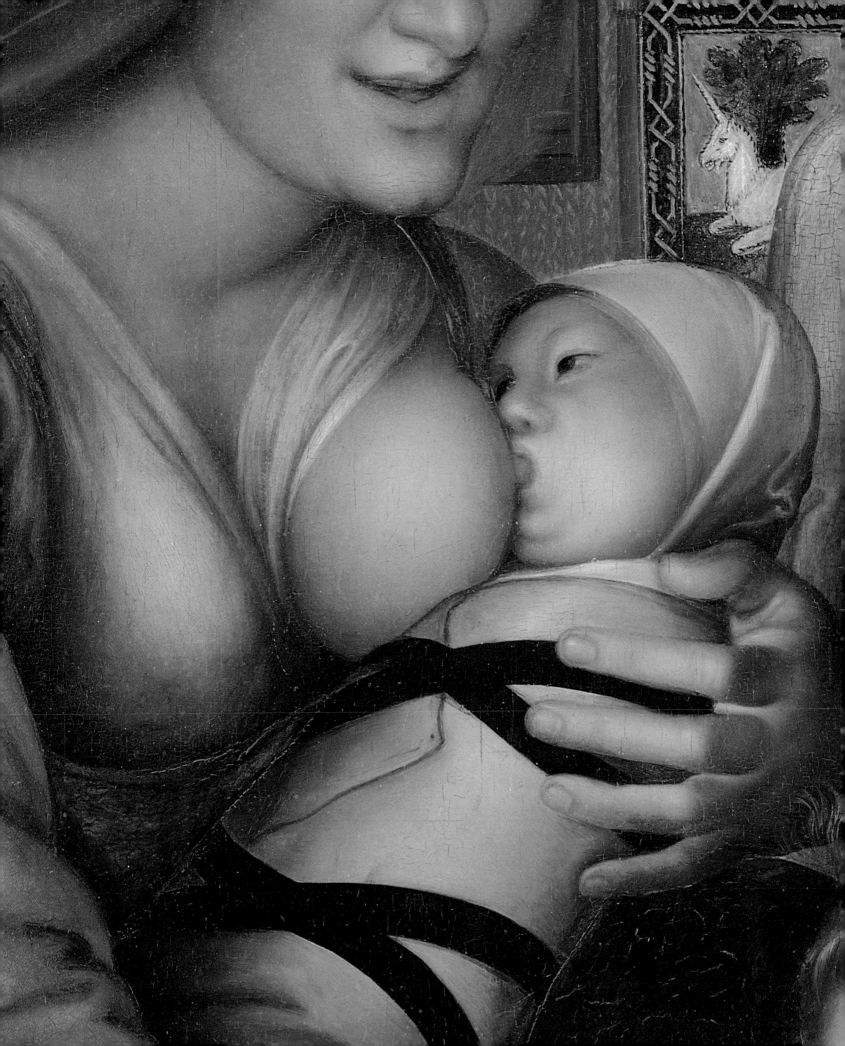

Landscape with Peasants

Louis Le Nain

(Laon, 1593? – Paris, 1648)
Oil on canvas, 46.5 × 57 cm
National Gallery of Art, Washington

There are three brothers: Antoine, Louis and Mathieu Le Nain. All are painters and they always work together. This makes the identification of their paintings very difficult, especially when they all signed in the same manner: Le Nain.

Louis seems the most prolific and the most famous one of the three. After having followed the fashion of the *bambochade* or burlesque painting, he turns to realism and paints the poor of rural France. His peasants wear rags, they are dirty, they are hungry and drink to forget their condition.

At the end of the afternoon, the peasants stop their work and take some rest. The sun's last rays gently caress the vast landscape. The herds graze at the sound of the flute. The grandmother, the brother and the younger sister are under the charm of the poet-shepherd right out of Virgil's bucolic poems.

Louis Le Nain recognizes the therapeutic virtues of nature: it soothes the poor and heals their misery.

The Education of the Virgin

Etienne de La Tour (?)
(Lunéville, 1621 – ?, 1692)
Oil on canvas, 83.8 × 100.4 cm
Frick Collection, New York

*E*tienne develops poorly in the shadow of his father George. Saint Anne lacks energy to bring up her daughter Mary. The little Chinese Virgin's profile is hard. She is about to burn her cardboard hand on the candle's flame. All these waxy shapes melt in the light of a sad reality: this art is of a conscientious amateur trying very hard to paint, but unfortunately the result is far from convincing.

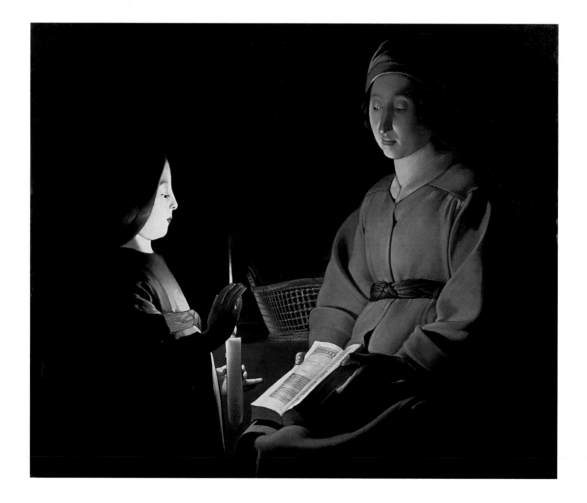

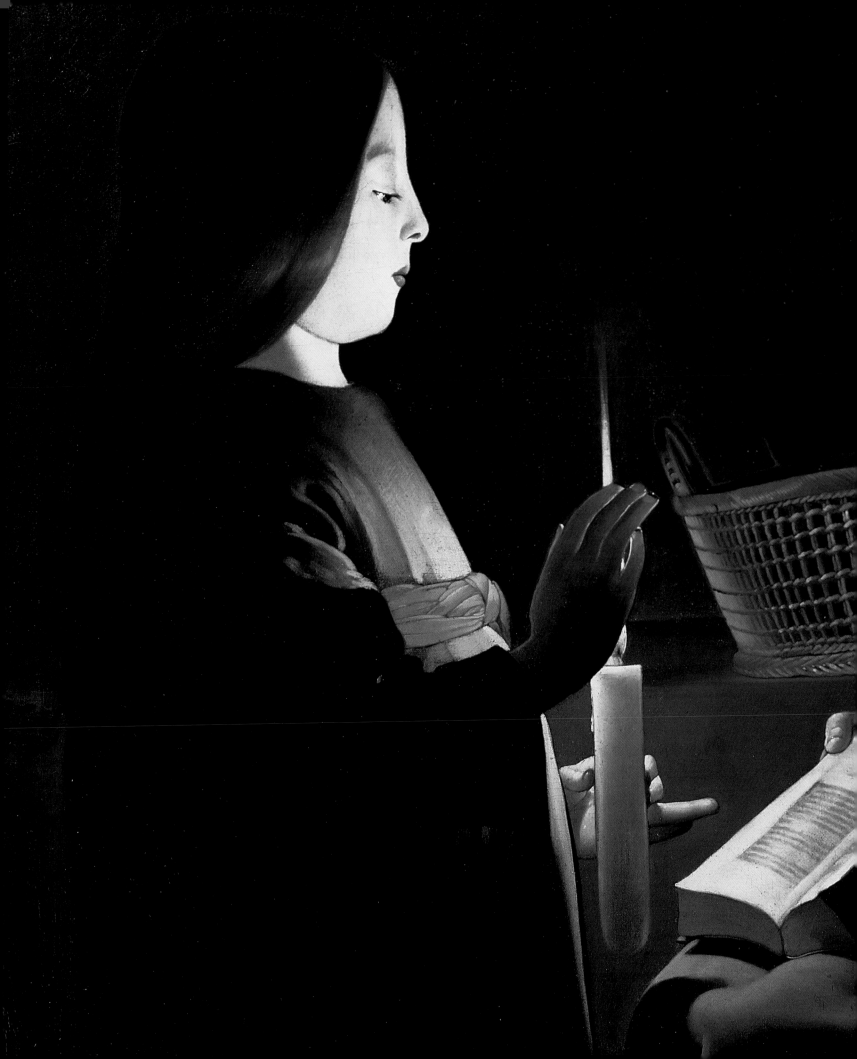

The Young Governess

Jean-Baptiste Siméon Chardin
(Paris, 1699–1779)
Oil on canvas, 61.6 × 66.7 cm
National Gallery, London

*I*t is rare for painters to be indulgent with their fellow-artists' work. Chardin is, and if he disapproves of their pictures, he does it silently.

The good and honest man is a loving husband and a disconsolate father after the premature death of his only son. He works without respite in spite of the terrible pains he suffers from kidney stones. He dies as he has lived: courageously and with dignity. This artist is a genius with modesty.

No other painter knows how to give importance to something which seems not to have any. His peaches roll next to plump cherries and a carnation sleeps in front of a basket of wild strawberries. Chardin intoxicates us with the smells of his "vivid lives". His fruit and his flowers wear his seal, they are his exclusivity and no one can contest it. His genre scenes always depict gentle moments. The artist puts his art and his emotions in them, and his pictures of daily life become great pictorial moments.

This little boy with his turban follows the letters on the page of his book with his forefinger. His young governess is ready to help him and to encourage him with the authority of her knowledge. Chardin's colours spring naturally from his palette: they are beautiful and land on the canvas like musical notes on a stave. They sing the most harmonious melody of beauty and truth, united.

Dressing Up in the Morning

c. 1740

Jean-Baptiste Siméon Chardin

(Paris, 1699–1779)

Oil on canvas, 49 × 39 cm

National Museum, Stockholm

o belong to the middle class in France is often regarded as a sin, a sign of absurdity, of mediocrity, of narrow-mindedness, of conventionality. All these are faults indeed, but as they say in France, the middle class has the qualities of its shortcomings, such as: honesty, stability and respect of moral, religious and social values… Chardin belongs to the middle class and he is happy that it is so. He paints all the values of his social class, including the taste for comfort. This comfort contributes to the warm intimacy of a home, which everyday follows its beloved and loving rites. These habits are far from heroism but they guarantee equilibrium without monotony.

Dressing Up in the Morning is a most ordinary and daily event, but with Chardin it becomes extraordinary. When this picture was exhibited at the Salon of 1741, the editor of the *Mercure de France* wrote: "Nothing is simpler than the action of an attentive mother. […] Something more lively still is the emotion of a child's heart, which the skilful painter has managed to express through the eye that the young girl sends stealthily to the mirror, so as to satisfy her own little vanity."

One does not feel ridiculed from looking at this middle-class picture executed by a great master.

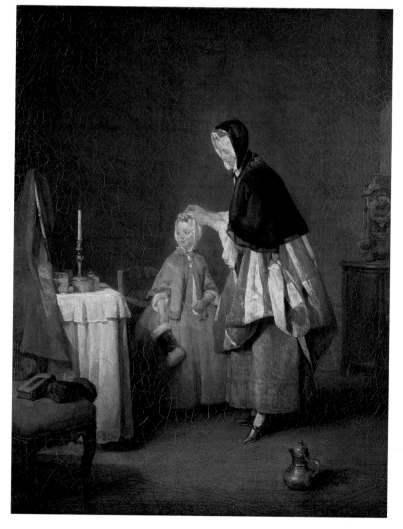

The Bubble

Charles André Van Loo, known as Carle
(Nice, 1705 – Paris, 1765)
Oil on canvas, 88.6 × 88.6 cm
National Gallery of Art, Washington

Children never tire of blowing soap bubbles, which fly away over their heads.
During the 18th century, they try to blow the biggest one with a straw. In this picture we observe the beginning of the action, the sister is ready to catch the bubble in her apron, which Van Loo happily decides to let overflow from the frame. The lifetime of this fragile balloon will be short but long enough to amuse the three rosy cheeked children.

A Visit to the Nursery

Jean-Honoré Fragonard
(Grasse, 1732 – Paris, 1806)
Oil on canvas, 73 × 92 cm
National Gallery of Art, Washington

Fragonard is lively and racy. With his friend Jean de La Fontaine he delights in gay parties and roguish tricks, and eroticism is one of their favourite sources of entertainment. The artist makes his fortune by painting canvases, which reinvigorate the gentry and sweep the new aristocrats off their feet. His technique is fast; his strokes shiver and give a marvellous idea of his refreshing sensuality. But Fragonard can also rejoice at the birth of a child, even if legitimate.

The father marvels at the sight of his fourth little wonder: he is on his knees to thank his wife and stares lovingly at the baby sleeping peacefully in his moses basket. Standing back are the three other children holding on to one another lovingly.

Fragonard is thrilled to paint this happiness and wraps it up in the softest light: is it not a marvellous birth present?

214

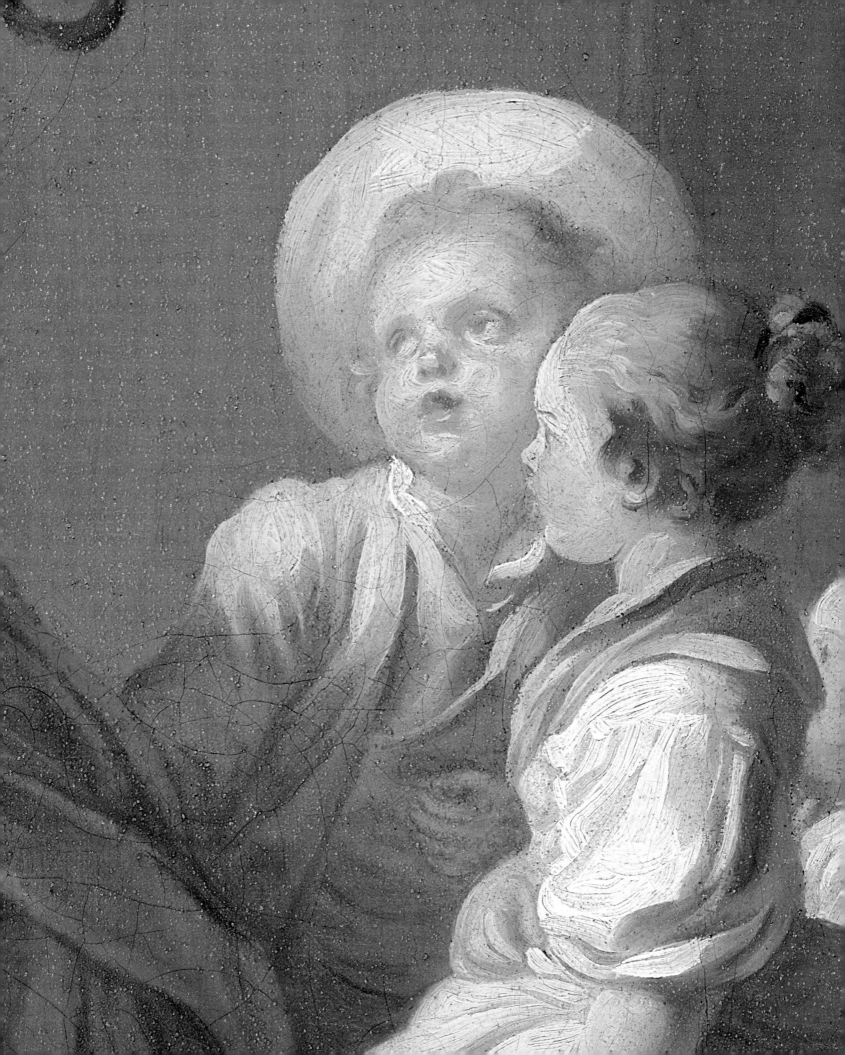

The Workshop

Gustave Courbet

(Ornans, 1819 – Vevey, 1877)

Oil on canvas, 359 × 598 cm

Musée d'Orsay, Paris

*B*eauty does not need scandal to be shocking. For Monsieur Courbet, however, the vision of *The Creation* passes through the most intimate parts of a woman's anatomy. These days, it is fashionable to join the chorus of bored intellectuals praising the greatness of an artist reconverted to the art of obstetrics.

The 19th century represses artistic and political freedom. Independent spirits are restrained and poor people are exploited. The French, specialists in revolutions after 1789, start yet again another one in 1848 to overthrow Louis Philippe. Gustave Courbet and his friends, including Baudelaire and Delacroix, militate for the freedom of expression. They all belong to the upper middle class. They want to fight its narrow-mindedness, its taboos and the social inequalities of the time. Unfortunately, art and politics are not the best of friends. *The Workshop* is a description of freedom with no revolutionary expression. Compared to Goya, Courbet is formal; his talent is stiff and does not cross the barriers of convention. His naked woman leaves us cold; she might as well go and dress. The artist is not afraid of ridicule, but he, himself, is ridiculous by becoming the centre of the composition. In full light, he tries to make us believe that he is painting a boring landscape, but offers us his best profile and does not take notice of the child admiring him. Painting leads to narcissism, but add vanity and superiority and it becomes the projection of an unbearable pretension. Imagine comparing side by side Courbet and Vermeer's workshops, and you will see the difference between genius and satisfied mediocrity.

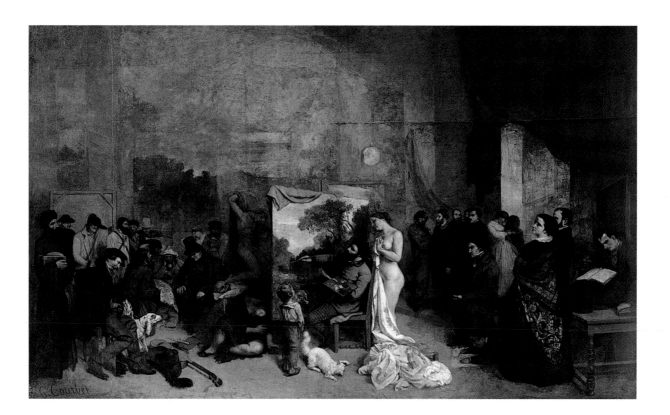

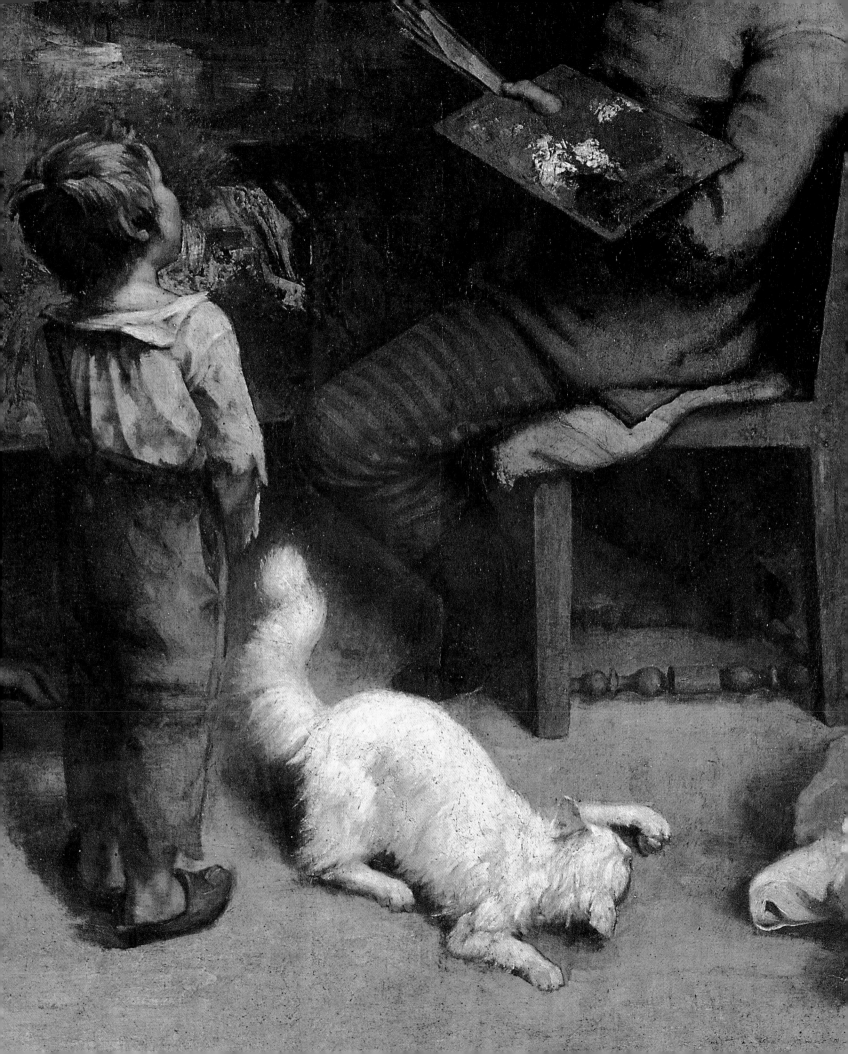

The Railway

1872

Edouard Manet

(Paris, 1832–1883)

Oil on canvas, 93.3 × 114.5 cm

National Gallery of Art, Washington

The leading figure of the Impressionist movement, Edouard Manet is happy, lively, "honest, excessive in everything", and at times hotheaded. "Manet has such talent, such ease that it would be a pity if he were to be discouraged. […] But he has personality, and this is what matters."

The Saint-Lazare railway station has a privileged place in the Impressionist iconography: it is where the Industrial Revolution takes place. From his workshop at number 4, Rue de Saint-Pétersbourg, the artist could contemplate the railways that fascinated him. He was Parisian, a city-lover who hates the countryside. During the autumn of 1872, he paints this picture, which he will exhibit at the Salon. The critics are hostile and mocking: this picture is "in prison for having lacked respect to the public."

It is a beautiful and warm day in September and the grapes on the wall are there to prove it. Facing us, Victorine Meurent poses again for the artist ten years after the *Olympia*. Less thin but still faithful to the black ribbon around her neck, she gives us an indifferent look; she is finding it difficult to read with her dog sleeping on her lap. Turning her back on us, the girl has put her Sunday frock on and stares at the coming and going of the new steam engines.

Edouard Manet is a brave *provocateur* but he is not original: Frans Hals' technique in the 16th century was Impressionist before his.

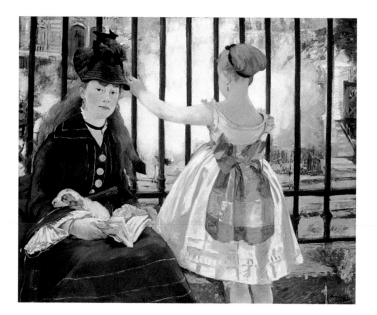

Paul, the Artist's Son

Paul Cézanne
(Aix-en-Provence, 1839–1906)
Oil on canvas, 38 × 35 cm
Musée de l'Orangerie, Paris

"A painter has to avoid the literary spirit, which often drives him away from his own way." This word of Paul Cézanne is an absolute truth, a motto for painting.

"I owe you the truth and I will tell you the truth": this sentence summarizes the integrity of Cézanne, who later was to start his own lonely fight, during which he was wounded by indifference and hostile criticism. He hated falsehood. Observing nature became his obsession, but this is what gives the intensity, the instinctiveness and the vivacity to his painting. Cézanne put his nose on mountains or apples, then took a step back to see them better and then returned yet again to take another close look. It is from this continuous movement, that he developed his technique and opened the way to a so-called abstraction that will kill art.

Cézanne lived in fear of his father, an ex-hatter turned banker and the wealthiest man in Aix. He hid from him his liaison with Hortense and the birth of his son Paul. He had to accept the pension given to him and lived confined at L'Estaque.

This portrait is an example of Cézanne's rigorous eye. A thousand and one coloured facets shape the face, draw its features and thicken the hair. A single red stroke is enough to create a lip and render the wilful expression of the mouth. Two black spots intensify the look. This is all the figurative abstraction of Cézanne's art. It is there and then that he is truly great.

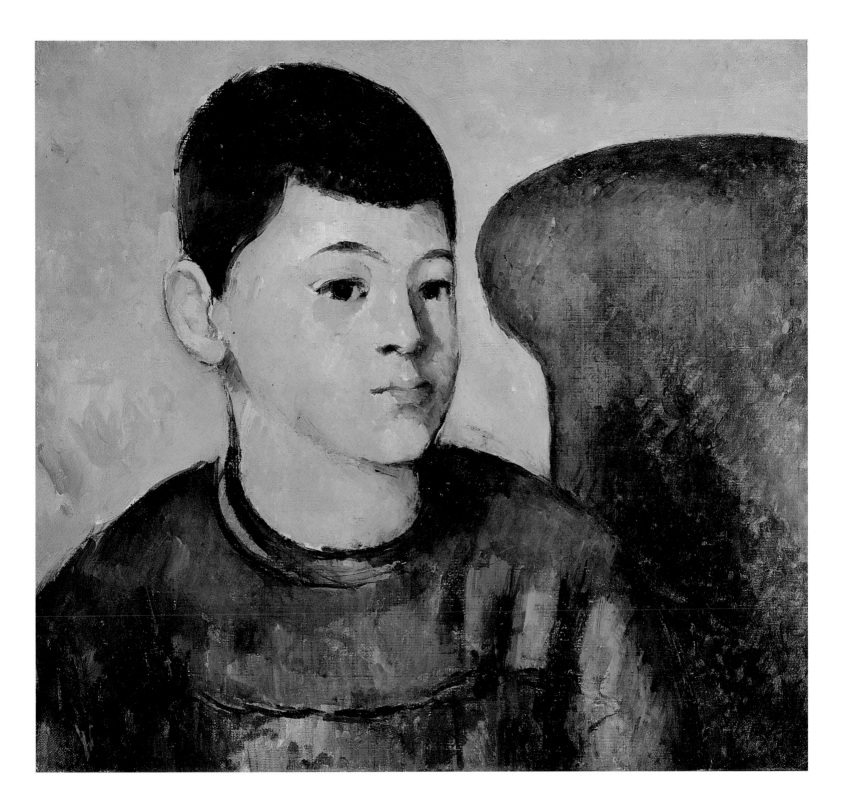

Camille with the Artist's Son Jean

Claude Monet

(Paris, 1840 – Giverny, 1926)

Oil on canvas, 116.8 × 88.9 cm

National Gallery of Art, Washington

*T*he master of Giverny was venerated by his fellow-artists. Claude Monet's eyes were an atmospheric case: they twinkled looking at the sky; they were dim with dampness and blew a breeze through the foliage. The artist created his palette in his garden. His colours are born in the water lilies, explode in the peonies and irises and fertilize the earth. They are the mauve, pink and blue snow that cover the fields where the magpie has nothing left to steal. Frozen, his whites float away like rafts covered in ice on the furious river Seine.

Monet sees life with flowers. Little Jean is lying in a bed of roses and there is nothing more beautiful. This picture is a moment of intimacy between two loved ones, witnessed by the artist from behind a door. But death will take them away too soon. Too young, Camille will leave two small children to her husband, and later Jean's death will be a drama from which the artist will never recover.

Creation is fed by happiness and unhappiness; you cannot have one without the other. They are the essence of artistic sensitivity.

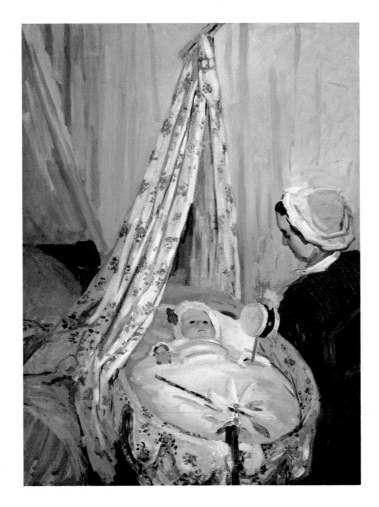

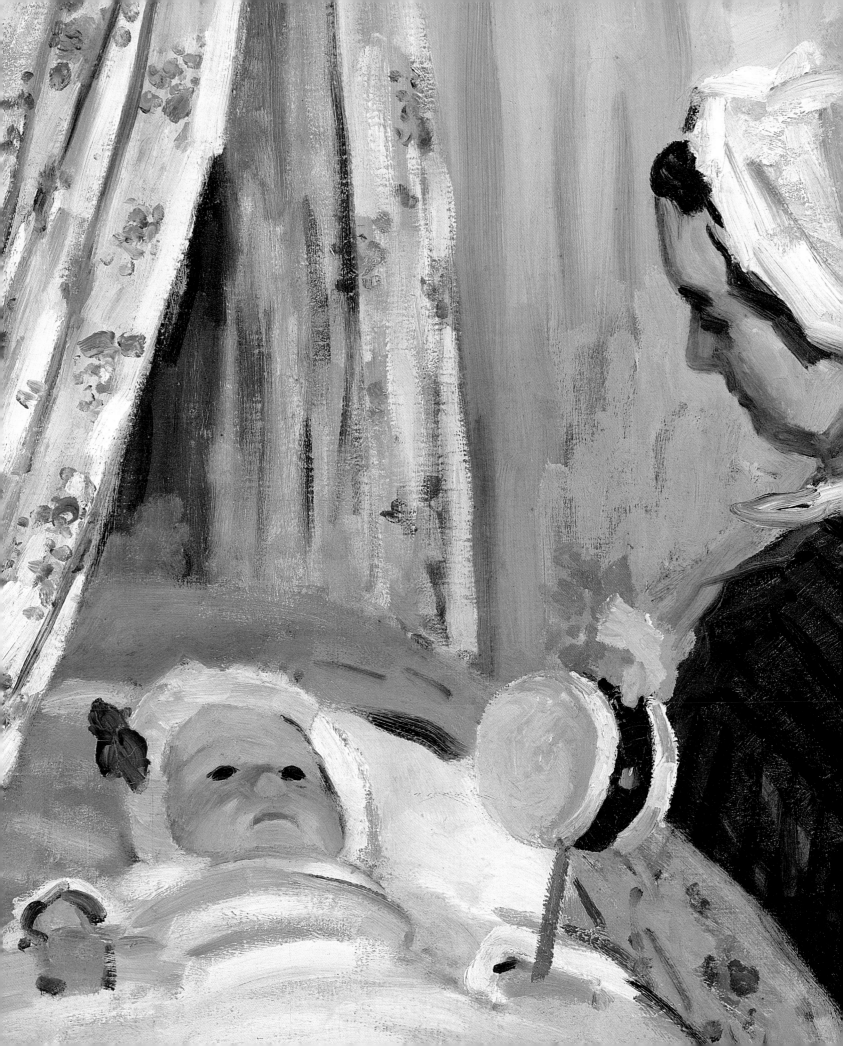

Madame Charpentier and Her Children
Pierre-Auguste Renoir
(Limoges, 1841 – Cagnes-sur-Mer, 1919)
Oil on canvas, 153.7 × 190.2 cm
Metropolitan Museum of Art, New York

*H*uysmans, Proust and Bertall's critiques of this picture are fair.

After having seen this picture at the Salon of 1879, Georges Charles Huysmans writes: "Mr Renoir has thought that it was better to represent Mrs C. active in her home with her children rather than to have her pose in a conventional manner against a purple or red curtain. [...] This is an interesting experience, which should be encouraged. There are, in this portrait, exquisite tones of flesh and ingenious associations. The manner is a bit light and intricate, wasting time in the accessories; but it is well executed and it is daring! In a way, this is the work of a talented artist who remains independent even if he exhibits at the Salon." Mr Huysmans expresses the nice commonplaces of someone who does not know what to say.

Marcel Proust calls Madame Charpentier a "petite bourgeoise ridicule". He is right, but the writer is a snob and concludes: "Is not the poetry of an elegant home and of the beautiful dresses of our days more likely to be found in the salon of the publisher Charpentier than in the portraits of the Princess Sagan or of the Countess de la Rochefoucauld by Cot or Chaplin?"

Bertall finishes with: "A most incomplete sketch done with exact colours. [...] A bland and transparent sketch, which seems to be made with cottons of various shades. [...] And with regard to the drawing, forget about it! Perspective is non-existent." I agree with this criticism, one would wish this "bland... cotton" transformed by cursive drawing and that all this blandness would

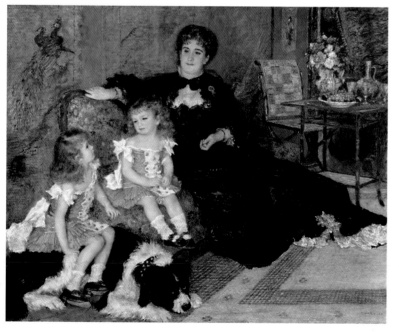

not slouch like the poor dog under the weight of the girl, who has to accept his resemblance to the lady of the house.

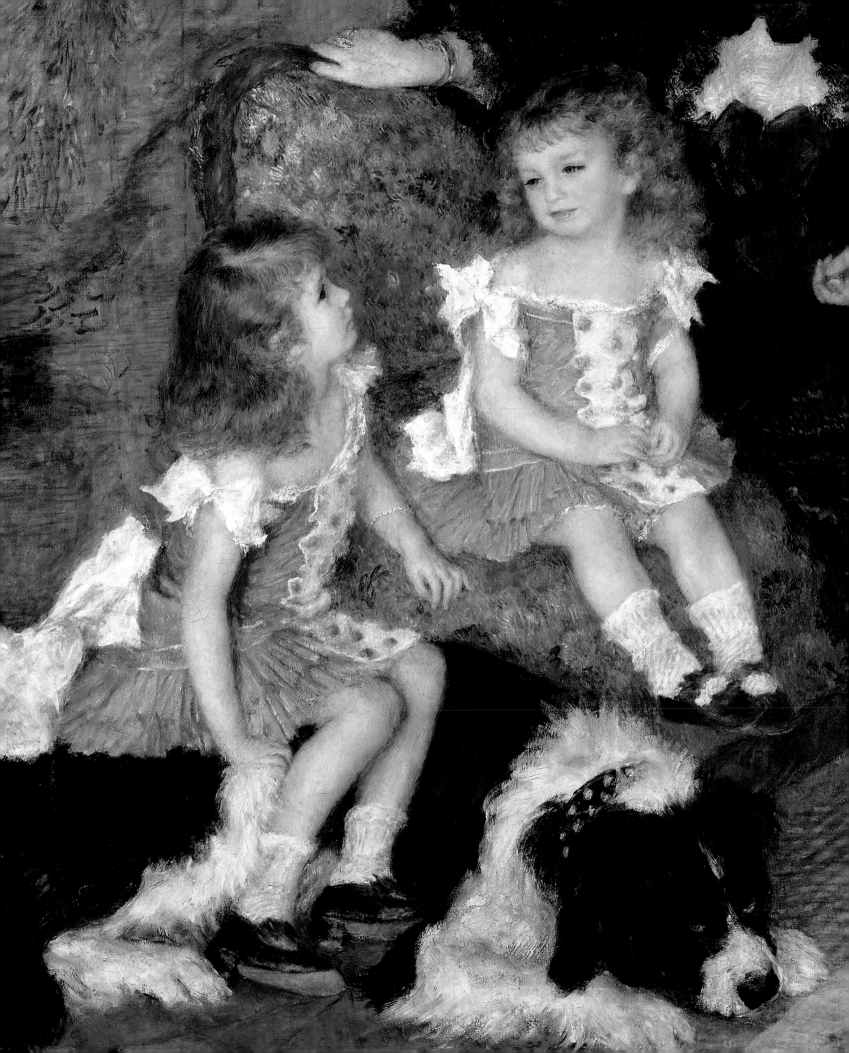

The Artist and His Model

1980–81

Balthus

(Paris, 1908 – Rossignière, Switzerland, 2001)

Oil on canvas, 233 × 227 cm

Musée National d'Art Moderne,
Centre Georges Pompidou, Paris

*H*is landscapes are a eurhythmy of heaven and earth, where light and shadows confront one another. They are the weapons Balthus uses to take up the defence of figurative art on its deathbed.

For him, abstraction is in nature. His technique does not boast beauty, it proves it. When he is not painting landscapes, he prefers to depict the bodies of nubile girls. The master reveals but does not pierce the mystery of this nudity, which excites the pleasures of love. These indecent, innocent girls are the mirror of a sensuality awaking under the eye of the observer, who is fascinated by the disquieting provocation of virgin femininity. The eye touches and caresses a forbidden fruit. The artist is the guardian of the body's juvenile beauty.

This picture leaves a sulphurous aftertaste for the casual observer, but the connoisseur is not shocked.

Nothing is violent; everything is subtle in this great composition. Balthus is light. The artist draws the curtain and all is lit. In the shade, damp colours stick to the walls but in the light they melt softly together and form into the firm shapes.

The young model reads before the pose. She leans on a chair. On it lies a piece of cloth, whose colour and shape are the only mistake of this picture.

It is with this pretty Sienese virgin that I end the marvellous journey I have taken through the ages with unforgettable children.

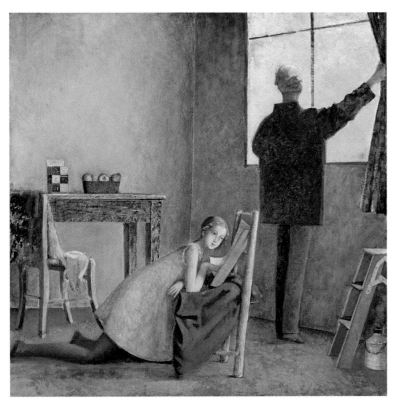

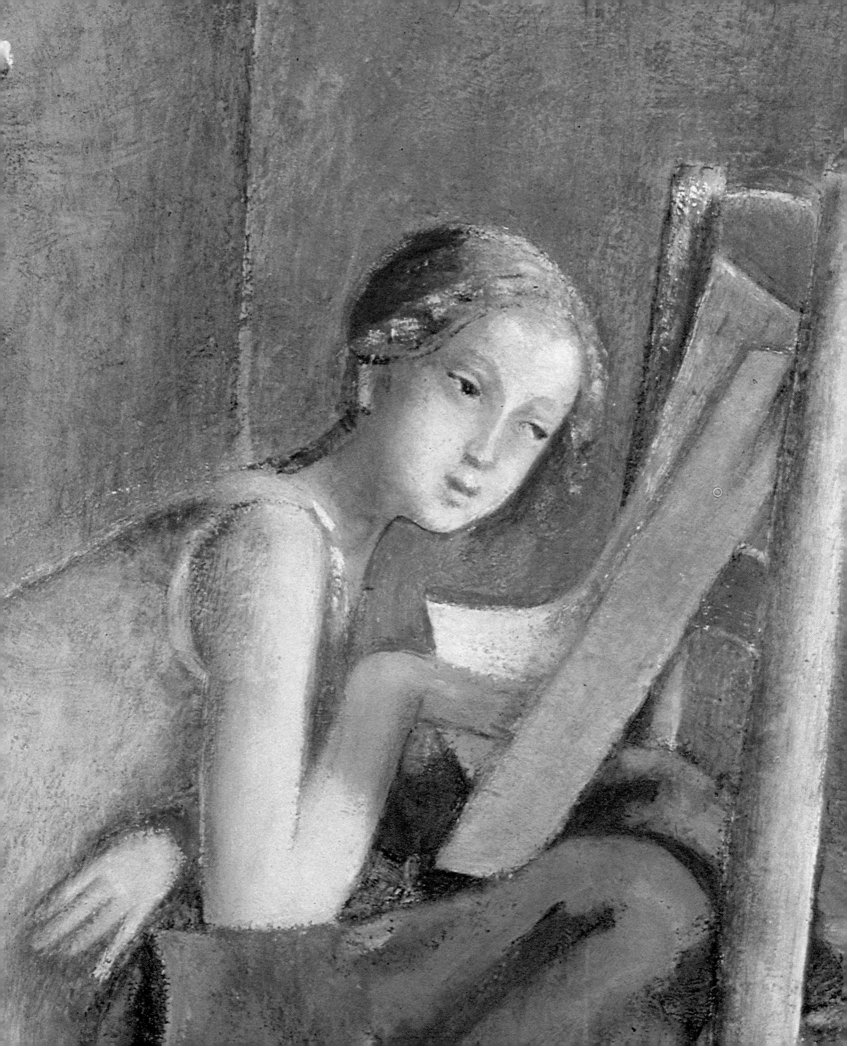

Acknowledgements

The publication of this book would not have been possible without the financial support and the immediate and enthusiastic approval of Mr. Pascal Pupet, Mr. Olivier Bizon and Mr. Thierry de Loriol of the bank Ferrier Lullin & Cie SA in Geneva. My gratitude goes to all of them.

The immense knowledge of Professor Alvar González-Palacios of Rome is a guarantee for the qualities of this book. To him, my deepest gratitude.

I must also sincerely thank my faithful professional translators Eléonore Pralle for the English version and Doriana Comerlati for the Italian edition.

Finally, Christine Urbanski and Gabriela Salazar have been exceptional assistants, attentive and patient, always with a smile.

Photographic Credits

ARtic Photodesign, The Hague (pp. 108, 109)

Artothek, Weilheim (p. 153)

Aurora Art Fund, photo courtesy of Stiebel Ltd., New York (pp. 120, 121)

Bildarchiv Preussischer Kulturbesitz, Berlin (pp. 57, 167, 178, 179)

Collection of the Prince of Liechtenstein, Vaduz (pp. 75, 87, 126, 127, 129)

Derby Museum and Art Gallery, Derby (pp. 174, 175)

© 2002 Fondation d'Art du Docteur Rau, Zurich (pp. 89, 97)

© The Frick Collection, New York (pp. 206, 207)

Gottfried Keller-Stiftung, Kunstmuseum, Bern (pp. 191, 196, 197)

Groeningemuseum, Cel Fotografie, Bruges (pp. 112, 113, 115, 116, 117, 122, 123)

© Hamburger Kunsthalle, photo Elke Walford, Hamburg (p. 13)

Leendert Jansen, Hilversum (p. 107)

KHM, Vienna (pp. 54, 55, 100, 101, 124, 125)

Kunstmuseum, Bern (pp. 194, 195)

© Lessing/Contrasto (p. 12)

Mauro Magliani fotografo, Padua (pp. 28, 29)

© 1992 The Metropolitan Museum of Art, New York (pp. 224, 225)

Musée Cantonal des Beaux-Arts, Lausanne, photo J.-C. Ducret (pp. 192, 193)

Musée Municipal, Saint-Germain-en-Laye, photo L. Sully-Jaulmes (pp. 118, 119)

Musées Cantonaux, Sion (pp. 198, 199)

Musées Royaux des Beaux-Arts de Belgique, Brussels, photo Cussac (pp. 130, 131)

Musei Vaticani (pp. 36, 37, 48, 49)

© Museo Nacional del Prado, Madrid (pp. 140, 141, 146, 147, 148, 149, 150, 151, 155, 156, 157, 161)

Museu Picasso, Barcelona (pp. 162, 163)

Museum Boijmans van Beuningen, Rotterdam (p. 95)

© National Gallery, London (pp. 41, 42, 43, 104, 105, 111, 132, 133, 136, 137, 208, 209)

© 2002 Board of Trustees, National Gallery of Art, Washington (pp. 44, 45, 59, 78, 79, 81, 83, 98, 99, 139, 159, 168, 169, 171, 173, 176, 177, 181, 182, 183, 185, 187, 189, 202, 203, 204, 205, 213, 214, 215, 218, 219, 222, 223)

National Gallery of Ireland, Dublin (pp. 102, 103)

National Museum of Fine Arts, Stockholm (pp. 210, 211)

Niedersächsisches Landesmuseum, Hanover (pp. 84, 85)

Nicolò Orsi Battaglini fotografo, Florence (pp. 16, 17, 19)

Luciano Pedicini, fotografo/archivio dell'arte, Naples (pp. 26, 27)

© Photo CNAC/MNAM Dist. RMN (pp. 226, 227)

© Photo RMN - Arnaudet, Paris (pp. 201, 221)

© Photo RMN - Hervé Lewandowski (pp. 216, 217)

© Photo RMN - J.G. Berizzi (p. 165)

Scala, Florence (pp. 21, 25, 34, 35, 38, 39, 46, 47, 61, 63, 65, 66, 67, 68, 69, 70, 71, 72, 73)

Soprintendenza per il Patrimonio storico artistico e demoetnoantropologico di Siena e Grosseto (pp. 30, 31, 32, 33)

Staatliche Kunstsammlungen, Gemäldegalerie Alte Meister, Dresde (pp. 51, 52, 53, 93)

Staatliches Museum, Schwerin (p. 91)

Städelsches Kunstinstitut, Frankfort (pp. 76, 77)

Szépmüvészeti Múzeum, Budapest (pp. 142, 143)

Bibliography

Adhémar Helène and Masson André, *Hommage à Claude Monet*, Editions de la Réunion des musées nationaux, Paris, 1980.

Angelini Alessandro, Chelazzi Dini Giulietta and Sani Bernardina, *Sienese Painting: from Duccio to the Birth of the Baroque*, H. N. Abrams, New York, 1998.

Baldini Umberto, Salmi Mario, Salvini Roberto and De Tolnay Charles, *Michelangelo artista, pensatore, scrittore*, volume II, Istituto Geografico De Agostini, Novara, 1965.

Balis A., Díaz Padrón M., Van De Velde C. and Vlieghe H., *La pintura flamenca en el Prado*, Fonds Mercator, Amberes, 1989.

Barnes Susan J., Boccardo Piero, Di Fabio Carlo and Tagliaferro Laura, *Van Dyck a Genova: grande pittura e collezionismo*, Electa, Milan, 1997.

Baticle Jeannine, *Zurbarán*, Editions de la Réunion des musées nationaux, Paris, 1987.

Baumstark Reinhold, *Trésor du Liechtenstein, chefs-d'œuvre des collections du Prince de Liechtenstein*, Editions Albin Michel, Paris, 1980.

Beaux-Arts Magazine, "Cézanne", 1996.

Bonsanti Giorgio, Improta Maria Cristina and Fisher Chris, *La chiesa e il convento di San Marco a Firenze*, volume II, Giunti, Milan, 1990.

Brown Christopher and Vlieghe Hans, *Van Dyck*, Rizzoli, New York, 1999.

Cabanne Pierre, *Rembrandt*, Profils de l'art, Editions du Chêne, Paris, 1991.

Cachin Françoise, Coffin-Hanson Anne, Moffett Charles and Melot Michel, *Manet*, Editions de la Réunion des musées nationaux, Paris, 1983.

Cairola Aldo, *Simone Martini e Ambrogio Lorenzetti nel palazzo pubblico di Siena*, IFI, Florence, 1979.

Cancogni Manlio and Perocco Guido, *Vittore Carpaccio*, Classici dell'arte, Rizzoli Editore, Milan, 1967.

Chastel André, *L'art français*, III, *Ancien Régime 1620–1775*, Flammarion, Paris, 1995.

Cinotti Mia, *Caravaggio. La vita e le opere*, Bolis, Bergamo, 1991.

Contini Gianfranco and Gozzoli Maria Cristina, *L'opera completa di Simone Martini*, Rizzoli Editore, Milan, 1970.

Cordaro Michele, *Mantegna, la chambre des époux*, Gallimard/Electa, Milan, 1992.

Cuyãs María-Margarita, Delenda Odile and Pérez Sánchez Alfonso, *Zurbarán al museu nacional d'Art de Catalunya*, MNAC, Barcelona, 1998.

Distel Anne, Gowing Lawrence and House John, *Renoir*, Editions de la Réunion des musées nationaux, Paris, 1985.

Duchet-Suchaux Gaston and Pastoureau Michel, *La Bible des Saints*, Flammarion, Paris, 1990–94.

Eimerl Sarel, *The World of Giotto*, Time, New York, 1977.

Faure Elie, Friedländer Max J., Raynal Maurice, Rosenberg Jakob and Schwarz D. Zervos Christian, *Lukas Cranach*, Jacques Damase éditeur, Paris, 1993.

Flores d'Arcais Francesca, *Giotto*, Abbeville Publishers, New York, 1995.

Franciscis de Alfonso, Schefold Karl and Laidlaw Anne, *La peinture de Pompéi*, Editions Hazan, Paris, 1993–99.

Gállego Julián, Ortiz Antonio Domínguez et Pérez Sánchez Alfonso, *Velázquez*, Ministerio de Cultura, Madrid, 1990.

Gemäldegalerie Berlin, Staatliche Museen Preussischer Kulturbesitz, Berlin, 1985.

Gemin Massimo and Pedrocco Filippo, *Giambattista Tiepolo. I dipinti : opera completa*, Arsenale Editrice, 1993.

Grimal Pierre, *Dictionnaire de la mythologie*

grecque et romaine, Presses Universitaires de France, Paris, 1951.

Hagen Rose-Marie and Rainer, *Les dessous des chefs-d'œuvre, un regard neuf sur les maîtres anciens*, tomes I–II, Taschen, Cologne, 1995.

Hertz Anselm and Loose Helmut Nils, *Fra Angelico*, Editions du Cerf, Paris, 1984.

Hirst Michael, *Michelangelo Draftsman*, Olivetti, Milan, 1988.

Hirst Michael, Colalucci Gianluigi, Mancinelli Fabrizio and Winner Matthias, *La chapelle Sixtine*, Robert Laffon, Paris, 1993.

Kaminski Marion, *Titien*, Könemann, Cologne, 1998.

Lepdor Catherine, Schaefer Patrick and Zutter Jörg, *Entre Rome et Paris : œuvres inédites du XIVe au XIXe siècle*, Musée cantonal des Beaux-Arts, Lausanne, 1995.

Levey Michael, *Giambattista Tiepolo: His Life and His Art*, Yale University Press, New Haven, 1986.

Leymarie Jean, *Balthus*, Skira, Geneva, 1982.

Martens P.J. Maximiliaan, Ainsworth W. Maryan and Blockmans Wim, *Bruges et la Renaissance: de Memling à Pourbus*, Ludion, Gand – Flammarion, Paris – Stichting Kunstboek, Bruges, 1998.

Meister Robert (ed.), *Albert Anker und seine Welt*, Zytglogge-Verlag, Gümligen, 1981.

Memling à Bruges, Stichting Kunstboek, Bruges, 1994.

Mignot Claude and Rabreau Daniel (eds.), *Histoire de l'art Flammarion. Temps modernes. XVe-XVIIIe siècles*, Flammarion, Paris, 1996.

Moreno de Las Heras Margarita and Luna J. Juan, *Goya*, Museo del Prado, Madrid, 1996.

Mossé Claude, *Les mythes grecs*, Editions Fernand Nathan, Paris, 1991.

Oberhuber Konrad, *Raphaël*, Editions du Regard, Paris, 1999.

Paccignini Giovanni, *Simone Martini*, Aldo Martello editore, Milan, 1955.

Paris Jean, *La fuite en Egypte*, Editions du Regard, Paris, 1998.

Pignatti Terisio, *Veronese: La villa Maser*, Fratelli Fabbri Editori, Milan – Albert Skira, Genève, 1968.

Post war, Christie's, 2001.

Restellini Marc (ed.), *From Fra Angelico to Bonnard. Masterpieces from the Rau Collection*, Skira, Milan, 2000.

Roberts-Jones Philippe and Françoise, *Pierre Bruegel l'Ancien*, Flammarion, Paris, 1997.

Rousseau Jean-Jacques, *Julie ou la Nouvelle Héloïse*, part IV, letter VI "A Milord Edouard", Gallimard, Paris, 1993.

Sgarbi Vittorio, *Carpaccio*, Editions Liana Lévi, Paris, 1994.

Spike John T., *Fra Angelico*, Abbeville Press, New York, 1996.

Tzvetan Todorov, *Eloge du quotidien*, Adam Biro, Paris, 1998.

Varone Antonio, *Pompéi*, Terrail, Paris, 1995.

Vaughan William, *British Painting, the Golden Age*, Thames and Hudson, London, 1999.

Von Tavel Hans Christophe, *Musée des Beaux-Arts de Berne*, Musées suisses, Geneva-Zurich, 1994.

Vos Dirk de, *Hans Memling*, Ludion, Gand, 1994.

Waincke Carsten-Peter and Ingo F. Walther, *Pablo Picasso (1881–1973)*, Taschen, Cologne, 1997.

Wildenstein Georges, *Chardin*, Hanesse, Zurich, 1963.

Wolf Norbert, *Painting of the Romantic Era*, Taschen, Cologne/London, 1999.

Zbinden Hans and Jeanneret Maurice, *Albert Anker*, Editions du Griffon, Neuchâtel, 1944.

List of Illustrations

Page numbers in italics refer to details of the paintings.

Amerling, Friedrich von
Portrait of Maria of Liechtenstein, Aged Two, Collection of the Prince of Liechtenstein, Vaduz, 87

Anker, Albert
Promenade of the Nursery Children in Bern, Kunstmuseum, Bern, 196, *197*
Sick Old Man and Fritz Gaschen Reading to Him, Kunstmuseum, Bern, 194, *195*

Anonymous
Family, Probably the One of Jan Gerritsz, Portret van Enkhuizen, St. Verzameling Semeijns de Vries van Doesburgh, 107, *108-109*

Anonymous
Francesca Caterina di Savoia, present whereabouts unknown, 10

Anonymous
Theseus Liberator, Museo Archeologico Nazionale, Naples, 26, *27*

Balthus, Balthazar Klossowski de Rola known as
The Artist and His Model, Musée National d'Art Moderne, Centre Georges Pompidou, Paris, 226, *227*

Bieler, Ernest
The Little Red Horse, Musée Cantonal du Valais, Château Mercier, Sierre, 198, *199*

Bocion, François
Bocion and His Family Fishing, Musée Cantonal des Beaux-Arts, Lausanne, 192, *193*

Bosch, Hieronymus
The Pickpocket, Musée Municipal, Saint-Germain-en-Laye, 118, *119*

Botticelli, Sandro Filipepi called
Mars and Venus, National Gallery, London, 41, *42-43*

Bronzino, Agnolo di Cosimo called
Giovanni de' Medici, Galleria degli Uffizi, Florence, 65
Portrait of Bia, Natural Daughter of Cosimo I de' Medici, Galleria degli Uffizi, Florence, 63

Bruegel, Pieter the Elder
Children's Games, Kunsthistorisches Museum, Vienna, 124, *125*

Caravaggio, Michelangelo Merisi called
The Martyrdom of Saint Matthew, Contarelli Chapel, San Luigi dei Francesi, Rome, 68, *69*

Carpaccio, Vittore
Presentation of the Virgin in the Temple, Pinacoteca di Brera, Milan, 46, *47*

Cassatt, Mary
Two Children on the Beach, National Gallery of Art, Washington, 187

Cézanne, Paul
Paul, the Artist's Son, Musée de l'Orangerie, Paris, 221

Chardin, Jean-Baptiste Siméon
Dressing Up in the Morning, National Museum, Stockholm, 210, *211*
The Young Governess, National Gallery, London, 208, *209*

Clouet, François
Diane de Poitiers, National Gallery of Art, Washington, 202, *203*

Copley, John Singleton
The Copley Family, National Gallery of Art, Washington, 182, *183*

Correa de Vivar, Juan
The Adoration of the Child, Museo del Prado, Madrid, 140, *141*

Correggio, Antonio Allegri called
Ganymede, Kunsthistorisches Museum, Vienna, 54, *55*

Courbet, Gustave
The Workshop, Musée d'Orsay, Paris, 216, *217*

Cranach, Lucas the Elder
A Saxon Prince, National Gallery of Art, Washington, 81

David, Gérard, or Gheeraert
Virgin and Child with a Bowl of Pap, Aurora Trust, New York, 120, *121*

Devis, Arthur
Conversation at Ashdon House, National Gallery of Art, Washington, 168, *169*

Eakins, Thomas
Baby Playing, National Gallery of Art, Washington, 185

Fra Angelico, Guido di Pietro called
Saint Lawrence Giving Alms to the Poor, Chapel of Nicholas V, Vatican, 36, *37*
Virgin and Child with Eight Saints (Virgin of the Shadows), eastern corridor, convent of San Marco, Florence, 34, *35*
Last Judgement, Museo di San Marco, Florence, 16-17, *19, 21*

Fragonard, Jean-Honoré
A Visit to the Nursery,
National Gallery of Art,
Washington, 214, *215*

Gainsborough, Thomas
John Heatcote, National
Gallery of Art, Washington,
173

Giotto
*Presentation of Mary at the
Temple*, Scrovegni or Arena
Chapel, Padua, 28, *29*

Girodet de Roucy
Trioson, Anne-Louis
*Presumed Portrait of
Romainville Trioson*, Musée
du Louvre, Paris, 12

Goya y Lucientes, Francisco
The Countess of Chinchón,
National Gallery of Art,
Washington, 159
*The Duke of Osuna and His
Family*, Museo del Prado,
Madrid, 155
Manuel Osorio, Metropolitan
Museum of Art, New York,
11

Hals, Franz
The Taste (Boy with a Glass),
Gemäldegalerie, Staatliches
Museum, Schwerin, 91

Henri, Robert
Catharine, National Gallery
of Art, Washington, 189

Holbein, Hans the Younger
Edward VI as a Child,
National Gallery of Art,
Washington, 83

Hooch, Pieter de
*Courtyard of a House
in Delft*, National Gallery,
London, 104, *105*

Jordaens, Jacob
The King Drinks, Musée
d'Art Ancien, Brussels,
130, *131*

La Tour, Etienne de (?)
The Education of the Virgin,
Frick Collection, New York,
206, *207*

Lawrence, Sir Thomas
Child Gardeners,
Gemäldegalerie, Berlin,
178, *179*

Le Nain, Louis
Landscape with Peasants,
National Gallery of Art,
Washington, 204, *205*

Leyster, Judith
Head of a Girl, Collection
of Doctor Rau, 97

Lorenzetti, Pietro
Virgin and Child, Museo
Diocesano, Pienza, 30, *31*

Manet, Edouard
The Railway, National Gallery
of Art, Washington, 218, *219*

Mantegna, Andrea
*Camera degli Sposi (The
Chamber of the Spouses)*,
Palazzo Ducale, Mantua,
38, *39*

Martini, Simone
*Stories of Blessed Agostino
Novello. Miracle of the Child
Falling from the Balcony*,
Pinacoteca Nazionale, Siena,
32, *33*

Master of the "Jardinet
de Paradis", also called
Master of the Middle Rhine
The Garden of Delights,
Städelsches Kunstinstitut,
Frankfurt, 76, *77*

Memling, Hans
Triptych Moreel,
Groeningemuseum, Bruges,
115, *116, 117*

Michelangelo Buonarroti
The Prophet Zechariah,
ceiling of the Sistine Chapel,
Vatican, 48, *49*

Monet, Claude
*Camille with the Artist's Son
Jean*, National Gallery of
Art, Washington, 222, *223*

Murillo, Bartolomé Esteban
The Holy Family, Museo
del Prado, Madrid, 150, *151*
The Pie Eaters, Alte
Pinakothek, Munich, 153

Picasso, Pablo
First Communion, Museu
Picasso, Barcelona, 162, *163*
Paul Drawing, Musée
Picasso, Paris, 165

Pourbus, Pieter
The Last Supper,
Groeningemuseum, Bruges,
122, *123*

Raeburn, Sir Henry
John Tait and His Grandson,
National Gallery of Art,
Washington, 176, *177*

Raphael, Raffaello Sanzio
called
The Sistine Madonna,
Gemäldegalerie Alte
Meister, Staatliche
Kunstsammlungen, Dresden,
51, *52-53*

Rembrandt Harmenszoon
van Rijn
The Abduction of Ganymede,
Gemäldegalerie Alte
Meister, Staatliche
Kunstammlungen, Dresden,
93
Titus at His Desk, Museum
Boijmans van Beuningen,
Rotterdam, 95

Renoir, Pierre-Auguste
*Madame Charpentier and
Her Children*, Metropolitan
Museum of Art, New York,
224, *225*

Reynolds, Sir Joshua
Lady Caroline Howard,
National Gallery of Art,
Washington, 171

Richter, Adrian Ludwig
*The Church of Graupen in
Bohemia*, Niedersächsisches
Landesmuseum, Hanover,
84, *85*

Roberti, Ercole de'
Hasdrubal's Wife and Her Children, National Gallery of Art, Washington, 44, *45*

Rosso Fiorentino, Giovanni Battista di Iacopo called
Angel Musician, Galleria degli Uffizi, Florence, 61

Rubens, Peter Paul
Clara Serena Rubens, Collection of the Prince of Liechtenstein, Vaduz, 129
Erichthonios in His Basket, Collection of the Prince of Liechtenstein, Vaduz, 126, *127*

Runge, Philipp Otto
Portrait of the Artist's Son, Kunsthalle, Hamburg, 13

Sorolla, Joaquín
Children on the Beach, Museo del Prado, Madrid, 161

Steen, Jan Havickzoon
The Schoolmaster, National Gallery of Ireland, Dublin, 102, *103*

Strigel, Bernhard
Saint Mary Cleophas and Her Family, National Gallery of Art, Washington, 78, *79*

Terborch, or Ter Borch, Gerard
The Apple Peeler, Kunsthistorisches Museum, Vienna, 100, *101*

Tiepolo, Giambattista
The Investiture of the Duchy of Francony to Bishop Harold, Residenz, Würzburg, 70, *71*

Tiepolo, Giandomenico
The Mandarin's Walk, Foresteria, Villa Valmarana ai Nani, Vicenza, 72, *73*

Titian, Tiziano Vecellio called
Clarissa Strozzi, Gemäldegalerie, Berlin, 57
Ranuccio Farnese, National Gallery of Art, Washington, 59

Van Dyck, Anthony
The Balbi Children, The Trustees of the National Gallery, London, 136, *137*
Woman and Child, The Trustees of the National Gallery, London, 132, *133*
The Young Diana, private collection, 135

Van Eyck, Jan
The Virgin with the Canon Van der Paele, Groeningemuseum, Bruges, 112, *113*

Van Loo, Charles André, known as Carle
The Bubble, National Gallery of Art, Washington, 213

Van Ostade, Adriaen
The Dooryard Cottage, National Gallery of Art, Washington, 98, *99*

Velázquez, Diego Rodriguez de Silva y
Doña Antonia de Ipeñarrieta y Galdós and Her Son Don Luis, Museo del Prado, Madrid, 148, *149*
Las Meninas or *The Family of Philip IV*, Museo del Prado, Madrid, 146, *147*

Veronese, Paolo Caliari called
Girl Opening a Door, Villa Barbaro, Maser, 66, *67*

Wright of Derby, Sir Joseph Wright called
Philosopher Giving a Lesson on a Table Planetarium, Derby Museum and Art Gallery, Derby, 174, *175*

Zurbarán, Francisco de
The Rest during the Flight to Egypt, Szépművészeti Múzeum, Budapest, 142, *143*
The Virgin Child Asleep, San Salvador Cathedral (former collegiate church), Jerez de la Frontera, 145